The Classics

THE CLASSICS

THE GREATEST HOLLYWOOD FILMS OF THE 20TH CENTURY

NH
NEW HOLLAND

Alan J. Whiticker
in association with
Mary Evans Picture Library

Contents

Introduction	7
1900–1929	9
The 1930s	33
The 1940s	81
The 1950s	131
The 1960s	189
The 1970s	243
The 1980s	301
The 1990s	351
Picture Credits	399

Sensational...
Daring...
Unforgettable...

Paramount's

SUNSET BOULEVARD

A HOLLYWOOD STORY

STARRING
WILLIAM HOLDEN · GLORIA SWANSON · ERICH von STROHEIM
WITH NANCY OLSON · FRED CLARK · LLOYD GOUGH · JACK WEBB
AND CECIL B. DeMILLE · HEDDA HOPPER · BUSTER KEATON · ANNA Q. NILSSON · H.B. WARNER · FRANKLYN FARNUM
PRODUCED BY CHARLES BRACKETT DIRECTED BY BILLY WILDER WRITTEN BY CHARLES BRACKETT, BILLY WILDER AND D.M. MARSHMAN JR. A PARAMOUNT PICTURE

Introduction

What makes a film a 'classic'? Perhaps they are movies that achieved both financial success and critical acclaim or they represent a key film in the career of a particular actor or director. Maybe they have claimed a place in history by winning one of the top five Academy Awards® (Film, Director, Actor, Actress and Supporting Actors). More generally, however, they are movies that have touched millions of people around the world and remain popular with a wide circle of critics and fans.

The Classics is a collection of great movies from the silent era through to the end of the 1990s. With more than 600 images of hundreds of featured films in this 400-page book, *The Classics* provides a unique history of the development of cinema from before the advent of the 'talkies', through Hollywood's golden age and up to the end of the 20th century.

The majority of films featured in this book have their origins in Hollywood, but British films that proved successful in the US also filter through. I have resisted the temptation, however, to include foreign language films or even English language films from other countries (especially my own homeland, Australia). A selection of classic French, German or Asian films would each fill books of their own, so rather than select a token two or three from each country, I have limited this book to reflect the 'Hollywood' experience.

As a 'baby boomer' growing up in the 1960s and 1970s, I was exposed to classic films on black and white TV sets that had a staple diet of war films, westerns, gangster, noir, drama, comedy and even 'shorts' from the silent era. Before our local movie theater closed in the early 1970s, I was lucky enough to see many films that were re-released during that period ... *Gone With the Wind* (1939), *Around the World in 80 Days* (1956) and *Spartacus* (1960) to name just three ... but I also had my fix of '60s and '70s classics at the local drive-in theater with my family (*Mary Poppins*, 1964 and *The Sound of Music*, 1965) or took the train into the city with friends to watch a new release (*Papillon*, 1973; *One Flew Over the Cuckoo's Nest*, 1975 and *Annie Hall*, 1977).

Films are like old friends. Part of the joy in revisiting your favorite movies time and time again is discovering and learning something new about them. With home videos in the 1980s, many great films from the past became accessible to a wider audience. The arrival of DVD technology had a similar effect. With the internet in the 1990s, the establishment of film websites (especially imdb.com) and the advent of streaming in the 2000s, viewing classic films (especially early silent films) and learning about film history has become much easier.

It would have been easy to fill this book with facts and figures on each film, but it was just as important for me to explain some films in a new way and to communicate what makes a particular film a 'classic'. Of the films that are featured in depth, I have endeavored to showcase different actors and directors across each decade. The classic films are complemented with wonderfully evocative photos and movie posters that have been selected from the files of the Mary Evans Picture Library.

The Classics is not meant to be a definitive history or a text book of film. I hope you find your favorite film in this book. If not, I hope this book in some small way encourages you to seek out new favorites and appreciate the rich history of film across the last century.

Alan J. Whiticker, 2018

1900–1929

It was a time of magic; flickering black and white images projected on a silver screen. The audience called them 'moving pictures' and these soundless comedies and melodramas ultimately turned the new film medium into an art form universally loved and admired around the world. After World War I, the American film industry took root in the Californian community of Hollywood. The great studios emerged – Warner Bros., Paramount, RKO, MGM, 20th Century Fox – and the minors, Universal, United Artists, Columbia and various independents. Shorts and silent-screen slapstick comedies gave way to 'feature' films of longer length and complexity, and film masters such as W.D. Griffiths, Charlie Chaplin, Buster Keaton, Harold Lloyd and Cecil B. DeMille made their reputations.

And then there were 'the stars', those luminous screen performers who captured the hearts and imagination of the cinema-going public. Rudolph Valentino, Lon Chaney, Douglas Fairbanks, Mary Pickford, John Gilbert and Greta Garbo to name just a few. Not all would survive the advent of 'talking pictures' at the end of the decade.

The release of *The Jazz Singer*, starring Al Jolson, revolutionized the film world in 1927. Synchronized sound changed the way films were made, ushering in the golden era of Hollywood.

Charlie Chaplin in *The Gold Rush* (1926)

D.W. Griffith

1875–1948

Regarded as the father of American film whose achievements cast a giant shadow over the medium in the first quarter of the 20th century, Griffith completed well over 400 'shorts' (one-reelers) in his early career, mastering the new medium with an actor's eye for the melodramatic and a cinematographer's sweep of the spectacular.

The Birth of a Nation (1915) is his signature epic; the fact that it was also seen as 'pro' Ku Klux Klan and 'anti-black' (featuring white actors in black face) didn't stop it from being a worldwide smash hit. *Intolerance* (1916) is regarded by critics as his masterpiece, and although his career effectively ended with the coming of the 'talkies', Griffith turned film direction into an art form and paved the way for those who came after.

KEY FILMS

The Sealed Room (1909)
Edgar Allan Poe (1909)
The Musketeers of Pig Alley (1912)
The Battle at Elderbush Gulch (1913)
Judith of Bethulia (1914)
The Birth of a Nation (1915)
Intolerance (1916)
Broken Blossoms (1919)
True Heart Susie (1919)
The Fall of Babylon (1919)
Way Down East (1920)
Orphans of the Storm (1921)
America (1924)

In cinematic history, *The Birth of a Nation* (1915) is a landmark film. At more than three hours long, this grand epic has many startling moments that, a century later, still have the power to shock and amaze. But it's also an irresponsible anachronism – a pro Confederate/pro Ku Klux Klan piece of propaganda, peddling the false premise that freed slaves during the American Civil War were a danger to white society and to womanhood. Politically dangerous at the time (the film created several riots in southern US cities where it was first shown), the politics of the film belong to the 1800s, let alone the 20th century, and would be so easily forgotten if it were not so brilliantly realized by director D.W. Griffith.

Intolerance: Love's Struggle Throughout the Ages (1916) was D.W. Griffith's answer to critics who pointed out the blatant racism and bigotry of his 1915 film *The Birth of a Nation*. Griffith weaves a masterful tale of man's inhumanity to man by intercutting four stories throughout history – the Babylonian Story (600BC), the French Story (1500s), The Judean Story (AD27) and the Modern Story (1914). Starring Lillian Gish and Douglas Fairbanks, it was made at a cost of $2 million making *Intolerance* the most expensive film produced to that date.

Charlie Chaplin
1889–1977

Charles Chaplin remains one of the most recognizable figures of the 20th century. His 'tramp' with the short mustache, bowler hat and cane captured the imagination of generations of fans around the world. The English immigrant proved so successful in the new medium that he quickly took full control of his career by writing, starring in and directing his own films, and forming his own production company and studio (United Artists).

So popular was Chaplin, that he was still making silent films in the 1930s (the classic *Modern Times*, with third wife, Paulette Goddard, in 1936). By this time, however, his private life had become increasingly scandalized.

Chaplin was exiled in Switzerland for the last 25 years of his life when his politics and private life alienated film audiences, Hollywood and the US government. Nevertheless, he remains a pioneering giant of the medium.

KEY FILMS

Work (1915)
The Tramp (1915)
The Bank (1915)
The Adventurer (1917)
The Immigrant (1917)
A Dog's Life (1918)
Shoulder Arms (1918)
The Kid (1921)
The Pilgrim (1923)
A Woman of Paris (1923)
The Gold Rush (1925)
The Circus (1928)
City Lights (1931)
Modern Times (1936)
The Great Dictator (1940)
Monsieur Verdoux (1947)
Limelight (1952)
A King in New York (1957)
(All films listed were directed by Chaplin)

The Kid (1921) was a phenomenon success when it was released. Chaplin squeezed every tear out of the audience in this famous story of a tramp who rescues a child bound for the orphanage. Once again, he drew on his impoverished childhood to create the story. In making the film, Chaplin made a giant leap in cinema art by focusing on visual storytelling to carry the narrative.

The 'kid', actor Jackie Coogan (1914–1984), became one of cinema's first child stars (he later famously sued his parents for squandering the millions he earned as an actor). Coogan, who earned pop culture fame as Uncle Fester on the 1960s TV series *The Addams Family*, was reunited with Chaplin fifty years later when the veteran actor-director was invited back to Hollywood after years in exile to receive an Honorary Academy Award in 1972.

At 95 minutes, *The Gold Rush* (1925) was the longest, most expensive comedy film ever made at the time. However, writer-director-actor Charlie Chaplin was able to show his genius in being able to sustain the 'poetry, pathos (and) tenderness' of his lone prospector story in the story. It contains Chaplin's famous 'roll dance' scene as he pursues his love Georgia (Georgia Hall) and the 'teetering cabin' scene. An incredible success at the time, grossing more than $4 million worldwide, this is considered by many critics to be Chaplin's greatest film achievement of all his silent films. When it was released in 1942 with a new musical score, it was nominated at the Oscars® for Best Original Music.

Rudolf Valentino
1895–1926

A worldwide phenomenon during the 1920s, Valentino's premature death at age 31 from peritonitis following a misdiagnosed ruptured gastric ulcer, sent millions of female fans (and a few males) into prolonged mourning.

Born in Italy in 1895, Valentino came to New York in 1913 and supported himself waiting on tables, 'taxi' dancing and working in a stage troupe. Relocating to the West Coast, he was encouraged to try his hand in silent films.

His good looks and athletic body resulted in his breakthrough role in *The Four Horsemen of the Apocalypse* (1921). *The Sheik* (also 1921) made the 'Latin Lover' one of the first sex symbols of the new mass medium of film and soon, due to his premature death, an icon and legend.

KEY FILMS

Stolen Moments (1920)
The Conquering Power (1921)
The Four Horsemen of the Apocalypse (1921)
The Sheik (1921)
Camille (1921)
Blood and Sand (1922)
The Young Rajah (1922)
Beyond the Rocks (1922)
Moran of the Lady Letty (1922)
Monsieur Beaucaire (1924)
Cobra (1925)
The Eagle (1925)
The Son of the Sheik (1926)

The Four Horsemen of the Apocalypse (1921), based on the Spanish novel by Vicente Blasco Ibáñez, made Rudolph Valentino a superstar of the silent era. The highest grossing film of 1921 (even beating Chaplin's *The Kid*), Rex Ingram's film was released soon after the end of World War I. It found a willing audience with its bold anti-war message that love conquers hatred.

The story focuses on a South American family torn apart when members join enemy French and German troops on the battlefield. Valentino (right), as the doomed hero Julio with his smoldering good looks (the tango scene is a standout) dominates the film. The film's staggering $1 million production costs were returned four-fold.

Harold Lloyd (1893–1971) is largely forgotten today as a pioneer film comedian but critics have always valued his contribution to the medium. As popular as Chaplin in his day and as influential as Keaton, Lloyd acted in his own films and performed his own stunts. *Safety Last* (1923) is perhaps his best-known film, where he hangs precariously from a giant clock on the side of a building (the scene was merely an optical illusion).

Known by his trademark dark-rimmed glasses, Lloyd's 'go-getter' persona was well suited to the 1920s (he made 12 feature films during the decade) but his film career was effectively over by the end of the 1930s. Many of his silent films were destroyed by a fire at his mansion in 1944, but although he was seriously injured, Lloyd lived long, and well enough, to be acclaimed as a film master by his peers.

16

The Big Parade (1924) takes its place alongside *The Four Horsemen of the Apocalypse* (1921), *What Price Glory* (1926) and *Wings* (1927) as one of Hollywood's great silent films about World War I. Starring John Gilbert, Renée Adorée, Hobart Bosworth, and Claire McDowell, *The Big Parade* tells the story of three soldiers who become friends on the battlefields of France. It was an enormous financial success and received critical acclaim in the mid-1920s.

The Phantom of the Opera (1925) was the first film adaptation of Gaston Leroux's 1910 novel (it was also filmed in 1943, 1962, 1989 and 2004, the 2004 version being an adaptation of Andrew Lloyd Webber's successful stage musical).

Starring Lon Chaney (1883–1930), the 'man of a thousand faces' and a master of cinema make-up brought the phantom to life and then scared his audiences half to death.

It had an auspicious start going through several rewrites and weeks of reshooting after a poor preview which resulted in the departure of director Rupert Julian. The film, after having special Technicolor effects added, was then shown accompanied by a live orchestra soundtrack. After yet another poor showing, extra scenes were shot by Chaney and Edward Sedgwick. After reedited, it was then released to enormous success.

Ben-Hur (1925) was the second film adaptation of Lew Wallace's classic 'tale of the Christ', with a one-reeler being produced as early as 1907. MGM gave the project the star treatment with principal photography starting in Rome in 1923. The film ran over-budget, the director was sacked and production returned to an expensive array of Hollywood sets.

Starring silent film star Ramon Navarro (1899–1968) as Judah Ben-Hur, the film cost $3. 9 million to make which made it the most expensive film produced in the silent era. It grossed more than double that as audiences worldwide flocked to see it. Like its more famous successor (*Ben-Hur*, 1959), the highlight of the film was the chariot race between Ben-Hur and Messala, his childhood friend-turned nemesis.

Buster Keaton

1895–1966

Buster Keaton was 'America's Chaplin'… a former vaudeville clown turned stuntman, who became a brilliant actor, writer and director. With his sad eyes and deadpan face, Keaton was a popular enough comedian of the period but he proved way ahead of his time as a filmmaker.

Innovative, creative, acrobatic, fearless even, Keaton was an immensely popular silent film star but was quickly left behind when audiences moved to 'talkies'. Keaton's alcoholism and foghorn, expressionless voice didn't help his cause during the 1930s and 1940s, although he was courted by filmmakers who valued his opinion.

Black and white TV helped rediscover Keaton's skill and brilliance, and the 1960s found him back in favor as a character actor in the years before his death.

KEY FILMS

The Butcher Boy (1917)
Backstage (1919)
One Week (1920)
The Goat (1921)
The Playhouse (1921)
Cops (1922)
Three Ages (1923)
Our Hospitality (1923)
The Navigator (1924)
Sherlock Jr (1924)
Seven Chances (1925)
Go West (1925)
The General (1926)
The College (1927)
Steamboat Bill Jr. (1928)
The Cameraman (1928)

The General (1926) is considered Buster Keaton's masterpiece, although this silent comedy did lukewarm business when it was released. Critics found it difficult to pigeonhole the film as 'straight comedy' or 'thrilling drama', but missed the point that is was a total original American film classic.

The General of the title refers to engineer Johnny Gray's (Keaton) beloved locomotive, and the film follows his efforts to save both his betrothed (Marion Mack) and his train falling into union hands during the Civil War.

The General is now regarded as one of the finest examples of silent film in the early 20th century and took its place in the AFI 1998 list of the 100 greatest films of all time.

The Black Pirate (1926) was shot in a two-color Technicolor, an early innovation that split black and white negative film into red and green strips that later led to full Technicolor films being produced in the 1930s. *The Black Pirate* was based on a story suggested by Douglas Fairbanks and tailored to his popular film persona as an athletic, swashbuckling adventurer. The film features Fairbank's famous set piece of ripping down a ship's sails on the end of a dagger, a film trick often repeated but never bettered.

The original Hollywood swashbuckler, **Douglas Fairbanks** wrote, directed and produced many of his films and was one of the founding members of United Artists (1919) and the Academy of Motion Picture Arts and Sciences (1927). Fairbanks was equally adept in comedy but his career suffered badly with the advent of sound and, at the age of 50, he lost his enthusiasm for the roles he played in his youth – Zorro, Robin Hood and Don Juan.

Fairbanks' career was all but over by the mid-1930s. He died of a heart attack in 1939 aged 56, the one-time 'King of Hollywood' gone far too soon.

The Jazz Singer (1927) was the film that changed everything in Hollywood. Starring Al Jolson (1886–1950), America's highest paid entertainer at the time, this film contained barely two minutes of spoken sound but featured several songs on accompanying wax Vitaphone discs which hastened the end of the silent era.

Other films (*Don Juan* and *The Better 'Ole*, both 1926) had accompanying instrumental music and sounds effects, but *The Jazz Singer* was the first feature length synchronized sound film. When audiences heard Jolson's first words, "Wait a minute, wait a minute. You ain't heard nothin' yet", there was pandemonium in cinemas around the world and no going back for the medium.

1st Academy Awards®

1927–1928

Best Film: *Wings* (Paramount)

Best Director: Lewis Milestone, *Two Arabian Knights*

Best Actor: Emil Jannings, *The Last Command / The Way of All Flesh*

Best Actress: Janet Gaynor, *Seventh Heaven / Street Angel / Sunrise: A Song of Two Humans*

Wings (1927), the inaugural recipient of the Best Film award from the newly-formed Academy of Motion Picture Arts and Sciences, was the only silent film to receive the Best Film Oscar.

Starring Charles 'Buddy' Rogers, Richard Arlen, a young Gary Cooper as a doomed pilot and 'It Girl' Clara Bow as the love interest, this romanticized story of US pilots fighting in Europe during World War I is excitingly brought to the screen.

Directed by William A. Wellman, who served as a fighter pilot during the war, *Wings* was acclaimed for its technical achievement in re-enacting realistic aviation battles.

Sunrise: A Song of Two Humans (1927) stars Janet Gaynor and George O'Brien. German director F.W. Murnau utilizes symbolic art design, innovative cinematography and expressionism to achieve an almost dreamlike romance. The plot involves an unnamed man being lured away from his faithful wife by a 'city woman' only to reconcile after first believing his wife has killed herself. Although technically a 'silent' film, *Sunrise* was one of the first films to have a synchronized musical score and a 'sound effects' soundtrack.

Janet Gaynor (1906–1984) won the first Academy Award for three films released in 1927; *Sunrise: A Song of Two Humans*, *Seventh Heaven* and *Street Angel*. Gaynor had come to films as a teenager in 1924, but after 17 years in the industry she quit acting at the end of the 1930s to marry and raise a family.

Based on a successful Broadway play, *Seventh Heaven* was beaten for the inaugural Best Film Award (originally Outstanding Film) by the war drama, *Wings*, but it did earn Frank Borzage the Best Director award. Originally released as a silent film, the Fox film studios hastily released it with a synchronized musical soundtrack with sound effects. The 'talkies' were coming.

25

Cecil B. DeMille

1881–1959

Cecil B. DeMille has become a Hollywood byword for spectacular film production of biblical proportions. DeMille got his start in the silent era when 'the show' was everything. *The King of Kings* (1927), *The Sign of the Cross* (1932) and *The Crusades* (1935) mined The Bible for material, but it was DeMille's panache and sense of the spectacular that brought the subject matter to life.

An accomplished director of western films, the success of *The Greatest Show on Earth* (1952) proved DeMille's skill in taking even the broadest material (the circus world) to a higher dramatic plane. He returned to The Bible in the 1950s, delivering what he did best, bringing a color remake of *The Ten Commandments* (1956) to a new generation of fans which was his last film before his death.

KEY FILMS

The Squaw Man (1914)
The Cheat (1915)
The Little American (1917)
The Whispering Chorus (1918)
Don't Change Your Husband (1919)
The Ten Commandments (1923)
The King of Kings (1927)
Madam Satan (1930)
The Sign of the Cross (1932)
Cleopatra (1934)
The Crusades (1935)
The Plainsman (1936)
Union Pacific (1939)
Reap the Wild Wind (1942)
Unconquered (1947)
Samson and Delilah (1949)
The Greatest Show on Earth (1952)
The Ten Commandments (1956)

The King of Kings (1927) was a Cecil B. DeMille religious epic of the life of Christ starring H.B. Warner. The resurrection scene was filmed in two-color Technicolor, as was the introduction to the film in which Jesus is already an adult. The writers took some scriptural and dramatic liberties with this film but DeMille never ran out of material as far as The Bible was concerned. A 155-minute cut of the film premiered at the newly opened Grauman's Chinese Theatre in 1927, but was later reduced 122 minutes for general release.

2nd Academy Awards®

1928–1929

Best Film: *The Broadway Melody* (MGM)

Best Director: Frank Lloyd, *The Divine Lady*

Best Actor: Warner Baxter, *In Old Arizona*

Best Actress: Mary Pickford, *Coquette*

1928–29 Best Film winner *The Broadway Melody* took full advantage of the new sound recording technology that revolutionized the medium in the late 1920s. Featuring a cast that are long forgotten in the annals of movie history – Charles King, Anita Page, Bessie Love and Jed Prouty – the film was Hollywood's first all-talking musical and even featured an early color sequence that no longer exists.

Centered on the lives and loves of the stars of a Broadway musical, this was the first in a long history of musicals released by Metro-Goldwyn-Mayer over the ensuing decades.

MGM made three 'sequels' using the same title, *The Broadway Melody*, in 1936, 1938 and 1940.

Mary Pickford (1892–1979) was one of the most popular film actresses of the silent era and was known as America's Sweetheart. She won the Oscar® for Best Actress in 1928–29 for *Coquette*, but by 1933 her career was over and she retired from films.

With second husband Douglas Fairbanks, she was one part of Hollywood's 'golden couple' but the marriage ended in divorce in 1936. She remained as a producer for United Artists, which she formed with her husband D.W. Griffith, and Charles Chaplin. Overcoming bouts of alcoholism and depression, she lived a fulfilled life away from the cameras.

Warner Baxter (1889–1951) won the second ever Oscar® Award for Best Actor for playing the Cisco Kid in the breakthrough western film *In Old Arizona*, the first all-talkie western filmed outdoors. Baxter was the highest paid actor in Hollywood in the 1930s but moved away from lead roles into B-films and serials and today, his contribution to the Golden Years of Hollywood is largely forgotten.

Greta Garbo
1905–1990

Greta Garbo was one silent screen star who enhanced her film career when 'talkies' came in. The Stockholm-born beauty – a star in her native Sweden before coming to America in 1925 – projected an elusive personality which was amplified by her cool European accent.

The 1930s produced several major hits for her, making Garbo the critics' darling and a favorite with fans. Her stoic persona was best seen in *Mata Hari* (1931), *Grand Hotel* (1932) and *Queen Christina* (1933), however, her porcelain-like face threatened to reduce her to a one-dimensional character in a developing medium. The comedy *Ninotchka* (1939) proved that Garbo could laugh, but when her next film, *Two-Faced Woman* (1941) was shrouded in controversy not of her making, she retired from the screen at age 36. Garbo, it appears, really did 'want to be alone'.

KEY FILMS

The Saga of Costa Berling (1924)
Flesh and the Devil (1926)
The Kiss (1929)
Anna Christie (1930)
Romance (1930)
Mata Hari (1931)
Grand Hotel (1932)
Queen Christina (1933)
Anna Karenina (1935)
Camille (1936)
Ninotchka (1939)

Flesh and the Devil (1926) was an MGM romantic drama set in Germany during World War I starring Greta Garbo and John Gilbert. Garbo and Gilbert became lovers in real life during the making of the film, but Gilbert's career did not survive the end of the silent era. Four-times married, his affair with Garbo was similarly doomed and he sank into a haze of alcoholism before dying of a heart attack in 1936, aged 40.

Anna Christie (1930), based on the Eugene O'Neill play of the same name, broke records on release and solidified Garbo as a star. Interestingly, Garbo filmed a German language adaptation at the same time, utilizing the same sets and equipment, but with a German-speaking supporting cast.

The 1930s

The 1930s witnessed the sound revolution, the establishment of the Motion Pictures Production Code and the development of color technology. During the Depression years, a new generation of film stars appeared on screen – Clark Gable, James Cagney, Bette Davis, Gary Cooper, James Stewart, Spencer Tracy and Katharine Hepburn.

Heavily influenced by European filmmakers and the social issues of the era, directors such as Frank Capra, Leo McCarey, Ernst Lubitsch, William Wyler, Victor Fleming and George Cukor took cinema to a new level.

Hollywood also looked towards classic literature for inspiration – *All Quiet on the Western Front* (1930), *Dr Jekyll and Mr Hyde* (1931), *A Tale of Two Cities* (1935), *Captains Courageous* (1937), *Gone With the Wind* (1939) and *Goodbye Mr Chips* (1939) were just some of the film adaptations to find favor.

Horror films also made their mark, especially *Dracula* (1931), *Frankenstein* (1931), *The Mummy* (1932) and *King Kong* (1933), a true Hollywood original. Audiences also continued their love affair with the western. The decade began with *Cimarron* (1931), which won for Best Film, and ended with one of the best of the genre, John Ford's *Stagecoach* (1939). However, the 1930s was dominated by the gangster film, though by the end of the decade their heyday, like gangsters themselves, was over.

Fred Astaire and Ginger Rogers in *The Gay Divorcee* (1934)

3rd Academy Awards®

1929–1930

Best Film: *All Quiet on the Western Front* (Universal)

Best Director: Lewis Milestone, *All Quiet on the Western Front*

Best Actor: George Arliss, *Disraeli*

Best Actress: Norma Shearer, *The Divorce*

Almost nine decades after *All Quiet on the Western Front* won Best Film at the 1929–30 Academy Awards®, this film still packs an amazing punch.

Based on the novel by German writer Erich Maria Remarque, published barely a decade after the end of World War I, this film shows the terror, tragedy and disillusionment of war from the German viewpoint.

Idealist young students are whipped into a frenzy of nationalism by their teachers and march off to war to be cannon fodder in the mud and the blood of trench warfare.

Director Lewis Milestone won his second Best Director Oscar in two years for this uncompromising anti-war film.

In *All Quiet on the Western Front* (1930) Oscar®-winning director Lewis Milestone recreated World War I battle conditions across a thousand acres of farmland south of Los Angeles. Hollywood heartthrob Lew Ayres (1908–1996) was cast as central character Paul Baumer, with Louis Wolheim as Kat, Slim Sommerville as Tjaden, and Berryl Mercer as Mrs Baumer. The film also included some 2,000 extras, many of whom were war veterans themselves.

What is still refreshing about this film is that it was produced just before the rise of Nazism in the 1930s. Perhaps for this reason, the German soldiers are not caricatures, but real men with hopes and fears, and even experience moments of black humor.

The final scene of the film (right) is a tribute to the power of the medium. In the scene, Paul is killed when he reaches out to touch a butterfly (which was not in the original book but remains a wonderfully-realized visual allegory about life and death). The final scene of the ghosts of thousands of men look back accusingly at those who sent them to war, as they march over acres of graves, is a scathing indictment of the waste of human life.

Frankenstein (1931), one of the earliest film versions of Mary Shelley's gothic 1818 novel, became a pop culture favorite because of the monster's iconic make-up designed by Jack Pierce. Frankenstein's monster was an undeniable hit for Universal Studios and started a long tradition of horror films produced by the studio.

The monster (above, with actor Colin Clive as Dr. Frankenstein) was played by English character actor Boris Karloff (1887–1969) after early make-up tests with Bela Lugosi, the star of *Dracula*, proved unsuccessful.

The success of this movie launched several sequels, notably *Bride of Frankenstein* (1935) and *Son of Frankenstein* (1939), the last with Karloff as the monster. The story behind director James Whales' association with the film – and the monster – became the basis of the 1998 film, *Gods and Monsters*.

Dracula (1931), directed by Tod Browning (*Freaks*, 1932) and co-produced by Carl Laemmle Jr (*All Quiet on the Western Front*, 1930) brought Bram Stoker's classic vampire story to life and saved Universal Studios from bankruptcy.

This 1931 film was different in style to the German classic *Nosferatu* (1922), with Hungarian actor Bela Lugosi (1882–1956) originating the role on Broadway. Lugosi's dramatically 'creepy' performance made him an unlikely star and he remained associated with the iconic role for the remainder of his career.

4th Academy Awards®

1930–1931

Best Film: *Cimarron* (RKO)

Best Director: Norman Taurog, *Skippy*

Best Actor: Lionel Barrymore, *A Free Soul*

Best Actress: Marie Dressler, *Min and Bill*

Cimarron (1931), starring Irene Dunn and Richard Dix, charts the forty-year journey of a frontier family in Oklahoma whose fortunes mirror the oil boom and development of the US state.

Featuring the famous 1889 Oklahoma 'land rush' which portrayed thousands of homesteaders racing to secure a piece of land – and with it their future – *Cimarron* was lavishly produced (almost $1.5 million) by RKO, winning Academy Awards® for Best Film, Art Direction and Adapted Writing.

The film was remade in 1960, starring Glenn Ford and Maria Schell, but it would be another six decades before a western won Best Film (*Dances with Wolves*, 1990).

In a world of beauty and glamour, Wallace Beery (1885–1949) and Marie Dressler (1869–1935) were an unlikely couple to find fame and popularity in Hollywood. **Min and Bill** (1930) teamed the pair with their lived-in faces for the first time and won Dressler the Academy Award for Best Actress. She played the role of a dockside innkeeper keeping her inn full of bad influence away from her adopted daughter.

The film proved such a hit that the pair featured again in *Tugboat Annie* (1934), which was the penultimate film of Dressler's career before succumbing to cancer. Wallace Beery didn't have to wait long for his recognition from the Academy, winning the Best Actor Oscar® (shared with Fredric March) for *The Champ* (1931).

Little Caesar (1931) made Edward G. Robinson (1893–1973) a star overnight. As the gangster, Rico, the actor's snarling, staccato delivery was used to good effect in more than 100 film performances in both good guy and bad guy rolls.

The popularity of gangster films compelled Warner Bros. to add a moralizing prologue to this film reminding the audience that crime did not pay – except, perhaps, at the box office.

In *The Public Enemy* (1931) James Cagney was originally cast as the second lead but director William Wellman quickly realized that Cagney's persona was better suited to lead protagonist, budding gangster Tom Powers.

The film is known for the 'grapefruit' scene, in which Cagney's character shows his arrogance by squashing a grapefruit in Mae Clarke's face.

The film made a star of Cagney, although it typecast him in gangster films (*Lady Killer*, 1933; *Angels with Dirty Faces*, 1938; and *The Roaring Twenties*, 1939) for much of the decade.

Scarface (1932), loosely based on the rise and fall of Al Capone, starred Paul Muni (pictured right) as Chicago gangster Tony Camonte and George Raft (left) as his friend, Guino.

Directed by Howard Hawks and Richard Rosson, with a topical storyline from Ben Hecht, *Scarface* continued Hollywood's fascination with the gangster genre. The 1932 film was attacked by censors who blocked its widespread release, and an alternate ending was filmed (which Hawks disowned). Interestingly, the violent 1983 remake by director Brian de Palma and starring Al Pacino also failed to find a mainstream audience because critics felt it glorified the gangster lifestyle too much. Both films are now regarded as classics of the genre.

5th Academy Awards®

1931–1932

Best Film: *Grand Hotel* (MGM)

Best Director: Frank Borzage, *Bad Girl*

Best Actor: Fredric March, *Dr Jekyll and Mr Hyde*; Wallace Beery, *The Champ*

Best Actress: Helen Hayes, *The Sin of Madelon Claudet*

Grand Hotel (1932) boasted one of the first all-star ensemble casts, including Greta Garbo, John Barrymore, Joan Crawford, Wallace Beery and Lionel Barrymore, in a film featuring several overlapping storylines.

Based on the stage play of the same name (which was adapted from Vicki Baum's German language book), it is in Grand Hotel that Garbo utters her famous line, "I want to be alone".

Grand Hotel won the Oscar® for Best Film despite not receiving a single nomination in any other category.

Dr Jekyll and Mr Hyde (1931) won Fredric March (1897–1975) the first of two Academy Awards® for Best Actor. Based on Robert Louis Stevenson's 1866 novella, the story had been brought to the screen on five previous occasions between 1908 and 1920, but March's performance as the troubled doctor surpassed even John Barrymore's silent version. March tied for the Best Actor Award that year with Wallace Beery (*The Champ*, 1932). He won a second Best Actor Award in 1946 for *The Best Years of Our Lives.*

Even as the movie world embraced 'talkies' in the 1930s, **Charlie Chaplin** was content to stay with the silent medium. He produced two of his finest films during this decade, *City Lights* (1931) and *Modern Times* (1936) before embracing sound in *The Great Dictator* (1940).

In his later career films, Chaplin proved his mastery by writing, producing, directing and acting in the film as well as composing the musical score. One of his most-loved films, *City Lights* (1931) has Chaplin's tramp falling in love with a blind girl (Virginia Cherrill) and befriending a forgetful millionaire with comically poignant results.

Stan Laurel (1890–1965) and **Oliver Hardy** (1892–1957) were both established silent comedy actors when they teamed up after signing with Hal Roach Productions in 1927. The childlike Englishman and the rotund American appeared in more than 100 films together, from silent shorts, sound shorts and finally feature-length films.

Bonnie Scotland (1935) was one of the team's best sound films that nevertheless features a wonderful silent dance sequence after the pair find themselves in India serving in the Scottish Army. Following their retirement from the screen, Laurel and Hardy were rediscovered through television and championed by 1960s comics.

The Marx Brothers – Groucho, Chico, Harpo and Zeppo – in their second feature film, *Animal Crackers* (1930) follows the brothers' early films at Paramount that were based on their successful Broadway productions.

The Cocoanuts (1929) and *Animal Crackers* (1930) were written by noted playwright George S. Kaufman. Additional songs were by Harry Ruby and Bert Kalmer. After *Duck Soup* (1933) Zeppo Marx, the youngest of the team, left acting behind and became talent manager in Hollywood with fifth brother Gummo Marx.

Groucho, Chico and Harpo went on to achieve arguably their greatest successes at MGM with *A Night at the Opera* (1935), *A Day at the Races* (1937) and *Go West* (1940).

Duck Soup
1933

"You can leave in a taxi. If you can't get a taxi, you can leave in a huff. If that's too soon, you can leave in a minute and a huff."

Rufus T. Firefly (Groucho Marx)

Duck Soup was the least successful of the early Marx Brothers films, but it stands the test of time because of its parody about the politics of war. With the rise of fascism in the early 1930s and with war clouds threatening, *Duck Soup* may have been viewed as 'silly fun' at the time but the film really connected with college kids in the 1960s when it was shown in 'revival movie' houses at the height of the Vietnam War.

The film opens with ducks swimming in a barrel and animated graphics depicting the four brothers – Chico (Leonard, 1887–1961), Harpo (Arthur, 1888–1964), Groucho (Julius, 1890–1977) and Zeppo (Herbert, 1901–1979), but the name and the opening sequence have nothing to do with the actual story.

Duck Soup features long musical numbers by Bert Kalmar and Harry Ruby who, because the music was so important to the movie, were credited with the screenplay. Set comedy pieces were developed by Arthur Sheekman and Harry Ruby, but two of the best scenes in the film were provided by director Leo McCarey.

McCarey had worked with vaudevillian Edgar Kennedy on several Laurel and Hardy films (interestingly, McCarey also made a film called *Duck Soup* in 1927). Kennedy's slow burn routine was used to good effect as a street vendor who takes on Chico and Harpo. The trio have two great scenes together, doing the Brothers' famous 'swapping hats' shtick (which is also in *Go West*, 1940) and 'leg in hand' act which features in several films. The battle of wills ends hilariously with Harpo bathing in Kennedy's drink dispenser.

McCarey also devised the film's famous 'mirror scene' where spies Chico and Harpo impersonate Groucho in night clothes and take turns mirroring his actions in a doorway. The act had its origins in silent film and was often repeated (especially in animated shorts), but once the Marx Brothers applied Groucho's greasepaint mustache and eyebrows, it was almost impossible to tell them apart.

Duck Soup dispenses with Chico's piano solo and Harpo's usual musical interludes. Zeppo has so precious little to do in the film, it was no surprise to see him quit the team soon after and head into management with fifth brother, Gummo. This was the last 'pure' Marx Brothers film before the team received the MGM polish from Irving Thalberg, who added musical numbers and romantic subplots, and led to the team's mainstream success.

Duck Soup has some of the best lines from any of the dozen or so Marx Brothers films – "I got a good mind to join a club and beat you over the head with it," Groucho (Rufus T. Firefly) tells Chico (Chicolini). "Remember," Groucho admonishes his troops, "you're fighting for this woman's honor, which is probably more than she ever did."

The absurdity of war, and the joy of this movie, is best summed up by Groucho's throwaway line, "It's too late. I've already paid a month's rent on the battlefield."

The battle won, the movie ends with Groucho (wearing a racoonskin hat, no less) joining his brothers in throwing oranges at the hapless Margaret Dumont (Mrs Teasdale) as she sings the Freedonia National anthem. If only all wars could end so absurdly.

Paramount: 68 minutes

Produced by: Herman J. Mankiewicz

Directed by: Leo McCarey

Written by: Bert Kalmar, Harry Ruby, Arthur Sheekman and Nat Perrin

Music by: John Leipold, Arthur Johnson and Bert Kalmar and Harry Ruby (music and lyrics)

Cinematography by: Henry Sharp

Starring: Groucho Marx (Rufus. T. Firefly), Harpo Marx (Pinky), Chico Marx (Chicolini), Zeppo Marx (Bob Roland), Margaret Dumont (Mrs Teasdale), Louis Calhern (Trentino), Raquel Torres (Vera Marcal), Edgar Kennedy (Street Vendor).

6th Academy Awards®

1932–1933

Best Film: *Cavalcade* (Fox)

Best Director: Frank Lloyd, *Cavalcade*

Best Actor: Charles Laughton, *The Private Life of Henry VIII*

Best Actress: Katharine Hepburn, *Morning Glory*

Cavalcade (1933) was based on the Noel Coward play of the same name. Spanning a thirty-year period from New Year's Eve 1899, *Cavalcade* looks at the effect of the era's historic events – the death of Queen Victoria, the sinking of the *Titanic* and the horrors of World War I – from the lives of a wealthy London family, the Marryots (Diana Wynyard and Clive Brook).

British director Frank Lloyd (below), seen directing a large crowd scene for the film, won the Oscar® for this film. He brought an authentic English sensibility to a Hollywood-produced film that proved a huge hit with US and English audiences.

Charles Laughton (1899–1962) won Best Actor for his role in *The Private Life of Henry VIII* (1933). Pictured with Laughton is his wife Elsa Lancaster, who played the King's fourth wife, Anne of Cleves. The success of this British film, directed by Alexander Korda (*The Thief of Bagdad*, 1940), resulted in Korda and minor players Robert Donat playing Thomas Culpepper and Merle Oberon as Anne Boleyn also establishing their Hollywood careers.

Laughton, who was already well known in Hollywood, was also a screenwriter and director (of the underrated *Night of the Hunter*, 1955).

Morning Glory (1933) won Katharine Hepburn the first of a record four Academy Awards® for Best Actress. Hepburn's haughty persona was ideal for this story of aspiring actress Eva Lovelace who is shown the ropes by Broadway veterans and finds initial success on the New York stage. But will success last?

Interestingly, this film mirrors Hepburn's 1930s career in that she was considered 'box office poison' after this early success and did not become a bankable star again until after *The Philadelphia Story* (1940).

King Kong
1933

"It wasn't the airplanes … It was beauty killed the beast."

Carl Denham (Robert Armstrong)

The original *King Kong* film has been described as the 'most popular and most intriguing horror fantasy film ever made'. Special effects genius Willis O'Brien brought the 'eighth wonder of the world' to life using the 'stop motion animation' process of filming 3D models frame by frame after subtly changing the models' position. The Mighty Kong, at 50 feet (15 meters) tall, was only 15 inches (38 cm) of rubber with a steel skeleton and patted down rabbit fur for hair. A huge model of the face was made for close ups, with eyebrows and eyeballs operated by motors and compressed air to create Kong's facial expressions.

Despite changes in size which sees the ape's ratio to people and buildings change throughout the film, *King Kong* was a marvelous technical achievement for the time. Shown against a series of matte shots, Kong battles men and monsters, and creates havoc in 1930s New York before climbing the newly-built Empire State Building for one of the most iconic finales in film history. Along the way, Kong fights a pterodactyl, captures a beauty (Fay Wray) and peels away her clothing, before killing his captors and escaping from his chains in New York.

A scene where some of the sailors fall into a ravine and are eaten by giant spiders was deleted because it so shocked preview audiences and supposedly slowed down the pace of the film. It was not the last cut the film was to suffer over the years.

King Kong caught the imagination of the world at the height of the Great Depression, with millions of people identifying with a hero – even a tall, hairy one – who took on the system and ultimately lost everything.

The pathos of his death is aided by Max Steiner's wonderfully manipulative film score which directs audience sympathies throughout the film.

The story of *King Kong*, as imagined by notable adventure author Edgar Wallace and producer-director Merian C. Cooper, was based on the 'Beauty and the Beast' myth but with a modern edge. Interpreted and reinterpreted by critics over many generations, *King Kong* has been seen as a critique on colonialism, an attack on capitalism, criticized for its inherent racism and even explored for its sexual overtones (I particularly like critic Danny Peary's take on the film: that Kong is the manifestation of showman's Carl Denham's lust for Ann Darrow … whenever Darrow shows affection for Jack Driscoll, Denham's jealously manifests itself as Kong). But basically, *King Kong* is just great fun.

When I showed the film to my six-year old nephew on video in the 1980s, he said he loved the 'big monkey movie' and asked to watch it over and over again. As 'big monkey movies' go, the original *King Kong* is easily the best. *Kong* was remade in 1976 and 2005 with mixed results, although director Peter Jackson pulls off a clever parody of the original movie in the New York dance sequences on stage in the latter film.

While special effects genius Willis O'Brien later brought his movie magic to *Mighty Joe Young* (1949), the movie lacked a most important quality – heart. There is only one King Kong.

RKO: 100 minutes

Produced by: Merian C. Cooper, Ernest B. Schoedsack and David O. Selznick (executive)

Directed by: Merian C. Cooper and Ernest B. Schoedsack

Screenplay by: James Ashmore Creelman and Ruth Rose

Based on the story by: Merian C. Cooper and Edgar Wallace

Music by: Max Steiner

Cinematography by: Eddie Linden, J.O. Taylor, Vernon Walker

Starring: Fay Wray (Ann Darrow), Robert Armstrong (Carl Denham), Bruce Cabot (Jack Driscoll), Frank Reicher (Captain Englehorn), Noble Johnson (Native Chief).

7th Academy Awards®

1934

Best Film: *It Happened One Night* (Columbia)

Best Director: Frank Capra, *It Happened One Night*

Best Actor: Clark Gable, *It Happened One Night*

Best Actress: Claudette Colbert, *It Happened One Night*

It Happened One Night (1934) won Oscars® for Best Film, Best Director, Best Writing and for both acting leads for Clarke Gable as newspaper reporter Peter Warne and Claudette Colbert as spoiled heiress Ellie Andrews. It was not until *One Flew Over the Cuckoo's Nest* in 1975 that another film claimed all top four Oscar® awards.

The story of a runaway bride who is befriended by a recently sacked newspaper reporter who wants the exclusive story, Colbert's Ellie eventually falls for Gable's Peter after first believing he was only interested in her for the reward money posted by her exasperated father (Walter Connolly).

It Happened One Night (1934) was a sensation in the 1930s. Colbert and Clark Gable shine in a film many thought would be a lesser Columbia film but director Frank Capra delivers a finely-tuned comedy that was a precursor to many of the 'screwball' comedies made during the decade.

The film is famous for several scenes that seem modest by today's standards – when the pair share a room while on the run, they pitch a blanket as "the walls of Jericho" to maintain their modesty (opposite). After Gable appeared wearing a singlet in that scene, sales of the garment went through the roof. Later in the film, Colbert raises her skirt to show off her leg to attract a passing car ride, which was also considered risqué for the time. Earlier in the scene, when Gable is seen at the side of the road nibbling on a carrot, it became the basis of the Warner Bros. cartoon character, Bugs Bunny.

Clark Gable

1901–1960

Clark Gable oozed virility and manliness in romantic dramas, action films and wry comedies in the 1930s and 1940s. Women love him and men wanted to be like him. After winning an Oscar® in *It Happened One Night* (1934), Gable starred in many of the great films of the era including, perhaps, his finest and most natural performance as Rhett Butler in *Gone With the Wind* (1939).

 Following the death of wife Carol Lombard in a plane crash in 1942, Gable lost his zest for films and post-war audiences encountered an older, more world-weary actor than the virile star of the 1930s. 'The King of Hollywood' retained his crown with some solid films in the 1950s, but his death from a heart attack at age 59, after filming *The Misfits* (1961), was the end of a golden era.

KEY FILMS

Night Nurse (1931)
Red Dust (1932)
Manhattan Melodrama (1934)
It Happened One Night (1934)
Mutiny on the Bounty (1935)
San Francisco (1936)
Saratoga (1937)
Test Pilot (1938)
Gone With the Wind (1939)
Boom Town (1940)
The Hucksters (1947)
Homecoming (1948)
Across the Wide Missouri (1951)
Mogambo (1953)
The Tall Men (1955)
Run Silent, Run Deep (1958)
Teacher's Pet (1958)
The Misfits (1961)

San Francisco (1936) is Hollywood melodrama at its very best. Take a great story, in this case the 1906 San Francisco earthquake, add three of the biggest stars in film – Clarke Gable as saloonkeeper 'Blackie' Norton, Spencer Tracy as his childhood friend, Father Tim Mullen, and Jeanette MacDonald as songstress Mary Blake, mix in some wonderful special effects for the time and you have a certified winner at the box office.

Gable and Tracy were among the biggest stars of the era and appeared together again in *Test Pilot* (1938) and *Boom Town* (1940), but MacDonald's career in musicals barely survived the 1940s.

8th Academy Awards®

1935

Best Film: *Mutiny on the Bounty* (MGM)

Best Director: John Ford, *The Informer*

Best Actor: Victor McLaglen, *The Informer*

Best Actress: Bette Davis, *Dangerous*

The 1879 mutiny aboard HMS *Bounty* has been the basis for several feature films, none better than this 1935 Academy Award winner. Directed by Frank Lloyd, Charles Laughton (below left) is an archetypal Captain Bligh, with Clark Gable (right) as Fletcher Christian.

Mutiny on the Bounty (1935) won the Oscar® for Best Film, although Gable and Laughton missed out on what would have been a second award for either of them. The story was retold in 1962 (an ill-fated production starring Marlon Brando and Trevor Howard) and 1984, with Anthony Hopkins and Mel Gibson trading barbs.

John Ford's *The Informer* (1935) won Oscars® for Best Director, Best Screenplay, Best Music and Best Actor. Victor McLaglen (1886–1959) won the Best Actor award for his role as Gypo Nolan in this movie about the Irish War of Independence in 1920. The English-born boxer and actor was a popular member of Ford's film troupe. He was often cast as John Wayne's rival (*The Quiet Man*, 1952).

Bette Davis won the Academy Award for *Dangerous* in 1935 after being overlooked for a nomination for her previous role in *Of Human Bondage* (1934). The roles were incredibly similar, with Davis looking set to play 'down on their luck' girls for much of her career. The Academy righted their wrong and Davis won the award for the lesser film … and arguably the lesser performance.

Incredibly, Davis was nominated another six times for Best Actress in the next decade, winning her second Oscar® for *Jezebel* (1938). She would achieve a perfect 10 nominations during a remarkable career, the last for her comeback role in the gothic *What Ever Happened to Baby Jane?* (1962).

David Copperfield (1935) was a prestige project produced by David O. Selznick at MGM and directed by George Cukor. The film featured young Freddie Bartholomew in the title role alongside a stable of MGM stars – W.C. Fields, Lionel Barrymore, Maureen O'Sullivan, Basil Rathbone, Una O'Connor, Elsa Lancaster, and Lewis Stone. It was rated the year's best film by critics.

For the second time that year, David O. Selznick and MGM succeeded in bringing a Charles Dickens classic to the screen.

A Tale of Two Cities (1935) is arguably the best version of Dickens' tale of self-sacrifice during the French Revolution largely because of the performance of Ronald Coleman (1891–1958) as the hero, Sydney Carton. Two scenes in particular, the storming of the Bastille and the final march to the guillotine, are brilliantly realized by director Jack Conway.

Top Hat (1935) was the most successful of the ten films made by Fred Astaire (1899–1987) and Ginger Rogers (1911–1995) between 1933 and 1949. With songs by Irving Berlin, this RKO musical broke all records when it was released during the Depression.

Astaire and Rogers had long careers apart from each other, and not always in musicals. Rogers won an Oscar® for her role in *Kitty Foyle* (1940), a dramatic retelling of a Cinderella love story. Fred Astaire was an underrated singer and a master choreographer of dance, but an Academy Award for dramatic roles eluded him during his career (he was nominated only once, for Best Supporting actor in *The Towering Inferno*, in 1975).

Astaire and Rogers' final pairing on film was in *The Barkleys of Broadway* (1949). Astaire may have been the creative brains behind the team but, as the old joke goes, as good a dancer as he was, Rogers had to mirror his steps and dance backwards – and in high heels too.

9th Academy Awards®

1936

Best Film: *The Great Ziegfeld* (MGM)

Best Director: Frank Capra, *Mr Deeds Goes to Town*

Best Actor: Paul Muni, *The Story of Louis Pasteur*

Best Actress: Luise Rainer, *The Great Ziegfeld*

Best Supporting Actor: Walter Brennan, *Come and Get It*

Best Supporting Actress: Gale Sondergaard, *Anthony Adverse*

A fictionalized biopic of Broadway producer Florenz Ziegfeld Jr starring William Powell as Ziegfeld, *The Great Ziegfeld* (1936) won Oscars® for Best Film, Best Actress (Luise Rainer, in the role of Ziegfeld's first wife, Anna Held) and Best Dance Direction (Seymour Felix).

Featuring comic turns from Fanny Brice and Ray Bolger, who play themselves, the highlight of the three-hour epic film is the Oscar®-winning 'wedding cake' dance sequence, 'A Pretty Girl is Like a Melody'.

'Flo' Ziegfeld (1867–1932) produced such stage successes as *Show Boat* (1927), *Rio Rita* (1927) and *Whoopee!* (1928) but lost much of his fortune in the 1929 stock market crash.

German-born actress **Luise Rainer** (1910–2014) won back-to-back Oscars® for *The Great Ziegfeld* (1936) and *The Good Earth* (1937),). Ill-prepared for her early success, she appeared in only a handful of Hollywood films before retiring from the industry in 1943.

Living in Europe between trips back to the US (Rainer was a naturalised citizen), she appeared on TV occasionally but was content to stay out of the limelight. More than half a century later, Rainer returned to the screen for one last film appearance in *The Gambler* (1997). The oldest surviving Oscar®-winner, she died in London at the grand age of 104 in 2014.

Paul Muni (1895–1967) was one of Hollywood's most versatile actors in the 1930s. Born in present day Ukraine in 1895, he emigrated to the United States with his family in 1902 and made his name in Yiddish Theatre in Chicago. Moving to Hollywood, he won the Academy Award® for Best Actor in *The Story of Louis Pasteur* (1936) and despite making only 22 films, was nominated five times during his career.

Muni was so popular in the 1930s he had enormous power at Warner Bros., including final script control and being able to chose which film to star in. *The Story of Louis Pasteur* (1936) joined the wave of biopics made during the decade and Muni would repeat this success with the lead role in Oscar®-winning *The Life of Emile Zola* the following year.

Frank Capra

1897–1991

Frank Capra made classic films about the 'little guy' taking on the system in the 1930s and 1940s, displaying a heart and social conscience few filmmakers dared show in the wake of the Depression.

Born in Sicily, Capra knew firsthand how hard it was for outsiders to grasp a piece of the American dream. The characters in his films may have been poor and working class, as were his family, but they had hopes and aspirations that could not be denied by big business and government corruption. Not surprisingly, Capra's socialist leanings were out of favor with audiences during the Cold War of the 1950s, and his most loved film, *It's a Wonderful Life* (1946) – which was not a huge commercial success at the time – represents the highpoint in his career.

KEY FILMS

American Madness (1932)
Lady for a Day (1933)
It Happened One Night (1934)
Mr Deeds Goes to Town (1936)
Lost Horizon (1937)
You Can't Take It With You (1938)
Mr Smith Goes to Washington (1939)
Meet John Doe (1941)
Arsenic and Old Lace (1944)
It's a Wonderful Life (1946)
State of the Union (1948)
Here Comes the Groom (1951)
A Pocketful of Miracles (1961)

The team of Frank Capra and Robert Riskin produced ***Mr Deeds Goes to Town*** (1936) starring Gary Cooper as Longfellow Deeds, the recent heir to a fortune, and Jean Arthur as newspaper hound 'Babe' Bennett. When Deeds decides to use his $20 million to help the homeless, his financial advisors try to have him committed to an institution and the disillusioned young man refuses to defend himself.

Only when Bennett declares her love for him does he stand up for himself and expose the vested interests of his advisors. Cooper proved an ideal foil for Capra's morality tale, while Jean Arthur (1900–1991) would star in two more Capra films before the end of the decade, *You Can't Take it With You* (1938) and *Mr Smith Goes to Washington* (1939).

10th Academy Awards®

1937

Best Film: *The Life of Emile Zola* (Warner Bros.)

Best Director: Leo McCarey, *The Awful Truth*

Best Actor: Spencer Tracy, *Captains Courageous*

Best Actress: Luise Rainer, *The Good Earth*

Best Supporting Actor: Joseph Schildkraut, *The Life of Emile Zola*

Best Supporting Actress: Alice Brady, *In Old Chicago*

The story of the French writer who defended falsely-accused army officer Alfred Dreyfus in 1894, *The Life of Emile Zola* (1937) provided the talented Paul Muni with another Oscar®-nominated role following his success in The Story of Louis Pasteur the previous year.

This intelligent Warner Bros. biopic was the first film to receive 10 Academy Award nominations in an expanded list of categories, and won Oscars® for Best Film, Best Supporting Actor (to Joseph Schildkraut as Captain Dreyfus) and Original Screenplay.

Leo McCarey (1898–1969) brought a lightness and logic to the films of comedy heavyweights Laurel and Hardy, Eddie Cantor, Mae West, W.C. Fields and The Marx Brothers in the late 1920s and 1930s before graduating to romantic comedies and drama. He won an Oscar® for the comedy *The Awful Truth* (1937), which he produced and directed.

As a devout Irish Catholic, he was the ideal director to guide Bing Crosby to an Oscar® in *Going My Way* (1944), for which Carey won his second award.

The Awful Truth (1937) is a screwball comedy starring Irene Dunne and Cary Grant as a soon-to-be divorced couple who wreck each other's chances for love with other people before realizing they still love each other.

It was the first of three films starring Dunne and Grant, with *My Favorite Wife* (1940) and *Penny Serenade* (1941) to follow.

Captains Courageous
1937

> "You touch that kid, I tear you apart, see! … so don't get me mad, Long Jack. I get all crazy and sick inside."
>
> Manuel Fidello (Spencer Tracy)

In 1937, Hollywood took quality source material and improved it in this story of Rudyard Kipling's 1897 novel of the same name. From the opening moments, when the credits printed on the side of a ship dissolve with every wave that crashes over them, *Captains Courageous* develops as a wonderful film about the transformative nature of love.

Spencer Tracy was at the top of his game in the role of Manuel Fidello, the seaman who rescues young Harvey Cheyne from the sea. He would go on to win back-to-back Oscars® for this role and his role in *Boys Town* (1938).

Tracy was unsure about taking on the role – he had to have his hair curled, speak in an unknown accent and even sing in one scene – but he got away with it later remarking that it was because 'of the kid's performance'.

It's interesting to note that the young Bartholomew received top billing for this film. The English-born lad, who was twelve years old when *Captains Courageous* was filmed, made his name in *David Copperfield* (1935) and *Little Lord Fauntleroy* (1936). He was a huge star at the time. Mickey Rooney, who went on to have a much longer and influential career in film, took on the minor role of the son of Disko Troop, the schooner captained (Lionel Barrymore). A host of character actors complete the cast, including Barrymore, John Carradine (as rival Long Jack) and Melvyn Douglas (as Harvey's father).

Under the direction of Victor Fleming and the cinematography of Hal Rosson, *Captains Courageous* captures both the beauty and the terror of the open sea. Filmed off the coast of Gloucester, Massachusetts, where the film is set, the outdoor scenes on this film are amazing and are craftily linked to the staged shots.

The death of Manuel is handled in masterful style by Fleming (who took three days to film it), with Tracy squeezing every bit of emotion from the scene. In a flash, Manuel is gone and Harvey's life is changed forever.

The key to the film is the opening act where much time is spent exploring Harvey Cheyne's indulged childhood and the errors he makes in his relationships with the other boys at a privileged school. This is almost another film, with Douglas (later a dual Oscar®-winner in supporting roles) outstanding as the boy's only parent.

The final scenes, when Harvey prays to Manuel and then, reunited with his father, lets the elder Cheyne into his heart where Manuel now dwells, is superior film-making.

A more faithful film adaption of the book was made for TV in 1977 but, without the death of Manuel, it did not pack the emotional wallop of the 1937 film nor the cinematic sweep and the MGM production values of the original.

MGM: 115 minutes

Produced by: Louis D. Lighton

Directed by: Victor Fleming

Screenplay by: John Lee Mahin, Marc Connelly and Dale Van Every, based on the novel by Rudyard Kipling

Music by: Franz Waxman

Cinematography by: Harold Rosson

Starring: Freddie Bartholomew (Harvey Cheyne), Spencer Tracy (Manuel Fidello), Lionel Barrymore (Captain Disko Troop), Melvyn Douglas (Frank Burton Cheyne), Charley Grapewin (Uncle Salters), Mickey Rooney (Dan Troop), John Carradine (Long Jack).

11th Academy Awards®

1938

Best Film: *You Can't Take It With You* (Columbia)

Best Director: Frank Capra, *You Can't Take It With You*

Best Actor: Spencer Tracy, *Boys Town*

Best Actress: Bette Davis, *Jezebel*

Best Supporting Actor: Walter Brennan, *Kentucky*

Best Supporting Actress: Fay Bainter, *Jezebel*

The screwball comedy ***You Can't Take It with You*** (1938) was based on the Pulitzer Prize-winning Broadway play by George S. Kaufman and Moss Hart. It won Oscars® for Best Film and Best Director (Frank Capra).

The movie stars (below from left) Lionel Barrymore, James Stewart, Jean Arthur and Edward Arnold, and successfully captures the 1930s anarchy of a free-spirited household of eccentrics who hold out against a soulless banker intent on developing their property.

Capra reunited James Stewart and Jean Arthur in his next film, *Mr Smith Goes to Washington*, (1939) with Edward Arnold again playing the bad guy.

The Adventures of Robin Hood (1938) cast Errol Flynn in the role he was destined to play, and reunited him with director Michael Curtiz and actress Olivia de Havilland. With Basil Rathbone (Sir Guy of Gisbourne), Claude Rains (Prince John), Patric Knowles (Will Scarlett), Eugene Pallette (Friar Tuck) and Alan Hale (John Little) this a rollicking adventure story shown in glorious three-strip Technicolor. Australian-born Errol Flynn (1909–1959) came to Hollywood via English repertory theatre and in *Captain Blood* (1935), proved an overnight sensation as cinema's newest swashbuckler. Flynn starred in 12 films directed by Michael Curtiz and seven films with the lovely Olivia De Havilland (b. 1916) but by the end of the 1950s his 'wicked, wicked ways' had taken their toll and Flynn was dead, aged just 50.

Spencer Tracy

1900–1967

Spencer Tracy was the face of integrity in American cinema from the late 1930s through to the 1960s. No other actor could portray inner conflict like Tracy – when he looked into the camera and fixed his gaze, it was as if there were a whole world of drama unfolding behind his eyes. Not so surprising, for a man who was a recovering alcoholic for much of his professional career and who, as a devout Catholic with a wife and family, lived with frequent on-screen partner Katharine Hepburn for the last 25 years of his life.

As an actor, however, Tracy was courageous in his film choices and conscientiously disciplined in his craft. He was an actor's actor, perhaps even, the best of them all. He won back-to-back Oscars® in 1937–38, and then spent the next 30 years perfecting his cinematic persona.

KEY FILMS

20,000 Years in Sing Sing (1932)
Fury (1936)
San Francisco (1936)
Captains Courageous (1937)
Test Pilot (1938)
Boys Town (1938)
Northwest Passage (1940)
Dr Jekyll and Mr Hyde (1941)
Woman of the Year (1942)
A Guy Named Joe (1943)
State of the Union (1948)
Adam's Rib (1949)
Father of the Bride (1950)
Pat and Mike (1952)
Bad Day at Black Rock (1955)
Desk Set (1957)
The Old Man and the Sea (1958)
Inherit the Wind (1960)
Judgment at Nuremberg (1961)
It's a Mad, Mad, Mad, Mad World (1963)
Guess Who's Coming to Dinner (1967)

Boys Town (1938) earned Spencer Tracy his second straight Best Actor Oscar® following the success of *Captains Courageous* in 1937. The Academy made the mistake of writing 'Dick Tracy' on the statuette, and then suggested Tracy give the award to the real Father Flanagan of *Boys Town*. Tracy reluctantly agreed, but made sure the Academy got the name right.

Following their success in *San Francisco* (1936), Spencer Tracy and Clark Gable again teamed together in ***Test Pilot*** (1938), directed by Victor Fleming. Once again, Tracy played second fiddle to Gable in this aviation flick but following his second straight Oscar® for *Boys Town* (1938) in the same year, he never again played the second lead. Throw in Myrna Loy as Gable's love interest and character actor Lionel Barrymore for flavor, and MGM had an enormous hit on their hands which more than eclipsed the hefty $1.7 million budget.

12th Academy Awards®

1939

Best Film: *Gone With the Wind* (Selznick International Pictures / MGM)

Best Director: Victor Fleming, *Gone With the Wind*

Best Actor: Robert Donat, *Goodbye, Mr Chips*

Best Actress: Vivien Leigh, *Gone With the Wind*

Best Supporting Actor: Thomas Mitchell, *Stagecoach*

Best Supporting Actress: Hattie McDaniel, *Gone With the Wind*

Nominated for 13 awards, *Gone With the Wind* (1939) won a then record eight Oscars® in 1940 for Best Film, Best Director, Best Actress, Best Supporting Actress, Screenplay, Cinematography, Editing and Art Direction. The epic also won two special awards for technical achievements and was the benchmark for filmmaking in the stellar year of 1939.

Clark Gable and Vivien Leigh (below) starred in David O. Selznick's film adaptation of Margaret Mitchell's bestselling novel about the American Civil War. Gable sensationally missed out on the Oscar® for Best Actor – beaten by Robert Donat in *Goodbye, Mr Chips* (1939) – and never received another nomination before his death in 1961, aged 60.

If not the most important film made by Hollywood in the golden era of cinema, **Gone With the Wind** certainly marks the highpoint of film achievement at the end of the 1930s. A spectacle in every sense of the word, the film may be viewed as being decidedly 'old-fashioned' by today's standards but you have to admire producer David O. Selznick for bringing Margaret Mitchell's bestselling saga to the screen.

Clarke Gable was a natural to star as Rhett Butler, but almost every actress in Hollywood auditioned for the role of Scarlet O'Hara before Selznick's brother Myron (a talent manager) suggested little-known English actress Vivien Leigh (1913–1967), the then girlfriend of his major client, Laurence Olivier, for the part. Leigh was the first of her two career Oscars® for the role.

Olivia de Havilland (pictured right with Leslie Howard) was also Oscar®-nominated for the role of Melanie Wilkes. However, it was Hattie McDaniel as Mammy (shown below with Vivien Leigh) who won the award for Best Supporting Actress, thus becoming the first African American actor or actress to be so honored.

Leslie Howard (1893-1943), who played role of Ashley Wilkes – surely one of the most insipid characters ever to grace an epic – was a huge star at the time but was killed during World War II. Also featured in a stellar cast were Thomas Mitchell (as Gerald O'Hara), Evelyn Keyes and Ann Rutherford (as Scarlett's sisters), Laura Hope Crews (as Aunt Pittypat Hamilton), Ona Munson (as Belle Watling) and the wonderful Butterfly McQueen (as house servant, Prissy).

Goodbye, Mr Chips
1939

"Pity I never had any children? But you're wrong. I have. Thousands of them. Thousands of them... and all boys."

Mr. Chipping (Robert Donat)

Of all the great films one could pick from 1939 – which is arguably the pinnacle year in Hollywood production under the studio system – *Goodbye Mr Chips* remains an unmistakable classic starring a largely forgotten film star. The film won British actor Robert Donat (1905–1953) an Oscar®, beating hot favorite Clark Gable (for Rhett Butler in *Gone With the Wind*) in a major upset. A huge star in the 1930s, Donat made only another 10 films because of poor health (asthma) before dying of a brain tumor at age 53.

Told in flashback, *Goodbye Mr Chips* tells the story of Mr Chipping (Donat) and his career as a Latin teacher at an English private school for boys in the late 1800s. Decidedly stodgy in his manner, 'Chips' as the boys refer to him, is overlooked for promotion because he has no balance in his life. On a vacation with his friend Max (Paul Henreid), Chips meets and falls in love with Katharine (Greer Garson), who agrees to marry him and changes his life. The film details the trauma Chips suffers with the death of his wife and child during childbirth, the coming of the First World War and the loss of many of his former students in the ensuing battle. In retirement, he is afforded the honor denied him during his career and takes over as Headmaster because all the able-bodied men are fighting in Europe.

Goodbye Mr Chips made a star out of British actress Greer Garson (1904–1996), who had signed a contract with MGM some years before but waited for the right vehicle to display her considerable talents. Within three years she would win a Best Actress Oscar® for *Mrs Miniver* (1942). A young John Mills (as Peter Colley) had to wait until 1970 to win his gong for Best Supporting Actor for his role in *Ryan's Daughter*. Special note must go to young Terry Kilburn who plays four generations of the same family at fictitious Brookfield Grammar School.

Although decidedly old-fashioned, especially the way it depicts the administration of corporal punishment (the film is set in the late Victorian and Edwardian eras), *Goodbye Mr Chips* remains one of the MGM's best-loved films. The scene where the boys play a prank on Chips after he stoically fulfills his teaching duties, after the death of his wife and child, is particularly resonant. Later when Chips reads the names of those who died during the war – including his German friend Max and former pupil Peter Colley – Donat beautifully portrays the awful resignation of the human cost of the war.

Directed by Hollywood veteran Sam Wood, (who also filled in on *Gone With the Wind* that year when Victor Fleming became ill), *Goodbye Mr Chips* was filmed on located in England after MGM opted to use Alexander Korda's Denham Film Studios. Based on the 1933 novella of the same name by James Hilton (also the author of *Lost Horizon*, which was filmed in 1937), the film was dedicated to MGM head of production, Irving Thalberg, who died suddenly during filming, aged just 37.

MGM / Denham Studios: 114 minutes

Produced by: Victor Saville

Directed by: Sam Wood

Screenplay by: R.C. Sherriff, Claudine West and Eric Maschwitz, based on the novella by James Hilton

Music by: Richard Addinsell

Cinematography by: Freddie Young

Starring: Robert Donat (Mr Chips), Greer Garson (Katherine), Lyn Harding (Dr John Hamilton Wetherby), Paul Henreid (Max Staeffel), Terry Kilburn (John Colley/Peter Colley I, II and III), John Mills (Peter Colley as an adult).

Bette Davis

1908–1989

Bette Davis chewed up the Hollywood cinema scene with her dramatic performances in the 1930s and 1940s and then spat it out in the 1950s as a free agent. After early Oscar® success with *Dangerous* (1935) and *Jezebel* (1938), Davis took on the Hollywood star system that treated creative talent like slave labor and won.

Cold, hard and cynical, with a tendency toward the over-dramatic, Davis grew as a character actress in the 1950s and 1960s as her beauty faded – a situation she relished and celebrated with an increasing list of quirky, almost gothic, performances.

For movie fans who always adored her 'Bette Davis eyes', perhaps the sardonic *All About Eve* (1950) best portrays the actress as she really was – a larger than life talent, but unlucky in love and poignantly vulnerable.

KEY FILMS

Of Human Bondage (1934)
Dangerous (1935)
The Petrified Forest (1936)
Jezebel (1938)
Dark Victory (1939)
The Private Lives of Elizabeth and Essex (1939)
All This, and Heaven Too (1940)
The Letter (1940)
The Man Who Came to Dinner (1941)
The Little Foxes (1941)
Now, Voyager (1942)
Watch on the Rhine (1943)
Mr. Skeffington (1944)
All About Eve (1950)
The Virgin Queen (1955)
The Catered Affair (1956)
What Ever Happened to Baby Jane? (1962)

Dark Victory (1939) is the quintessential Bette Davis film. A wealthy young woman with the world at her feet is diagnosed with a terminal brain tumor and must decide whether to completely fall apart or to die with dignity. At first, Judith Traherne (Davis) is both manic and depressed, but as her vision slowly fades, she heeds the advice of her horse trainer (Humphrey Bogart), who is in love with her, to live her last days to the full and she falls in love with her surgeon (George Brent).

Also starring Geraldine Fitzgerald as her faithful secretary and a young Ronald Reagan as suitor Alec Hamm, *Dark Victory* is Davis's film from start to finish – she and the film were Oscar®-nominated in a year dominated by *Gone With the Wind*.

Mr Smith Goes to Washington (1939) is one of Frank Capra's most satisfying films which still has much to say about politics and personal integrity.

James Stewart plays idealistic young congressman Jefferson Smith who goes to Washington full of hope and refuses to be corrupted by the political 'machine'. It was nominated for 11 Oscars®, but up against *Gone With the Wind* had to settle for Best Original Story.

In any other year James Stewart would have won the Best Actor award but the relative newcomer was up against heavyweights Clark Gable, Robert Donat and Laurence Olivier (teenager Mickey Rooney was the other nominee). Hollywood did the next best thing and awarded Stewart the Best Actor for his role in *The Philadelphia Story* the following year.

After a decade in B-grade westerns, John Ford's classic **Stagecoach** (1939) provided John Wayne with a one-way ticket to stardom as the Ringo Kid.

Wayne is given the star treatment by his director friend Ford in this film, from the moment the camera pans in as his character flags down the stagecoach to the final scene of the shootout in Lordburg, New Mexico.

From left: Andy Devine, George Bancroft, John Carradine, Donald Meek, Louise Platt, Claire Trevor and the then 32-year-old Wayne. Thomas Mitchell took out the Best Supporting Actor gong for his role as the alcoholic doctor.

The Wizard of Oz (1939) was MGM's response to the phenomenal success of RKO's *Snow White and the Seven Dwarfs* (1937). *The Wizard of Oz* had been filmed previously during the silent era, but the addition of musical numbers (by Herbert Stothart and Harold Arlen) including the Oscar®-winning 'Over the Rainbow', along with effectively placed Technicolor sequences and brilliant casting, combined to make a fantasy classic.

Teenager Judy Garland (1922–1969) stars in her career-defining role as Dorothy while Ray Bolger (the Scarecrow), Bert Lahr (the Lion), Jack Haley (the Tin Man) and Frank Morgan (the Wizard) were never better.

The 1940s

The start of World War II in Europe had a profound effect on the films produced in the first half of the 1940s, even more so when America entered the conflict at the end of 1941.

Hollywood rallied to the call, and the success of *Sergeant York* (1941), *Mrs Miniver* (1942), *Yankee Doodle Dandy* (1942), *Casablanca* (1943) and *The Best Years of Our Lives* (1946) galvanized film audiences around the world behind the Allies' cause. The remnants of the gangster genre – *High Sierra* (1941), and belatedly, *White Heat* (1949) – morphed into film noir, a bleak look at the dark side of human nature.

Humphrey Bogart, one of the gangster movies' best, broke through as a romantic leading man in *Casablanca* (1942) and later teamed with his wife Lauren Bacall in four films ending with *Key Largo* (1948).

John Wayne made the western genre his own, while Spencer Tracy and Katharine Hepburn established one of the most endearing Hollywood partnerships.

Musicals and comedies remained immensely popular but by the end of the war in 1945, a new reality dawned on Hollywood. 'Message films' were in – *The Lost Weekend* (1945), *Gentleman's Agreement* (1947) and *Johnny Belinda* (1948) were just some of the films to prick the social conscience, while the success of Lawrence Oliver's *Hamlet* (1948) announced the rebirth of British films.

Walter Brenna, Spencer Tracy and Robert Young in *Northwest Passage* (1940)

13th Academy Awards®
1940

Best Film: *Rebecca* (Selznick / Universal)

Best Director: John Ford, *The Grapes of Wrath*

Best Actor: James Stewart, *The Philadelphia Story*

Best Actress: Ginger Rogers, *Kitty Foyle*

Best Supporting Actor: Walter Brennan, *The Westerner*

Best Supporting Actress: Jane Darwell, *The Grapes of Wrath*

Rebecca (1940), based on the Daphne du Maurier novel of the same name, marked the Hollywood debut of British director Alfred Hitchcock. Laurence Olivier and Joan Fontaine (below), star as the recently married de Winters, the newlyweds return to 'Manderlay' and a houseful of secrets guarded over by the mysterious house servant Mrs Danvers (Judith Anderson).

Producer David O. Selznick was keen for the film to remain faithful to Du Maurier's novel and resisted Hitchcock's attempts to tinker with the suspenseful elements of the dark, often sinister, story.

Hitchcock was nominated five times for Best Director during his career, for *Rebecca* (1940), *Lifeboat* (1940), *Spellbound* (1945), *Rear Window* (1954), *Psycho* (1960), without winning.

The Grapes of Wrath (1940), based on John Steinbeck's Pulitzer Prize-winning novel, was brought to the screen by director John Ford and screenwriter Nunnally Johnson who turned a great book into a classic film. Staring Henry Fonda, John Carradine, John Qualen and Jane Darwell (in the role that won her Best Supporting Actress), *The Grapes of Wrath* tells the story of the Joad family who, forced from their farm during the Depression, travel to Southern California as itinerant workers.

Tom Joad's (Fonda) farewell speech to his decimated family – "wherever there's a fight, so hungry people can eat, I'll be there. Wherever there's a cop beatin' up a guy, I'll be there …" – has become iconic in American cinema history. Like the working class it portrays, the film has endured over the years because of its gritty, unsentimental depiction of the hope people find during the hardest times.

James Stewart won the Academy Award for Best Actor in *The Philadelphia Story* in 1940, co-starring Katharine Hepburn (far right, with Stewart) and Cary Grant. Stewart's win was compensation for his wonderful performance in the previous year's *Mr Smith Goes to Washington* (1939). Stewart put his career to one side during World War II to serve in the army and did not make any films between 1941 and 1946.

Humphrey Bogart
1899–1957

Humphrey Bogart seemed an unlikely candidate for film stardom when he started out in the 1920s, let alone being named the greatest actor of the 20th century by the American Film Institute (AFI) in 1998.

Short, moderately handsome and with a twitching upper lip and lisp, 'Bogie' developed from character actor to leading man material during the early 1940s.

After a decade as a struggling stage actor and bit-player in films, Bogart was a member of Warner Bros.' rotating band of stock gangsters before his star-turn in *High Sierra* (ironically, as an aging gangster) and *The Maltese Falcon* (as Detective Sam Spade) in 1941.

His partnering with Ingrid Bergman in *Casablanca* (1942) made him a star – and an unlikely sex symbol – as well as securing his on-screen persona as a disillusioned anti-hero with a heart of gold.

KEY FILMS

The Petrified Forrest (1936)
Dead End (1937)
The Roaring Twenties (1939)
High Sierra (1941)
The Maltese Falcon (1941)
Casablanca (1942)
To Have and to Have Not (1944)
The Big Sleep (1946)
The Treasure of the Sierra Madre (1948)
Key Largo (1948)
In a Lonely Place (1950)
The African Queen (1951)
Beat the Devil (1953)
The Caine Mutiny (1954)
Sabrina (1954)
The Barefoot Contessa (1954)
We're No Angels (1955)
The Desperate Hours (1955)
The Harder They Fall (1956)

After a decade of supporting roles and quality performances in B-movies, ***High Sierra*** (1941) made Humphrey Bogart a bankable leading man.

Directed by Raoul Walsh with a script co-written by John Huston from the novel of the same name by William R. Burnett, Bogie actively sought the role of aging mobster 'Mad Dog' Ray Earle and played a complex, even sympathetic, sociopath who could show affection to a mongrel dog (Bogie's own pet), a crippled girl (the lovely Joan Leslie) and a pretty gangster's moll (Ida Lupino, who was top-billed) while displaying the doomed inevitability of his character.

Filmed largely on location in the Sierra Nevada mountains in California, Earle's death in the High Sierras brought the curtain down on Warner Bros.' gangster era.

Released in the same year as *High Sierra*, ***The Maltese Falcon*** (1941) confirmed Humphrey Bogart's star status in Hollywood. Having worked with John Huston on the former film, Bogart was keen to star in Huston's directorial debut. He even beat the more bankable Georg Raft for the part.

Dashiell Hammett's novel had been previously filmed in 1931 and 1936, but under Huston's fine direction and textured screenplay, the story of an eclectic group of crooks pursuing the statue of a falcon speeds along at a solid clip and bristles with smart dialogue.

As enigmatic private detective Sam Spade, Bogie plays the film's villains (pictured from left, Peter Lorre, Mary Astor and Sydney Greenstreet) against each other while staying true to his personal code of integrity.

14th Academy Awards®

1941

Best Film: *How Green Was My Valley* (20th Century Fox)

Best Director: John Ford, *How Green Was My Valley*

Best Actor: Gary Cooper, *Sergeant York*

Best Actress: Joan Fontaine, *Suspicion*

Best Supporting Actor: Donald Crisp, *How Green Was My Valley*

Best Supporting Actress: Mary Astor, *The Great Lie*

How Green was My Valley, John Ford's sentimental depiction of a Welsh mining family, won Best Film in 1941 and also picked up Oscars® for Ford's direction and supporting actor Donald Crisp.

Producer Darryl F. Zanuck had a realistic set built on the 20th Century Fox backlot and filled Ford's film with great actors – Walter Pidgeon, Maureen O'Hara (below second from left), Anna Lee, Donald Crisp and newcomer, 12-year old Roddy McDowall. The result was classic filmmaking for the era.

A year after her nomination for Best Actress in *Rebecca* (1940), British actress Joan Fontaine (1917–2013) won the award for Alfred Hitchcock's **Suspicion** (1941). Fontaine, the younger sister of Oliva de Havilland, was born in Tokyo to English parents before the family moved to California when she was still a child. After coming to Hollywood in the 1930s, Joan changed her last name so as not to be confused with her more-famous older sister who was already a big star in Hollywood.

Not unlike her role in *Rebecca*, Fontaine brings just the right blend of nervousness and suspicion to the role of Lina, who believes her former playboy husband Johnnie (Cary Grant) is trying to kill her.

Interestingly, Fontaine is the only actor in a Hitchcock film to with a Best Actor/Actress award.

With America on the brink of war in 1941, Gary Cooper was a popular winner of Best Actor for his role as a World War I hero in **Sergeant York** (1942).

The story of a god-fearing hillbilly pacifist (who realizes his duty to fight and wins the Congressional Medal of Honor for his bravery) was given the full Hollywood treatment by director Howard Hawks and a team of writers including John Huston and Howard Koch.

87

Gary Cooper

1901–1961

Gary Cooper was born in Montana, making him well-suited to the western genre.

However, his calm, straight-talking idealist persona also allowed the easy-going actor to excel in urban dramas, romantic comedies and biopics.

After a supporting role as a doomed pilot in the Oscar®-winning *Wings* (1927), Cooper became a fully-fledged star in the 1930s. He was a knockout in two Frank Capra films of the era, tapping into a wellspring of disillusionment few actors could hope to portray. 'Coop' was just the hero the world needed in the 1940s. *Sergeant York* (1941) earned him his first Oscar®, while *High Noon* (1952), showed a different hero for a different time.

Cooper's early death from cancer at age 60, robbed cinema of another decade of laconic performances.

KEY FILMS

Wings (1927)
The Virginian (1929)
A Farewell to Arms (1932)
Mr. Deeds Goes to Town (1936)
The Plainsman (1936)
Beau Geste (1939)
The Westerner (1940)
Meet John Doe (1941)
Sergeant York (1941)
Ball of Fire (141)
The Pride of the Yankees (1942)
For Whom the Bell Tolls (1943)
Unconquered (1947)
The Fountainhead (1949)
High Noon (1952)
Vera Cruz (1954)
Friendly Persuasion (1956)
Love in the Afternoon (1957)
Man of the West (1958)

In ***Meet John Doe*** (1941) the Oscar®-winning team of director Frank Capra and screenwriter Robert Riskin (from an original story by Richard Connell and Robert Presnell) tell the tale of a sacked newspaper reporter (Barbara Stanwyck) who, in an effort to get her job back, pens a fictitious letter from a 'John Doe' lamenting society's disregard for the poor and who now threatens to suicide on Christmas Eve.

When the letter strikes a chord with the public, Stanwyck's Ann Mitchell has to find a homeless man to play the role and chooses a broken-down baseball player (Gary Cooper). When John Doe's message of hope spreads across the country, Cooper's everyman is conflicted and he later tries to expose his media backers (Edward Arnold, left) at a rally. The tables are turned, however, and when Doe is revealed as a fake, he contemplates ending it all until Stanwyck declares her love for him.

Meet John Doe rounds off Capra's populist trilogy after *Mr Deeds Goes to Town* (1936) and *Mr Smith Goes to Washington* (1939), but Capra never worked with Riskin again.

Citizen Kane
1941

> "You know, Mr. Thatcher, if I hadn't been very rich, I might have been a really great man."
>
> Charles Foster Kane (Orson Welles)

In 1941, cinema's newly-appointed boy genius Orson Welles (1915–1985) produced, directed and co-wrote *Citizen Kane*, his first film. Widely regarded as the greatest film ever made (heading the AFI Top 100 Films list in 1998 and 2007), *Citizen Kane* raised filmmaking to a new level of art. Breaking all the rules of the era, the subsequent career of the then 25-year-old Welles was much like his central character in his film – a wasted talent.

In portraying an idealistic businessman corrupted and destroyed by his own success, Welles first had billionaire Howard Hughes in his sights, but having relocated to Hollywood from New York, he became enamored by the story of media mogul, William Randolph Hearst, of Hearst newspapers fame. Welles based his cautionary tale on Hearst and in doing so, made a powerful enemy.

Welles parodied Hearst's wealth and supposed lack of class, his relationship with actress Marion Davies and his efforts to make her into a star. Welles went too far, however, when he made the crux of the film – Kane's uttering of the word 'rosebud' on his deathbed – the same name Hearst allegedly used for a sensitive part of Davies' anatomy.

The narrative of *Citizen Kane* is ingeniously structured. Kane dies in the first scene and a newsreel of Kane's life shows the sad trajectory of his life in the first act. As a team of reporters seek out the meaning of the word 'rosebud', former colleagues recall the major points of Kane's life – his humble beginnings, the disintegration of his marriage as portrayed at the opposite ends of the breakfast table, and the gradual betrayal of his family and friends as he pursues a political career. In the end, Kane's life is defined not by what he achieved nor the possessions he accumulates in a grand castle, but what he lost – 'rosebud'.

Citizen Kane also showcases the revolutionary camerawork of Gregg Toland, whose deep focus and composition of the frame changed movies for all time. Instead of cutting in for close-ups, Toland uses such depth of field in his photography that foreground and background elements all appear in focus. He also shows scenes from a low angle and often had ceiling shots, which was unheard of at the time. Many of Toland's Mercury Theatre colleagues made their films debuts in *Citizen Kane* – Joseph Cotten, Agnes Moorehead and Everett Sloane.

The Hearst press refused to review the finished film or carry ads for it. The Academy gave *Citizen Kane* nine Oscar® nominations (including a record three to Welles), but it won only Best Original Screenplay for Hank Mankiewicz and Welles (who was in South America at the time and did not attend the ceremony).

At the Awards presentation, every time a presenter read out the name of the film, the audience booed. The film failed to make a profit and faded from circulation until it was rediscovered by the French in the 1950s and later became lauded as one of the greatest films ever made.

Mercury Productions / RKO: 119 minutes

Produced and Directed by: Orson Welles

Screenplay by: Herman J. Mankiewicz and Orson Welles

Music by: Bernard Herrmann

Cinematography by: Gregg Toland

Starring: Orson Welles (Charles Foster Kane), Joseph Cotten (Jedediah Leland), Dorothy Comingore (Susan Alexander Kane), Everett Sloane (Mr Bernstein), Ray Collins (Jim W. Gettys), George Coulouris (Walter Parks Thatcher), Agnes Moorehead (Mary Kane), Ruth Warrick (Emily Monroe Norton Kane), William Alland (Reporter).

15th Academy Awards®
1942

Best Film: *Mrs Miniver* (MGM)

Best Director: William Wyler, *Mrs Miniver*

Best Actor: James Cagney, *Yankee Doodle Dandy*

Best Actress: Greer Garson, *Mrs Miniver*

Best Supporting Actor: Van Heflin, *Johnny Eager*

Best Supporting Actress: Teresa Wright, *Mrs Miniver*

Mrs Miniver may have been Hollywood's version of the Battle of Britain from the view of an idealistic English family but it was superior story-telling from Metro-Goldwyn-Mayer under the Oscar®-winning direction of William Wyler.

Greer Garson (centre left) as Kay Miniver and Teresa Wright (standing next to her) as her daughter won Best Actress and Supporting Best Actress respectively. Also pictured are Walter Pidgeon (centre right with hat) played Mr Miniver and Richard Ney (right) as their son.

Woman of the Year (1942) marked the start of the professional and personal partnership of Spencer Tracy (left) and Katharine Hepburn.

The story of competing journalists at a fictitious New York newspaper who fall in the love yet continue their battle of wills couldn't miss with the talent of Joseph L. Mankiewicz (producer) and George Stevens (director). Credit must also go to Garson Kanin (original story), and Ring Lardner Jr and Michael Kanin (screenplay), but ultimately the chemistry between Tracy and Hepburn – who soon became off-screen lovers – carries the film.

Tracy and Hepburn would go on to work together in another eight movies – *Keeper of the Flame* (1942), *Without Love* (1945), *The Sea of Grass* (1947), *State of the Union* (1958), *Adam's Rib* (1949), *Pat and Mike* (1952), *Desk Set* (1957) and *Guess Who's Coming to Dinner* (1967).

James Cagney
1899–1986

James Cagney was a song and dance man trapped in a gangster's persona. His early success in *The Public Enemy* (1931) could have left him playing gangster roles for decades, except for his versatility and talent. Cagney could play hero or villain, friend or scoundrel, cold-blooded killer or national hero.

His Oscar®-winning role as George M. Cohan in *Yankee Doodle Dandy* (1942) showcased his dancing and comedic talents, but *White Heat* (1949) and *Mister Roberts* (1955) saw him back at his most dangerous.

A maverick who fought the power of the studio system, Cagney retired in 1961 having lost enthusiasm for the medium, before venturing back to the big screen in *Ragtime* (1981).

KEY FILMS

The Public Enemy (1931)
Footlight Parade (1933)
A Midsummer Night's Dream (1935)
'G' Men (1935)
Angels with Dirty Faces (1938)
The Roaring Twenties (1939)
Each Dawn I Die (1939)
City for Conquest (1940)
The Strawberry Blonde (1941)
Yankee Doodle Dandy (1942)
Blood on the Sun (1945)
Rue Madeleine (1947)
White Heat (1949)
Mister Roberts (1953)
Love Me or Leave Me (1955)
Man of a Thousand Faces (1957)
The Gallant Hours (1960)
One, Two, Three (1961)

The biopic **Yankee Doodle Dandy**, a line from one of George M. Cohan's most popular songs, won Academy Awards® for Best Film, Best Actor, Best Music, Best Sound and Best Musical Score in 1942. In doing so, it became Warner Bros. most successful film to date.

Even if James Cagney's Oscar®-winning performance is more Cagney than Cohan, the brilliant dancing sequences evokes Cohan's unique style. Veteran Walter Huston (who worked with Cohan in vaudeville) plays Cohan Sr and Rosemary de Camp, who was younger than Cagney, takes the part of Cohan's mother. Cagney's sister Jeanne plays Cohan's sister Josie. Joan Leslie, who was only 17 years old at the time, plays Cohan's wife Mary. (Cohan was actually married twice and he had four children who are not featured in the film.)

Yankee Doodle Dandy glosses over many aspects of Cohan's life, as Hollywood musicals are wont to do, but then Cohan's famed temper, alleged aloofness and ultimate estrangement from his own children do not a happy musical make.

16th Academy Awards®

1943

Best Film: *Casablanca* (Warner Brothers)

Best Director: Michael Curtiz, *Casablanca*

Best Actor: Paul Lukas, *Watch on the Rhine*

Best Actress: Jennifer Jones, *The Song of Bernadette*

Best Supporting Actor: Charles Coburn, *The More the Merrier*

Best Supporting Actress: Katina Paxinou, *For Whom the Bell Tolls*

Casablanca (1943) was the perfect romantic drama for a world at war in the early 1940s. The resulting cinematic magic remains fixed in the public consciousness, not only because of the song 'As Time Goes By' (which featured in the original play *Everybody Comes to Rick's* by Murray Bennett and Joan Alison) but also for the on-screen chemistry between Humphrey Bogart and Ingrid Bergman (below).

Receiving nine Academy Award® nominations, including for both leads and Supporting Actor (Claude Rains), *Casablanca* won Oscars® for Best Film, Best Director, and not surprisingly, Best Writing (Screenplay) for brothers Julius and Philip Epstein.

Jennifer Jones (1919–2009) was a struggling actress named Phyllis Isley when she came to the attention of producer David O. Selznick in 1942. Selznick changed her name and signed Jones (right) to a seven-year contract. The following year she played the role of a peasant girl who sees a vision of the Virgin Mary, in *The Song of Bernadette* (1943), for which she won Best Actress.

Jones married Selznick in 1949 after divorcing her first husband, the actor Robert Walker. Her marriage to Selznick lasted until the famed producer's death in 1965.

For Whom the Bell Tolls (1943) is director-producer Sam Wood's successful screen adaptation of Ernest Hemingway's novel set during the Spanish Civil War. Gary Cooper (below left) plays Hemingway's doomed hero Robert Jordan, with Ingrid Bergman (centre) as love-interest Maria in her first Technicolor film.

The film was nominated for nine Academy Awards®, but won only one. Katina Paxinou took home the gong for Best Supporting Actress.

Casablanca
1942

"Ilsa, I'm no good at being noble, but it doesn't take much to see that the problems of three little people don't amount to a hill of beans in this crazy world."

Rick Blaine (Humphrey Bogart)

Casablanca (1942) should never have succeeded. With its ambiguous political setting that no one had ever heard of, filmed on a Hollywood backlot with a script that was written and re-written daily, and with Humphrey Bogart and Ingrid Bergman cast as romantic leads for the first time, Warner Bros. took a huge risk with this film.

With superior story-telling from screenwriter brothers Julius and Philip Epstein (on a treatment by Howard E. Koch with additions from several other writers), skilful direction from Michael Curtiz and brilliant casting, however, the original material (the 1940 play *Everyone Comes to Rick's*) was raised to the level of high art.

America had just entered World War II when this film was made in 1942, and Warner Bros. no doubt saw the film as a timely call to arms. The film received an enormous boost on its release – originally in the final weeks of 1942 in Hollywood and then released nationally in early 1943 – when US President Roosevelt and British Prime Minister Winston Churchill met in Casablanca, Morocco, in January 1943 to plan the allied invasion of Europe.

Rick Blaine is an ex-pat American in faraway Casablanca who, when a former lover re-enters his life (the beautiful Ingrid Bergman), has to choose sides in a war he wants no part of. The film reunites Bogart with his *Maltese Falcon* (1941) co-stars Sidney Greenstreet and Peter Lorre. It also boasts an array of talent, Leonid Kinskey, John Qualen, S.Z. Sakall and, of course, Dooley Wilson (who didn't really play piano) delivering the perfect rendition of 'As Time Goes By'.

Paul Henreid (who was equal top-billed with Bogart and Bergman), as well as Claude Rains and Conrad Veidt were stars in their own right, and added to the depth of talent on the screen.

Many lines from this film have become part of popular culture – "Here's looking at you kid", "Of all the gin joints, in all the towns, in all the world, she walks into mine" and "Round up the usual suspects" are just some of the gems although no one in the film utters the oft-misquoted "Play it again, Sam".

There is wry, sardonic humor throughout the film, which is a testament to the Oscar®-winning screenplay (a favorite line is when Rick reads the dossier the Germans have prepared on him and asks facetiously, "Are my eyes really brown?")

Winning the award for Best Film for 1943, *Casablanca* is a triumph of Hollywood movie magic and is one of the most popular romantic films in cinema history. There are so many great moments in *Casablanca* – the repartee between Rick and Sgt Renault; the flashback to Paris where Rick and Isla fall in love; and the characters that frequent Rick's nightclub. When French citizens burst into a rousing rendition of 'La Marseillaise', it's hard not to get goose bumps.

The last line of the film was a last-minute addition – "Louie, I think this is the beginning of a beautiful friendship". But the film became more than that for millions of fans around the world and across many generations – for so many, it was the beginning of a love affair with the film. They don't make pictures like *Casablanca* anymore.

Warner Bros.: 102 minutes

Produced by: Hal B. Wallis

Directed by: Michael Curtiz

Screenplay by: Julius J. Epstein, Philip G. Epstein and Howard Koch, based on *Everybody Comes to Rick's* by Murray Burnett and Joan Alison

Music by: Max Steiner

Cinematography by: Arthur Edeson

Starring: Humphrey Bogart (Rick Blaine), Ingrid Bergman (Ilsa Lund), Paul Henreid (Victor Laszlo), Claude Rains (Captain Louis Renault), Conrad Veidt (Major Heinrich Strasser), Sydney Greenstreet (Signor Ferrari), Peter Lorre (Signor Ugarte), Leonid Kinskey (Sascha), John Qualen (Berger), S.Z. Sakall (Carl), Dooley Wilson (Sam).

17th Academy Awards®

1944

Best Film: *Going My Way* (Paramount)

Best Director: Leo McCarey, *Going My Way*

Best Actor: Bing Crosby, *Going My Way*

Best Actress: Ingrid Bergman, *Gaslight*

Best Supporting Actor: Barry Fitzgerald, *Going My Way*

Best Supporting Actress: Ethel Barrymore, *None But the Lonely Heart*

The story of two parish priests with different outlooks on life, ***Going My Way*** won seven Oscars® in 1944 including Best Film. Co-stars Bing Crosby (below left) and Barry Fitzgerald (right) were also honored, as well as devout Catholic Leo McCarey (Best Director and Best Original Story), Frank Butler (Best Screenplay) and 'Swinging on a Star' (Best Music).

Only a director as skilled and as sure of his material as Leo McCarey could deliver the sequel, *The Bells of St Marys* (1945), which teamed Crosby with fellow Oscar®-winner Ingrid Bergman as a nun.

The Keys of the Kingdom (1944) heralded a new star on the Hollywood horizon, California-native Gregory Peck. At 6 ft 3 in (1. 91 m) and with a deep, resonant voice, Peck first came to prominence as the central character of A.J. Cronin's novel of a Catholic priest's life in early 20th century China with a warm, practical humanity.

It's hard to believe this was only Peck's second film (he was 28 when the film was released) but his character embodies the passing of half a century of history in just over two hours of classic storytelling.

With a quality cast – Thomas Mitchell (pictured above left, with Benson Fong and Gregory Peck), Vincent Price and especially Rose Stradner as a headstrong nun – the film received four Academy Award nominations, including one for Peck as Best Actor, but the Oscar® went to another Hollywood priest that year, Bing Crosby for *Going My Way*.

A year after *Casablanca* (1943), the Academy rewarded Ingrid Bergman (pictured immediately right) with the Best Actress for **Gaslight** (1944), in which she plays a frightened wife who is convinced her husband in trying to drive her insane. Charles Boyer (far right) plays the suspicious husband, Angela Lansbury (centre) is an impressionistic maid, and Joseph Cotton stars as the Scotland Yard detective who solves the case.

101

Double Indemnity (1944) is one of the best noir films ever made. Based on the novel by James M. Cain, who also wrote *The Postman Always Rings Twice* and *Mildred Pierce*, the screenplay was co-written by Raymond Chandler.

Writer-director Billy Wilder tells the story of a gullible insurance salesman who is convinced by a beautiful woman to murder her husband so they can collect the insurance. Wilder took a huge chance casting the likeable Fred MacMurray (far left) as the murderous Walter Nerf, Barbara Stanwyck (in a blonde trashy wig, below) as the beautiful femme fatale and Edward G. Robinson (left) as the suspicious insurance inspector. Seduced by Stanwyck's Phyllis Dietrichson, Nerf agrees to kill her husband and make it look like an accident so they can claim 'double the indemnity'. It doesn't end well.

Barbara Stanwyck (1907–1990) played strong career women, brittle wives, beautiful ingénues, murderesses and matriarchs with the same grace and skill that characterized her fifty plus years in film and on television. An orphan who became the highest paid female star in America in the 1940s, her professionalism on set made her a favorite to work with among other actors and directors.

As film noir goes, they don't come any better than **Laura** (1944), director Otto Preminger's stylish murder mystery set in 1940s New York. Gene Tierney (above right) stars as the beautiful Laura, Clifton Webb (centre) is her obsessive mentor and Dana Andrews (left) is the detective who investigates Laura's 'murder' and quickly falls in love with her memory.

When Laura rematerializes – it is her flatmate who has been murdered – Andrews falls in love with her all over again and the pair unmask the killer. As improbable a plot as it now seems, *Laura* was a triumph of style over substance and made an unlikely star out of character actor Clifton Webb (1889–1966).

18th Academy Awards®
1945

Best Film: *The Lost Weekend* (Paramount Pictures)

Best Director: Billy Wilder, *The Lost Weekend*

Best Actor: Ray Milland, *The Lost Weekend*

Best Actress: Joan Crawford, *Mildred Pierce*

Best Supporting Actor: James Dunn, *A Tree Grows in Brooklyn*

Best Supporting Actress: Anne Revere, *National Velvet*

Director Billy Wilder and British-born actor Ray Milland (pictured below with actress Doris Dowling) won Oscars® for *The Lost Weekend* in 1945.

Based on the Charles R. Jackson novel of a writer's battle with alcoholism, Wilder allegedly drew on his collaboration with crime writer Raymond Chandler who had co-written *Double Indemnity* (1944) the previous year.

The Lost Weekend attempts to get inside the mind of an alcoholic – with melodramatic and somewhat dated results. Re-released after the studio added a much needed music score by Miklós Rózsa, *The Lost Weekend* was an enormous critical and popular success.

National Velvet (1944) starred 12-year Elizabeth Taylor and Mickey Rooney (top-billed) in MGM's production of Enid Bagnold's classic story of a young girl who rides her horse to victory in the Grand National Steeplechase.

Lusciously produced with sure direction from Clarence Brown, *National Velvet* boasted the likes of Donald Crisp, Anne Revere (who won Best Supporting Actress for her role as Velvet's mother) and the young Angela Lansbury also in a supporting role.

National Velvet made a star of English-born Taylor and showcases one of Rooney's most balanced performances (director Clarence Brown elicited a similar effort from Rooney in *The Human Comedy*, 1941). Sentimental, but not in a manipulative way, *National Velvet* focuses more on the relationships than the horse race, which nevertheless provides the film with a startling climax and denouement.

Joan Crawford (1905–1977) had been in Hollywood since the silent era, but ***Mildred Pierce*** (1945) displays her toughness and vulnerability as a single mother who starts a successful business only to be double-crossed by her spoiled daughter. Based on the James M. Cain novel of the same name (he also wrote *Double Indemnity,* 1944; *The Postman Always Rings Twice*, 1946), there were certain aspects of the story that could not be transferred to the screen in the 1940s.

Crawford's performance never falters throughout the film. Pictured left, with Ann Blyth as her daughter and Bruce Bennett as her former husband, Crawford succeeds in bringing the necessary empathy to the character of single-minded career mom Mildred Pierce who has one fatal flaw when it comes to her daughter.

Could the story of an unconsummated love affair between two middle-class people who meet in suburban England be the greatest romantic film of all time? Based on *Still Life*, the Noel Coward play, **Brief Encounter** (1945) is the story of a middle-class housewife (Celia Johnson) who escapes her humdrum marriage by meeting with a doctor (Trevor Howard) over the course of several weeks.

With Johnson's moving narration providing a unique insight into her state of mind, the film is inherently English in manner and style but universal in theme and emotional intimacy.

David Lean became the first British-based director to receive an Academy Award nomination for this film. *Brief Encounter* also features highly as one of the greatest British films of all times.

A Matter of Life and Death (1946) is one of the most beautiful and thought-provoking films to come out of England at the end of World War II. Produced and directed by the team of Michael Powell and Emeric Pressburger, David Niven plays a doomed pilot flying across the English Channel who talks to an American radio operator based in England (Kim Hunter) before he has to bail out of his stricken aircraft to his apparent death.

When Niven's character Peter Carter wakes up on a beach, alive, he seeks out the young woman he spoke to over the airwaves and they fall in love. An angel, Marius Goring playing Conductor 71, later visits Peter and tells him he was supposed to die in the crash and he must accompany him to Heaven. Peter is granted three days to launch an appeal to Heaven and it is only when Hunter offers to change places with him, that the heavenly jury relents and allows them both to live. Released as ***Stairway to Heaven*** in the US, the film shows scenes of startling Technicolor on Earth while Heaven is portrayed in monochrome hues – the reverse of *Wizard of Oz*, 1939.

19th Academy Awards®

1946

Best Film: *The Best Years of Our Lives* (Goldwyn / RKO)

Best Director: William Wyler, *The Best Years of Our Lives*

Best Actor: Fredric March, *The Best Years of Our Lives*

Best Actress: Olivia de Havilland, *To Each His Own*

Best Supporting Actor: Harold Russell, *The Best Years of Our Lives*

Best Supporting Actress: Anne Baxter, *The Razor's Edge*

William Wyler's *The Best Years of Our Lives* (1946) charts the different problems three veterans face after returning home at the end of World War II – below from left, Homer (Harold Russell), Fred (Dana Andrews) and Al (Fredric March).

The film won seven of the eight Oscars® it was nominated for, including Best Picture, Best Director, Best Actor (March, his second), Best Writing and Best Supporting Actor (Russell, the first 'non-actor' to win an Oscar®). Producer Sam Goldwyn received a special award for bringing the story to the screen, and Russell was also doubly honoured 'for bringing hope and courage to fellow veterans'.

The Best Years of Our Lives (1946) may just be the best film ever made by Hollywood about war and yet, it doesn't show a single battle scene. Intertwining the lives of three veterans, former bomber pilot Fred (Dana Andrews, above right) takes a menial job in a department store, alienating his showy wife (Virginia Mayo, above left). Fred is wracked by nightmares, and when he finally sits in the cockpit of a junked bomber in an aeroplane graveyard reliving his combat fears we get a real insight into what he has experienced in battle.

Al (Fredric March, pictured right with co-star Myrna Loy) finds it difficult to go back to his old job as a bank manager because he just can't say no to the returned servicemen who need a loan. Taking comfort in the bottle, he has to fall in love with his long-suffering, patient wife all over again and counsel his daughter (Teresa Wright) about falling in love with Fred.

The scene where Homer (Harold Russell) reveals the extent of his injuries to his fiancé is still shocking to watch today. Russell (1914-2002) lost both his hands in a training mishap in North Carolina during the war and only made two other film appearances, *Inside Moves* (1980) and *Dogtown* (1997).

Singer-songwriter Hoagy Carmichael is effective as a bar owner, Virginia Mayo plays against type as an unfaithful wife and Ray Neal has a showy part as a benign fascist who confronts Homer about being 'duped' by the war.

It's a Wonderful Life
1946

"I guess you're right. I supposed it would have been better if I'd never been born at all."

George Bailey (James Stewart)

Christmas favorite *It's a Wonderful Life* defies criticism. Although producer-director-writer Frank Capra had won three Oscars® in the 1930s, postwar audiences did not immediately embrace his fantasy family film and it did poorly in its initial run, only to find a home on TV and become a perennial classic. Ironically, this proved to be the only project for Capra's Liberty Films production studio, but what a great legacy it now has.

James Stewart plays George Bailey, a young man who dreams of seeing the world, only to be weighed down by business and family responsibility. While his younger brother is a war hero and his best friend becomes a millionaire, George stays in humble Bedford Falls to run a mortgage business and raise family after marrying his sweetheart Mary (Donna Reed). When his business faces ruin through no fault of his own, George believes the world would be better off if he had never lived and he contemplates suicide. An angel rescues him and shows George what the world would really be like if he hadn't lived.

This was Stewart's first film after serving in the US Army as a pilot during the war. Reunited with Capra after their success in *You Can't Take it With You* (1938) and *Mr Smith Goes to Washington* (1939), Stewart infuses George Bailey with a range of emotions – optimism, idealism, bitterness and resentment. Capra was not afraid to show George's dark side (this can't be avoided when a family man considers suicide and actually goes through with it, even if he is rescued by an angel).

Stewart excels in the scenes when George becomes increasingly cynical – mercilessly berating Uncle Billy (Thomas Mitchell) for misplacing the company money and expressing his own dissatisfaction with the way his life has turned out.

Capra was a master of populist filmmaking and both he and Stewart regarded this as their favorite film. The scenes when there is a 'run' by angry investors on the George's family business after the stock market crash in 1929 are particularly menacing. It's as if Capra had filmed them for *Meet John Doe* (1941) and slotted them into this picture.

In George's 'post suicide' world, Bedford Falls becomes Potterville, a slum of a town with a terrible darkness and lack of community spirit. When George is swamped by the townsfolk who bail him out of trouble, Capra completes the audience's rollercoaster ride of emotion which leaves us feeling appreciative of others.

Donna Reed (as Mary) and Henry Travers (as the angel) are particularly appealing. The byplay of George's friends Bert and Ernie (Ward Bond and Frank Faylen), especially in the makeshift honeymoon scene in the rain, is wonderful. Character actors Thomas Mitchell (Uncle Billy Bailey), Beulah Bondi (Ma Bailey), H.B. Warner (Mr Gower) and a young Gloria Grahame (Violet Bick), give the film real depth. Lionel Barrymore is the epitome of evil throughout the film – Capra and his writer resist the temptation to redeem his character at the end of the film.

It's a Wonderful Life is simply a wonderful film.

Liberty Films / RKO: 130 minutes

Produced and Directed by: Frank Capra

Screenplay by: Frances Goodrich, Albert Hackett and Frank Capra, based on the short story 'The Greatest Gift' by Philip Van Doren Stern

Music by: Dimitri Tiomkin

Cinematography by: Joseph Walker

Starring: James Stewart (George Bailey), Donna Reed (Mary Hatch Bailey), Henry Travers (Clarence Odbody), Lionel Barrymore (Mr Henry F. Potter), Thomas Mitchell (Uncle Billy Bailey), Beulah Bondi (Ma Bailey), Frank Faylen (Ernie), Ward Bond (Bert), Gloria Grahame (Violet Bick), H.B. Warner (Mr Gower).

James Stewart
1908–1997

James Stewart was the most versatile of actors. In romantic comedy, farce, western, thriller or drama, Stewart was rarely anything short of his best.

Although his 'good guy' persona would never let him take on a villainous role, Stewart could also display the darker side of the American hero – disillusionment (*It's a Wonderful Life*, 1946), inner conflict (*The Naked Spur*, 1953) and obsession (*Vertigo*, 1958).

A favorite actor of directors – Frank Capra (three films), John Ford (three), Alfred Hitchcock (four) and Anthony Mann (five) – it was 'Hitch' who fully exploited this darker side of the likeable, stammering Stewart in the 1950s. However, in the late 1960s, younger audiences drifted away from Stewart and his generation of stars, bringing an early end to a wonderful film career.

KEY FILMS

You Can't Take It With You (1938)
Mr Smith Goes to Washington (1939)
Destry Rides Again (1939)
The Shop Around the Corner (1940)
The Philadelphia Story (1940)
It's a Wonderful Life (1946)
Rope (1948)
The Stratton Story (1949)
Winchester '73 (1949)
Broken Arrow (1949)
Harvey (1950)
The Greatest Show on Earth (1952)
The Naked Spur (1953)
The Glenn Miller Story (1954)
Rear Window (1954)
The Far Country (1954)
The Man from Laramie (1955)
The Man Who Knew Too Much (1956)
Vertigo (1958)
Anatomy of a Murder (1959)
The Man Who Shot Liberty Valance (1962)
The Flight of the Phoenix (1965)

Winchester 73 (1950) may have been Jimmy Stewart's first western in more than a decade after *Destry Rides Again* (1939), yet 1950s post-war audiences embraced a mature, weather-beaten actor well suited to the rugged outdoors. Stewart's acting persona flourished in the genre – he made five westerns during the decade, all with director Anthony Mann (also *Bend of the River*, 1952; *The Naked Spur*, 1953; *The Far Country*, 1954; and *The Man From Laramie*, 1955). But then the laconic Stewart could pretty much play any role – except the bad guy.

Rope (1948) could be dismissed as an experimental film by the master, Alfred Hitchcock, except that it features wonderful performance from James Stewart (and John Dall and Farley Granger as the complicit killers). Hitchcock's attempt to shoot in real time (a bare 80 minutes) and his reliance on panning shots to minimize editing are mere distractions in this story of two young killers. The film echoes the case of Leopold and Loeb, two students who murdered a 14-year-old boy to impress their professor.

The rage and shame that Stewart's professor feels when he discovers what the young men have done is palpable. *Rope* succeeds in some small way in understanding the destructive power of murder.

20th Academy Awards®

1947

Best Film: *Gentleman's Agreement* (20th Century Fox)

Best Director: Elia Kazan, *Gentleman's Agreement*

Best Actor: Ronald Colman, *A Double Life*

Best Actress: Loretta Young, *The Farmer's Daughter*

Best Supporting Actor: Edmund Gwenn, *Miracle on 34th Street*

Best Supporting Actress: Celeste Holm, *Gentleman's Agreement*

Seven decades after it won Best Film, *Gentleman's Agreement* (1947) remains an incredibly brave film: the story of investigative journalist Skyler Green (Gregory Peck) who poses as a Jew to expose society's anti-Semitism. Based on the book by Laura Hobson, it boldly acknowledges that there was/is such a problem – that Jews (and other minorities, if truth be told) are routinely discriminated against.

Elia Kazan and Celeste Holm also won for Best Director and Best Supporting Actress respectively.

John Garfield, playing Dave Goldman, provides the film's gravitas as the friend who has experienced discrimination his entire life.

Body and Soul (1947) was the high-water mark of actor John Garfield's (1913–1952) short career.

The story of a boxer who quickly forgets his humble origins once he finds success was brilliantly realized by director Robert Rossen, and is regarded as one of the best films about the sport. Garfield (and co-star Anne Revere) both fell afoul of the House Committee on Un-American Activities (created to investigate alleged disloyalty and subversive activities of citizens and organizations suspected of having Communist ties). The stress was said to have contributed to Garfield's premature death from a heart attack, aged just 39.

Katharine Hepburn
1907–2003

Katharine Hepburn was a woman who refused to be compromised in her film choices and in her personal life. After winning the Oscar® for *Morning Glory* (1933), the Hepburn was commercially unsuccessful for the remainder of the decade.

She returned to favor in the 1940s, relishing her on-screen partnership with Spencer Tracy and forming a personal relationship with him that lasted until Tracey died in 1967.

Awarded a record four Oscars® (also *Guess Who's Coming to Dinner*, 1967; *The Lion in Winter*, 1968; and *On Golden Pond*, 1981) which punctuated prolonged periods of inactivity in the 1950s and 1970s, Hepburn remained a free spirit throughout her life and didn't care much for success or failure – only for her art.

KEY FILMS

Morning Glory (1933)
Little Women (1933)
Alice Adams (1935)
Sylvia Scarlett (1936)
Bringing Up Baby (1938)
The Philadelphia Story (1940)
Woman of the Year (1942)
Adam's Rib (1949)
The African Queen (1951)
Pat and Mike (1952)
Summertime (1955)
Desk Set (1957)
Suddenly, Last Summer (1959)
Long Day's Journey into Night (1962)
Guess Who's Coming to Dinner (1967)
The Lion in Winter (1968)
On Golden Pond (1981).

By the end of the 1940s the partnership between Katharine Hepburn and Spencer Tracy was well-established and *Adam's Rib* (1949), their sixth film collaboration, plays to their complementary film personas.

Playwrights Garson Kanin and Ruth Gordon, the pair's close friends, came up with this story of married lawyers who enter into a divorce after representing rival spouses in an attempted murder case.

Judy Holliday and Tom Ewell play the married couple who tried to murder each other while David Wayne is neighbor Kip who has more than a passing interest in Hepburn's pending divorce.

The film ends happily enough, with Tracy and Hepburn (above, with actor Emerson Treacy, centre) recommitting to their marriage and to continuing their ideological battles.

21st Academy Awards®
1948

Best Film: *Hamlet* (Universal / Rank)

Best Director: John Huston, *The Treasure of the Sierra Madre*

Best Actor: Laurence Olivier, *Hamlet*

Best Actress: Jane Wyman, *Johnny Belinda*

Best Supporting Actor: Walter Huston, *The Treasure of the Sierra Madre*

Best Supporting Actress: Claire Trevor, *Key Largo*

Hamlet (1948), Laurence Olivier's towering film achievement as actor-writer-director-producer brought Shakespeare's most complex and rewarding play to the screen. Controversially, Olivier jettisoned minor characters Rosencrantz and Guildenstern but at 155 minutes he made the story accessible to a broader audience.

In a role Olivier (1907–1989) appeared born to play, Hamlet won the award for Best Film (the first British film to do so) and the Best Actor award for Olivier. Though the play has been filmed many times in the years since, Olivier's black and white masterpiece stands the test of time. Though a trifle old at age 40 to play the melancholy Dane, Olivier's performance is mesmerizing.

Jane Wyman (above right) won Best Actress for her role in **Johnny Belinda** (1948), a daring film for the time about the politics of small town relationships. After a deaf mute (Wyman) is raped by a local man, she later kills him when he comes to take their child away from her.

Also starring Lew Ayres (above left) as a kindly doctor and Charles Bickford and Agnes Moorehead as the deaf woman's parents, *Johnny Belinda* was based on the successful 1940 play of the same name which itself was based on a real-life, turn-of-the-century incident.

Interestingly, Wyman (1917–2007) was married to fellow actor and future US president Ronald Reagan at the time, but the marriage soon ended in divorce.

Howard Hawks
1896–1977

Howard Hawks was such a versatile director of war films, romantic comedies, musicals, westerns and film noir, that the career of this 'great all-rounder', as he was once called, could easily have been overlooked. But one look at his film résumé and the people he worked with over half a century impresses even the most casual film fan.

Hawks was an American artist of the highest caliber; his films were directed in a straightforward, well-crafted style which emphasized the relationships and friendships of the actors on screen.

Although his films may not have had the emotional depth of other directors, Hawks excelled in 'emotional repression' that added to the tension. Think of his films, *To Have and to Have Not* (1944) with 'Bogie' and Bacall, *Red River* (1948) starring John Wayne and Monty Clift.

KEY FILMS

The Dawn Patrol (1930)
Scarface (1932)
Twentieth Century (1934)
Come and Get It! (1936)
Bringing Up Baby (1938)
Only Angels Have Wings (1939)
His Girl Friday (1940)
Sergeant York (1941)
Ball of Fire (1941)
To Have and to Have Not (1944)
The Big Sleep (1946)
Red River (1948)
I Was a Male War Bride (1949)
Gentlemen Prefer Blondes (1953)
Land of the Pharaohs (1955)
Rio Bravo (1959)
Hatari! (1962)
El Dorado (1966)

The setting for **Red River** (1948) may have been quintessentially American but the film can be viewed as Shakespearean in theme and increasingly influential in style.

John Wayne plays Texan rancher Thomas Dunson who sets out on a cattle drive to Missouri with his adopted son played by Montgomery Clift in his film debut, and a troupe of cowboys.

During the drive, Dunson becomes increasingly tyrannical in his determination to complete the drive and his son reluctantly leads a mutiny among the men.

The pair face off in the inevitable showdown once they reach the nearest town, and although they wound each other (in the original book, Tom Dunson is killed), they are ultimately reunited by the film's love interest Tess (Joanne Dru). Wayne excels in a rare complex role while Clift provides an excellent counterpoint to Wayne's almost Homeric character.

The Treasure of the Sierra Madre
1948

"I think I'll go to sleep and dream about piles of gold getting bigger and bigger and bigger."

Fred C. Dobbs (Humphrey Bogart)

Of all the Humphrey Bogart films one could profile from the 1940s alone – *High Sierra* (1941), *The Maltese Falcon* (1941), the immortal *Casablanca* (1942), *To Have and To Have Not* (1944), *The Big Sleep* (1946) and *Key Largo* (1948) – the latter three with wife Lauren Bacall – *The Treasure of the Sierra Madre* (1948) best shows Bogart's range as an actor.

The film was directed by John Huston, who made six films with Bogie and won Oscars® for this film for directing and adapted screenplay (Bogart would have to wait a couple of years for his Best Actor award for *The African Queen*, which was also directed by Huston).

The Treasure of the Sierra Madre can be viewed as an important piece of cinema history that never fails to disappoint. Fred C. Dobbs (Bogart) is a tramp down on his luck in Mexico in the 1920s (director Huston plays a brief role as a white-suited American who gives Dobbs a handout). Dobbs befriends fellow American Bob Curtin (Tim Holt) and the pair encounter an old man who tells them of the gold in the Sierra Madre mountains waiting to be found – if you know where to look. The role of the crafty old-timer, Howard, was played by Huston's father, veteran character actor Walter Huston, who won Best Supporting Actor for his role.

When Dobbs wins a local lottery, he decides to finance a gold-digging expedition into the hills with his new partners. Interestingly, the boy who sells Dobbs the ticket was played by Robert Blake, who would have a long career in film and on TV before hitting hard times in the 1990s.

Dobb's mental deterioration under the pressure of discovering the untapped riches in the hills is masterly portrayed by Bogart. His gradual descent from ordinary Joe (we root for Dobbs and Curtin early in the piece as they fight a boss for money they are owed) to demonic paranoid (after Howard stays behind to help a group of peasants, Dobbs leaves Curtin for dead and takes all the gold dust) is outstanding – much more effective than Bogart's more celebrated turn in *The Caine Mutiny* (1954).

Bogie gives little glimpses of Dobb's inherent greed that will eventually eat away at his piece of mind, building the tension in the film.

The moral ambiguity of the trio after they strike it rich is shown when they decide to kill a fellow prospector, James Cody (Bruce Bennett) who they come across and who wants to come in with them.

Alfonso Bedoya is a menacing presence as Gold Hat ('We don't need no stinking badges!' he famously roars when the Americans ask him and his bandits for their identification).

While the film is a tour de force for Bogart and Huston Sr, the largely forgotten Tim Holt more than holds his own. Holt had a long career in B-grade westerns during the 1930s before getting his big break in Orson Welles' *The Magnificent Ambersons* (1942). His career went into decline in the late 1950s but *The Treasure of the Sierra Madre* shows what a good actor Holt was with the right material.

Warner Bros. / First National Picture: 126 minutes

Produced by: Henry Blanke

Directed by: John Huston

Screenplay by: John Huston, based on the novel by B. Traven

Music by: Max Steiner Cinematography: Ted D. McCord

Starring: Humphrey Bogart (Fred C. Dobbs), Walter Huston (Howard), Tim Holt (Bob Curtin), Bruce Bennett (James Cody), Barton MacLane (Pat McCormick), Alfonso Bedoya (Gold Hat), Robert Blake (boy).

John Huston
1906–1987

An award-winning director and screenwriter, John Huston directed tall and true tales on screen, and lived many of those tales he wrote about off the screen.

The son of actor Walter Huston, John Huston got his big break directing Humphrey Bogart in *The Maltese Falcon* (1941). His collaborations with Bogie resulted in Oscars® for him and his father in the *Treasure of the Sierra Madre* (1948) and for Bogart in *The African Queen* (1951).

Huston's films were marked by rugged individualism and wry irony, qualities he brought to his own roles in such films as Roman Polanski's *Chinatown* (1974). He also directed daughter Angelica in her Oscar®-winning role in *Prizzi's Honor* (1985), completing the unique circle of father-son-daughter awards under his watch.

KEY FILMS

The Maltese Falcon (1941)
The Treasure of the Sierra Madre (1948)
Key Largo (1948)
The Asphalt Jungle (1950)
The Red Badge of Courage (1951)
The African Queen (1951)
Moulin Rouge (1952)
Beat the Devil (1953)
Moby Dick (1956)
Heaven Knows, Mr Allison (1957)
The Roots of Heaven (1958)
The Misfits (1961)
Freud (1962)
The Night of the Iguana (1964)
The Bible: In the Beginning (1966)
Fat City (1972)
The Life and Times of Judge Roy Bean (1972)
The Mackintosh Man (1973)
The Man Who Would Be King (1975)
Wise Blood (1979)
Prizzi's Honor (1985)

Key Largo (1948) was John Huston and Humphrey Bogart's second collaboration for the year (also *The Treasure of the Sierra Madre*) and is notable for being the last of the 'Bogie and Bacall' films.

Retired Major Frank McCloud (Bogart) visits the family of one of his fallen men and finds them held hostage in their hotel in Florida's Key Largo by a group of gangsters headed by crime boss Johnny Rocco (Edward G. Robinson).

With the film in danger of being trapped by its theatrical origins, *Key Largo* succeeds in portraying an increasingly claustrophobic and menacing atmosphere as the tensions inside the hotel more than match the storm raging outside.

Clare Trevor won Best Supporting Actress as Rocco's alcoholic moll, and while Lionel Barrymore (as James Temple) is nothing short of his usual best, it's Bogie's film from start to finish.

Cynically idealistic, McCloud bides his time before springing into action and dispatching the bad guys in one of Bogart's most understated performances.

22nd Academy Awards®
1949

Best Film: *All the King's Men* (Columbia)

Best Director: Joseph L. Mankiewicz, *A Letter to Three Wives*

Best Actor: Broderick Crawford, *All the King's Men*

Best Actress: Olivia de Havilland, *The Heiress*

Best Supporting Actor: Dean Jagger, *Twelve O'Clock High*

Best Supporting Actress: Mercedes McCambridge, *All the King's Men*

Based on Robert Penn Warren's thinly-veiled novel about former Louisiana governor Huey Long (1893–1935), ***All the King's Men*** (1949) won Academy Awards® for Best Film, Best Actor and Best Supporting Actress. The film was a triumph for writer-director-producer Robert Rossen, who was thrice nominated.

The role of Willie Stark provided character actor Broderick Crawford (below) with a career-defining role. Mercedes McCambridge also won an Oscar® for her scene-stealing turn as Stark's campaign manager. The film was remade in 2006 with Sean Penn but was not a success. Who could buy the rise of a power-hungry opportunist in today's age?

Louisa May Alcott's classic novel, ***Little Women,*** about the lives of four sisters in a Civil War family has been filmed on six occasions – two silent versions (1917 and 1918), in 1933 starring Katharine Hepburn, a TV version in 1978 and the 1994 film with Winona Ryder. MGM's 1949 film remains the best-known and best-loved. The central casting of the sisters is central to its success – June Allyson (as forthright Jo), Elizabeth Taylor (the vain Amy), Janet Leigh (the pragmatic Meg) and Margaret O'Brien (as ill-fated Beth).

Although not nominated for the main categories at the Oscars®, this lavishly produced Mervyn Le Roy film won Best Art Direction–Set Direction (Color) for Cedric Gibbons, Paul Groesse, Edwin B. Willis and Jack D. Moore.

Olivia de Havilland (b. 1916) won her second Best Actress award in *The Heiress* (1949) after first winning the award for her role in *To Each His Own* (1946).

Earlier in the decade, de Havilland's younger sister Joan Fontaine won the same award for her role in *Suspicion* (1941). The pair remains the only siblings to win Oscars® for Best Actress. They famously conducted a decades-long feud and did not speak to each other in the years leading to Fontaine's death in 2013.

At age 101 she is involved in legal action against the producer of the series *Feud: Bette and Joan* for its portrayal of her by Catherine Zeta-Jones as a gossip.

The Third Man (1949), written by Grahame Green (1904–1991) and directed by Carol Reed (1906–1976), is today regarded as one of the greatest British films ever made.

With innovative 'Dutch angle' cinematography and an ingenious plot, *The Third Man* discards the original happy ending for a world-weary, bittersweet yearning for a lost time.

As Harry Lime, Orson Welles – long presumed dead by his friend Holly Martins (Joseph Cotton) but resurrected as a criminal in decaying, postwar Vienna – plays one of the screen's most ambiguous villains.

Welles has great fun in the role. He wrote and delivers the film's most quoted expression: "In Italy, for thirty years under the Borgias, they had warfare, terror, murder and bloodshed, but they produced Michelangelo, Leonardo da Vinci and the Renaissance. In Switzerland, they had brotherly love, they had five hundred years of democracy and peace, and what did that produce? The cuckoo clock."

Anton Karas' distinctive musical score using only a zither became a worldwide hit and made its composer an unlikely star.

Black comedy doesn't come any better than ***Kind Hearts and Coronets*** (1949). It is considered to be one of the best of the Ealing Studio films to come out of England after World War II.

Roger Hamer's masterpiece is a showcase for the talented Alec Guinness who plays eight different characters of the D'Ascoyne family killed off in comic circumstances by Louis Mazzini (Dennis Price). Guinness' eccentric cast of characters are shot, poisoned, drowned, blown up, sent over a waterfall and shot down in an air balloon, with each death narrated in dry, understated style by the wronged Mazzini, who is eventually bought to justice and is condemned by his own memoirs.

White Heat (1949) contains a white hot performance from James Cagney as Cody Jarrett, a psychopathic criminal with a mother complex. Older, heavier and tougher in this role, Cagney returns to the gangster genre after a career absence of almost ten years.

In this film Cagney produces another classic character in his repertoire. Although production values are modest for a Warner Bros. film and the heist story is like so many others, Raoul Walsh's direction and Cagney's chilling performance dominate the film.

The scenes where Cagney kills his opponents (firing bullets into the boot of a car to give his captive some 'fresh air'), turns psychotic in prison after learning of his mother's death, and stages the final shootout on a gas tank platform as he shouts "Made it, Ma! Top of the world!" Definitely a classic of the gangster genre.

The 1950s

Many of the films of the 1950s had panache and sophistication. Romantic comedies, social dramas, intelligent westerns and even science fiction had a distinctive look and sound to them. Musicals – that trusty Hollywood staple – reached new heights, from *An American in Paris* (1951) to Oscar®-favorite *Gigi* (1958).

English director Alfred Hitchcock made a series of classic psychological thrillers in the 1950s and Billy Wilder combined drama and sardonic humor in his films. Directors George Stevens, Elia Kazan, Nicholas Ray and Stanley Kramer each had something important to say and were very much to the fore.

The biggest threat to the movie industry in the 1950s, however, was the arrival of television. Hollywood responded by giving audiences an enhanced movie-going experience with wide-screen formats such as Cinerama, 3D, Cinemascope, Panavision and Todd-AO 70mm. As a result, epic films such as *Giant* (1956), *The Ten Commandments* (1956), *The Bridge on the River Kwai* (1957) and *Ben-Hur* (1959) proved immensely popular.

The 1950s was the decade Marlon Brando ushered in a new style of acting, Marilyn Monroe became a sex symbol and the early death of James Dean fired the youth culture. The decline of the Hollywood studio system and the growth of independent producers would have a profound effect on the film industry in the coming decades and beyond.

Gene Barry and Ann Robinson (centre) in *The War of the Worlds* (1953).

23rd Academy Awards®

1950

Best Film: *All About Eve* (20th Century Fox)

Best Director: Joseph L. Mankiewicz, *All About Eve*

Best Actor: José Ferrer, *Cyrano de Bergerac*

Best Actress: Judy Holliday, *Born Yesterday*

Best Supporting Actor: George Sanders, *All About Eve*

Best Supporting Actress: Josephine Hull, *Harvey*

Written and directed by Joseph L. Mankiewicz, *All About Eve* (1950) was nominated for a record 14 Academy Awards® and won six Oscars® including Best Film, Best Director, Best Screenplay and Best Supporting Actor (George Sanders, in a wonderful performance as acid-tongued theatre critic Addison DeWitt).

One of the most successful films about the fleeting nature of fame, Davis delivers barb after barb as a theatrical star Margo Channing, who is undermined and gradually surpassed by her understudy, Eve (Anne Baxter, below centre, with Bette Davis, Gary Merrill and George Sanders).

Based on the stage play by Garson Kanin, George Cukor's **Born Yesterday** (1950) is a comedy showcase for oft-forgotten comedienne Judy Holliday (1921–1965). In the role she played on Broadway, Holliday is pitch-perfect as gangster's brassy moll Billie who is 'educated' by a young journalist, Paul Verrall (William Holden) who has been hired by her wealthy gangster (Broderick Crawford).

Billie turns out to be much more than another dumb blonde. During the course of her education, she falls for Verrall after he liberates her from the gangster's control.

Holden and Crawford star in rare comedic roles, but Holliday's subsequent film career was hampered by allegations of her political affiliations during the McCarthy communist witch hunts – House Committee on Un-American Activities – and her ill health. She died of breast cancer in 1965, aged just 43.

Sunset Boulevard (1950), a cynical look at Hollywood fame, was released barely 20 years after the advent of the 'talkies' and addresses some well-established themes about Hollywood: talking pictures ended the careers of many silent film stars; fame is intoxicating and potentially fatal; and some would sell their soul to find success.

This film could have been a camp cliché, but co-written and produced by Charles Brackett and co-written and directed by Billy Wilder, it is classic film noir.

Full of black humor and insider Hollywood jokes about many established stars and directors, *Sunset Boulevard* centers on the silent era stardom of reclusive Norma Desmond (Gloria Swanson) with Eric von Stroheim as her aide Max von Mayerling. William Holden plays Joe Gilles, an unsuccessful screenwriter who is drawn into Demond's fantasy of a triumphant comeback. The film made William Holden's career in the 1950s after the all-American actor had showed early promise.

Of note, Cecil B. DeMille, gossip columnist Hedda Hopper and leading silent movie stars including Buster Keaton play themselves in the film.

Quo Vadis (1951) was the fourth film adaptation of Henryk Sienkiewicz's novel. This film's all-star cast and magnificent production values proved a major hit with the public despite failing to win a solitary Oscar®.

Directed by Mervyn LeRoy and starring Robert Taylor, Deborah Kerr, Leo Genn and Peter Ustinov (as an archetypal Emperor Nero), *Quo Vadis* successfully dramatized the persecution of the early Christian church by the might of Rome – all in glorious Technicolor.

Elizabeth Taylor
1932–2011

Elizabeth Taylor was a remarkable actress whose private life overshadowed and eventually consumed her career. Coming to Hollywood from England during World War II, Taylor easily graduated from child star to adult roles.

A Place in the Sun (1951) portrayed her smoldering sexuality, while *Giant* (1954) and *Cat on a Hot Tin Roof* (1958) showcased her emotional range. Her Oscar® for *Butterfield 8* (1960) could be seen as Hollywood's 'get well card' after the death of second husband Mike Todd and a bout of ill health.

Marriages came and went, and her affair with Richard Burton on the set of *Cleopatra* (1963) proved a worldwide scandal. Taylor won another Oscar® for *Who's Afraid of Virginia Wolff?* (1966), but two marriages to Burton (unusual even for Hollywood) went the way of her others in the 1970s, by which time her film career was effectively over.

KEY FILMS

Jane Eyre (1944)
National Velvet (1944)
Courage of Lassie (1946)
Little Women (1949)
Father of the Bride (1950)
A Place in the Sun (1951)
Elephant Walk (1954)
The Last Time I Saw Paris (1954)
Giant (1956)
Raintree County (1957)
Cat on a Hot Tin Roof (1958)
Suddenly, Last Summer (1959)
Butterfield 8 (1960)
Cleopatra (1963)
The V.I.P. s (1963)
The Sandpiper (1965)
Who's Afraid of Virginia Woolf? (1966)
The Taming of the Shrew (1967)

A Place in the Sun (1951), loosely based on Theodore Dreiser's 1925 book *An American Tragedy*, explores the dark side of the American dream.

A young man (Montgomery Clift) climbs the corporate ladder of his uncle's factory and falls in love with a society débutante (Elizabeth Taylor). Just as his future appears set, the young man's working-class girlfriend (Shelley Winters) informs him that she is pregnant and wants to marry him. In desperation, Clift's character considers murdering her, and though he is too scared to go through with it, the girl drowns and he is condemned by his own deceit.

A Place in the Sun won six Oscars®, including Best Director for George Stevens, but the brilliant cast of actors missed out. All are excellent: there is an uneasy casualness to Clift's performance that suits his character; teenager Elizabeth Taylor is a picture of beauty; while Winters' poignant portrayal of the doomed girlfriend was a career-changing role for her.

24th Academy Awards®
1951

Best Film: *An American in Paris* (MGM)

Best Director: George Stevens, *A Place in the Sun*

Best Actor: Humphrey Bogart, *The African Queen*

Best Actress: Vivien Leigh, *A Streetcar Named Desire*

Best Supporting Actor: Karl Malden, *A Streetcar Named Desire*

Best Supporting Actress: Kim Hunter, *A Streetcar Named Desire*

Inspired by the George Gershwin music composition of the same name, ***An American in Paris*** (1951) was directed by Vincente Minnelli (the father of actress Liza Minnelli) and starred Gene Kelly (1912–1996) and Leslie Caron (both pictured below).

In awarding it six Oscars®, including Best Picture and Best Cinematography (Color), Best Writing, Story and Screenplay, Best Costume Design (Color) and Best Music (Scoring of a Musical Picture), Academy voters easily overlooked the somewhat slight love story and focused instead on the brilliant score by Alan Jay Lerner; Kelly's inventive, graceful dancing and the closing dance number in the film … an original masterpiece.

The African Queen (1951) earned Humphrey Bogart a long-awaited Best Actor award for his role as Charlie Allnut, a steamboat captain in German East Africa who agrees to evacuate a prissy English missionary (Katharine Hepburn) after World War I breaks out. The project had been in the works ever since C.S.Forrester published his novel in 1935 (try and imagine, if you will, Bette Davis and David Niven in the lead roles) but Bogart was born to play that part.

Bogart's reluctant hero is neither cynic nor coward – he's a drunk and a realist, but Hepburn's character shames him into taking her down river where they ultimately confront a German battleship and declare their love for each other.

Directed on location by John Huston (*The Treasure of the Sierra Madre*, 1948), making the film could have been a movie in itself ... and it was. In 1990, Clint Eastwood directed and starred in *White Hunter Black Heart*, a thinly veiled account of what happened in the jungle while making that film.

A Streetcar Named Desire
1951

"I am not a Pollack. People from Poland are Poles. They are not Pollacks. But what I am is one hundred percent American."

Stanley Kowalski (Marlon Brando)

Given that *A Streetcar Named Desire* was released in 1951 when Hollywood still operated under the moral guidelines of the Production Code, much had to be cut from Tennessee Williams' original play about an 'old maid' with a bag full of secrets who moves in with her sister and her 'Pollack' husband.

The title sets the sexual tension of the piece, with Blanche DuBois riding into town in a streetcar named Desire – an allegory that suggests she has often trolled for love in the gutters depending, as she says, "on the kindness of strangers".

As Blanche, Vivien Leigh plays a Southern belle for the second time on film – an older, even gothic Scarlet O'Hara if you will, transported to another century, but still down on her luck as far as love is concerned.

Leigh shows her vulnerability and brittleness in this role, which considering her later issues with mental health may not have been that far from reality. The lovely Kim Hunter (1922–2002) plays her protective younger sister who is married to a brutish, almost animalistic husband Stanley, while putty-nosed Karl Malden (1912–2009) is the sympathetic Mitch who comes into Blanche's emotional orbit. Both reprised their stage roles.

However, it is Marlon Brando who creates a character for the ages playing Stanley Kowalski. Brando had played the role on stage in 1947 and was a sensation opposite Jessica Tandy (who was overlooked for the film but later won Best Actress for *Driving Miss Daisy* in 1989, aged 80).

In only his second film appearance (after *The Men*, 1950), Brando transforms film acting to an art form. As Stanley, he is both repulsive and mesmerizing, filling out his sweat-soaked t-shirt with so much power and loathing that you can't take your eyes off him.

When Stanley enters into a series of mind games with his visiting sister-in-law Blanche, he methodically deconstructs her psyche and undermines her well-being until there is nothing left but a ghost of a woman.

Director Elia Kazan, who had worked with the young Brando in the Actor's Studio and on Broadway, creates a glasshouse of emotion in the Kowalski tenement in New Orleans' French Quarter. Combined with Harry Stradling's cinematography and Alex North's jazz-inspired scored, *A Streetcar Named Desire* is staged on an unstable powder keg of emotion. And when Brando explodes, it's a sight to behold – Stanley throwing his plate at the wall and asking Blanche and Stella if they want their plates cleared; or yelling in the rain for 'Stella' at the bottom of the stairs; unmasking Blanche's sexual indiscretions and later, menacingly moving towards her when she is at her most vulnerable, ready for the 'dance' that was always going to happen.

A Streetcar Named Desire won four Oscars®, one for Best Art Direction/Set Direction (Black and White) and a record three Oscars® for acting roles. Vivien Leigh won for Best Actress (her second), and Karl Malden and Kim Hunter for Best Supporting Actor and Actress respectively. Of the quartet of leading roles, only Brando missed out (to sentimental favorite Humphrey Bogart). Hollywood was not yet ready for an actor of Brando's power and originality, but the audience was.

Warner Bros: 122 minutes

Produced by: Charles K. Feldman

Directed by: Elia Kazan

Screenplay by: Tennessee Williams, based on his play

Music by: Alex North

Cinematography by: Harry Stradling

Starring: Vivien Leigh (Blanche DuBois), Marlon Brando (Stanley Kowalski) Kim Hunter (Stella Kowalski), Karl Malden (Harold 'Mitch' Mitchell), Peg Hillias (Eunice Hubbel), Rudy Bond (Steve Hubbel), Nick Dennis (Pablo Gonzales).

Marlon Brando

1924–2004

Marlon Brando was lauded as the most dynamic actor of his generation, rewriting the rules of acting on stage in the late 1940s and in film in the early 1950s.

Brando's angry, brooding, even violent portrayals in *A Streetcar Named Desire* (1951) and *On the Waterfront* (1954), for which we won his first Oscar®, spawned countless admirers and imitators.

With success and adulation, however, came disillusionment and dissatisfaction with the craft he so easily mastered. Brando lacked the discipline and real-life balance to sustain his career in the 1960s. During this time, he directed one film, the flawed western *One Eyed Jacks* (1960) but returned to acting with *The Godfather* (1972). After winning Best Actor, he famously declined the Oscar® in protest of Hollywood's portrayal of Native Americans in film. Although he returned to film sporadically over the final forty years of his life, Brando wasted his talent in his later life.

KEY FILMS

The Men (1950)
A Streetcar Named Desire (1951)
Viva Zapata! (1952)
Julius Caesar (1953)
The Wild One (1954)
On the Waterfront (1954)
Guys and Dolls (1955)
Sayonara (1957)
The Young Lions (1958)
*One Eyed Jacks** (1960)
Mutiny on the Bounty (1962)
Bedtime Story (1964)
The Godfather (1972)
Last Tango in Paris (1973)
The Missouri Breaks (1976)
Superman (1978)
Apocalypse Now (1979)
The Freshman (1991)
**also directed*

The year after their success in *A Streetcar Named Desire* (1951), director Elia Kazan and star Marlon Brando reunited in **Viva Zapata!** (1952), a fictionalized biopic of the famed Mexican rebel Emiliano Zapata. Co-star Anthony Quinn (1915–2001) won the first of his two Best Supporting Actor awards for the role of Zapata's brother. The finished film not only reveals the young Brando's social conscience but also his desire to stretch his acting talents.

There were doubts whether the mumbling, mono-syllabic Brando could play the role of Mark Antony in Joseph L. Mankiewicz's film adaptation of Shakespeare's *Julius Caesar* (1953). The film was favorably received, with Brando nailing the crucial role on the force of his personality rather than the delivery of the lines. He received his third Academy Award nomination for this film in as many years but would not be rewarded a win until his next film, *On the Waterfront* (1954).

25th Academy Awards®

1952

Best Film: *The Greatest Show on Earth* (Paramount)

Best Director: John Ford, *The Quiet Man*

Best Actor: Gary Cooper, *High Noon*

Best Actress: Shirley Booth, *Come Back, Little Sheba*

Best Supporting Actor: Anthony Quinn, *Viva Zapata!*

Best Supporting Actress: Gloria Grahame, *The Bad and the Beautiful*

The Greatest Show on Earth (1952) was a surprise winner for Best Film, but then no film with the name Cecil B. DeMille written over the title should surprise. De Mille actually filmed a real Ringling Bros. and Barnum & Bailey Circus, and wove a dramatic plot around proceedings that often stretched credulity.

The finished product was pure entertainment, with a fine cast that included James Stewart as a fugitive doctor hiding behind a clown's face, Cornell Wilde as an injured trapeze artist and newcomer Charlton Heston as the square-jawed circus manager. Comedian-dancer-singer Betty Hutton (1921–2007), a huge star at the time, was top-billed.

High Noon (1952) is not your usual Western drama. Written and co-produced by Carl Foreman, the story of a besieged sheriff who cannot find anyone in town to stand alongside him as he awaits the arrival of a gang of killers was told in 'real time' under the taught direction of Fred Zimmermann. Zinnemann heightens the tension as the killers approach the town, and the final showdown does not disappoint.

The film has a much deeper context, however. Released at the height of McCarthyism, the public hearings of the House Committee on Un-American Activities under Senator Joe McCarthy, High Noon was seen as a stinging criticism of the Communist 'witch hunts' of the time that resulted in the blacklisting of artists, including writer Carl Foreman who never worked in the US again.

The film stars Gary Cooper as the sheriff facing a moral crisis – stand and fight or get out of town – and won his second Oscar® following the success of *Sergeant York* in 1941. The then unknown Grace Kelly was selected to play Cooper's pacifist Quaker wife who ultimately stands by her man.

Nominated for seven Academy Awards® including Best Film, Best Director and Best Screenplay, it won Oscars® only for Cooper, Best Editing, Best Music Score and Best Song, 'Do Not Forsake Me, Oh My Darlin.'

145

John Ford

1894–1973

John Ford conquered the 'wild west' in film and populated its wildernesses and settlements with heroes and villains, savages and noble warriors, quirky townsfolk and immigrants.

In John Wayne, Ford found an actor to best deliver his pioneering vision and even fashioned the young actor in his own image – rough, tough and uncompromising.

Ford was already a master storyteller in the silent era and many of his best sound films – the underrated *3 Godfathers* (1948), the modern-day *The Quiet Man* (1952) and the classic *The Searchers* (1956), all starring Wayne – rely heavily on visual storytelling.

Ford's handling of female leads, however, was decidedly old-fashioned and '60s audiences, discovering a master filmmaker rooted in the past, exiled him from the new Hollywood.

KEY FILMS

The Lost Patrol (1934)
The Informer (1935)
Wee Willie Winkie (1937)
Stagecoach (1939)
Young Mr Lincoln (1939)
Drums Along the Mohawk (1939)
The Grapes of Wrath (1940)
How Green was My Valley (1941)
The Battle of Midway (1942, doc.)
They Were Expendable (1945)
My Darling Clementine (1946)
Fort Apache (1948)
3 Godfathers (1948)
She Wore a Yellow Ribbon (1949)
Rio Grande (1950)
The Quiet Man (1952)
Mogambo (1953)
The Searchers (1956)
The Last Hurrah (1958)
The Man Who Shot Liberty Valance (1962)
Cheyenne Autumn (1964)

The Quiet Man (1952) stars John Wayne in a rare non-western role as a 1920s Irish-American boxer who returns to Ireland to reclaim his family's land. After killing a man in the ring, Wayne's pacifist outsider falls in love with Mary Kate Danaher (Maureen O'Hara), the sister of the local landowner (Victor McLaglen).

Beautifully filmed in Technicolor – Wilton C. Hoch and Archie Stour won the Academy Award for Cinematography – this romantic comedy established the screen partnership of Wayne and O'Hara who went onto make five films together. And it earned John Ford a record fourth Best Director award.

Full of Irish whimsy and typical Ford touches, *The Quiet Man* may be decidedly old-fashioned in its attitude towards women and love, but with John Wayne playing the role of a pacifist, it questioned notions of manliness in the parallel on-screen universe.

Singin' in the Rain (1952) is that rare film that works on many levels – musical, dance, romantic comedy and satire. One of the first films to highlight Hollywood's transition from silent film to talking pictures, *Singin' in the Rain* benefits from the talents of its three stars – Gene Kelly (1912–1996), Donald O'Connor (1925–2003) and Debbie Reynolds (1932–2016) – a witty script by Betty Comden and Adolph Green, and masterly direction from Kelly and Stanley Donen.

Kelly relishes the role of a movie star and plays to his own vanity, while O'Connor steals the show as sidekick Cosmo Brown. Reynolds was 19 when this film was made. Kelly apparently did not take to her and had her singing voice dubbed by co-star Jean Hagan. Ironically, Reynolds' character has to dub Hagen's voice in the film's climax, so Hagen is effectively dubbing her own voice.

Kelly's dance routine in the rain has since become an iconic part of film history and the movie has so grown in stature over time that it was named by the American Film Institute in 2006 as the greatest musical ever produced.

Based on the 1949 novel by Jack Schaefer and produced and directed by George Stevens, **Shane** (1953) is a western full of traditional themes and characters. On many levels it is both ugly and beautiful.

Alan Ladd (1913–1964) shines in the title role as a drifter trying to escape his gunslinger past, alongside Jean Arthur and Van Heflin as homesteaders, and Brandon deWilde as their young boy, Joey. Jack Palance (1919–2003) is one of the screen's most memorable villains as a hired gun, and his murder of Elisha Cook's character remains one of the most shocking showdowns of the genre.

Shane won only the one Oscar, for Best Cinematography (Loyal Griggs), but it is Stevens' picture from start to finish. Filmed in 1951, it was not released until two years later because of the directors' meticulous post production (especially the sound editing, which successfully captures the shock of gunfire).

The film holds up marvelously to repeated viewings because there is so much to take in visually and emotionally. Come back anytime, Shane.

26th Academy Awards®
1953

Best Film: *From Here to Eternity* (Columbia)

Best Director: Fred Zinnemann, *From Here to Eternity*

Best Actor: William Holden, *Stalag 17*

Best Actress: Audrey Hepburn, *Roman Holiday*

Best Supporting Actor: Frank Sinatra, *From Here to Eternity*

Best Supporting Actress: Donna Reed, *From Here to Eternity*

From Here to Eternity (1953) won the Oscar® for Best Film, as well as six other awards, including director Fred Zimmerman and a rare pair for Frank Sinatra and Donna Reed in the two supporting roles. Both actors played against type to achieve their success – Sinatra as the doomed Maggio and Reed as the escort, Alma – but leads Burt Lancaster, Deborah Kerr and Montgomery Clift missed out.

Writer James Jones novel was later adapted for a more faithful TV series in 1979 (and a UK stage musical in 2013), but Lancaster, Clift, Maggio and Ernest Borgnine, as the sadist 'Fatso' Judson,' are all at the top of their game in the 1953 film.

From Here to Eternity (1953) was an ambitious, albeit heavily censored, retelling of James Jones' war novel about non-conformity and rampant passions on the eve of World War II. Burt Lancaster and Deborah Kerr (above) in the famous 'beach scene' at Pearl Harbor – symbolic waves of passion and ecstasy had to make do in the conservative 1950s. Audiences couldn't be told at the time of the barbarity of the stockade Private Maggio is placed in, that Donna Reed's 'Alma' is actually a prostitute, not a 'dance partner', or any hint of gay relationships for that matter.

Deborah Kerr (1921–2007), however, portrays arguably the truest screen character to what Jones wrote in his book as the unfaithful Army Officer's wife, and even Burt Lancaster, who had a habit of often chewing up the scenery with his film presence takes the back seat to Kerr's multi-layered performance. Both were Oscar®-nominated, and while Lancaster would be rewarded for his role in *Elmer Gantry* (1960), Kerr never won an Academy Award® despite being nominated six times.

Director **Fred Zinnemann** (1907–1997) won Best Director for *From Here to Eternity* (1953). Born in Poland, he developed his camera craft in Vienna, Paris and Berlin. With the advent of sound films, however, he realized Hollywood was the place to be and started his career all over again. Zinnemann made short films (he won two Oscars® for two 'shorts', in 1938 and 1951 respectively) before graduating to the majors.

Zinnemann's early films included Marlon Brando's debut in *The Men* (1950), the classic western *High Noon* (1952) and the epic *From Here to Eternity* (1953). Following this film, Zinnemann made just seven films in 25 years, all of them outside America.

Stalag 17
1953

"But when the war broke out, he came back to the Fatherland like a good little Bundist. He spoke our lingo, so they sent him to spy school and fixed him up with phony dog tags."

Sefton (William Holden)

Stalag 17 might look like just another prisoner-of-war drama, but much like its central character Sefton, played by William Holden in an Oscar®-winning performance, it is really not what it seems.

Produced and directed by Billy Wilder, the film is a biting commentary on society's norms and ideals – an always cynical, often amusing and ultimately dramatic portrayal of a life and death existence in a POW camp during World War II.

Stalag 17 started life as a play written by former POWs, Donald Bevan and Edmund Trzcinski (the latter has a funny role in this film as a POW struggling to believe his wife found a baby on the doorstep while he is overseas). Comedy relief is provided by 'Animal' (Robert Strauss) and Harry (Harvey Lembeck), but there is always a serious undertone to the film. German barracks sergeant Johann Schulz (Sig Ruman) is fed information by an informer and this results in the deaths of two escapees. The POWs believe that Sefton (Holden) is the 'stool pigeon' and the life of the recently arrived Lt. Dunbar (Don Taylor) is now threatened.

As played by Holden, Sefton is a stark individualist and capitalist. Wilder brilliantly stages the moment Sefton, who has been badly beaten by his own men after yet another sanction from the Germans is blamed on him, discovers how the 'stoolie' shares the camp's secrets with Schulz. Holden is nothing less than brilliant when he unmasks the informer at a critical moment in the film and redeems himself in the minds of the men who despise him.

The comedy may be broad at times, but rarely has a war film balanced humor so effectively. The scenes in the barracks when the men try to keep boredom at bay with mice races, when they use a telescope to view the Russian women bathing in the adjoining camp, when they receive their mail from home and even dance with each other at Christmas are all humorous but never detract from the fact that their lives are at always at risk.

Peter Graves as Price, the barracks security officer, and Neville Brand as Duke are both effective in their given roles while famed director Otto Preminger relishes his performance as a cruel commandant. Only Gil Stratton as 'Cookie' strikes a wrong note (Stalag 17 is a camp for sergeants, and it's hard to believe the stammering Cookie, who is also the narrator of the film, could lead a platoon of men).

Stalag 17 was a huge commercial success when it was released in 1953 and has since taken its place among the great POW films such as *The Bridge on the River Kwai* (1957), in which Holden played another antihero and *The Great Escape* (1963). The less said about its distant cousin, the TV spin-off *Hogan's Heroes,* the better.

Stalag 17 might play for cheap laughs at time, but the film remains a stinging critique on the powers of social conformity and the perilous danger of judging a book by its cover.

'Sprechen Sie Deutsch?'

Perhaps one word, and it's not 'kaput' – *Stalag 17* is 'wunderbar'.

Paramount: 120 minutes

Produced and Directed by: Billy Wilder

Screenplay by: Edwin Blum and Billy Wilder, based on the play by Donald Bevan and Edmund Trzcinski

Music by: Franz Waxman

Cinematography by: Ernest Laszlo, ASC

Starring: William Holden (J.J. Sefton), Don Taylor (Lieutenant Dunbar), Otto Preminger (Colonel von Scherbach), Robert Strauss ('Animal' Kuzawa), Harvey Lembeck (Harry Shapiro), Peter Graves (Price), Sig Ruman (Sergeant Johann Schulz), Neville Brand (Duke), Richard Erdman (Hoffy), Gil Stratton (Clarence 'Cookie' Cook, narrator), Jay Lawrence (Bagradian).

Audrey Hepburn
1929–1993

Audrey Hepburn appeared to came from nowhere in the early 1950s. The Belgian-born actress (no relation to Katherine Hepburn) came to America from England to star in *Gigi* on Broadway in 1953. With a ballerina's poise and grace, she was an immediate star after being cast in *Roman Holiday* (1953), her first American film.

A fashion icon in the 1950s with her lithe figure, short hairstyles and pixie-like face, her subsequent films confirmed her talent and a blossoming love affair with audiences.

The Nun's Story (1959) displayed great emotional depth but she was miscast in the musical *My Fair Lady* (1964), her singing voice needed to be dubbed and she was unable to portray the necessary cockney charm the character required.

After fine performances in *Two for the Road* and *Wait Until Dark* (both 1967), Hepburn lost interest in her film career and devoted her time to humanitarian work with UNICEF, before her death from cancer at age 63.

KEY FILMS

Roman Holiday (1953)
Sabrina (1954)
Love in the Afternoon (1957)
Funny Face (1957)
The Nun's Story (1959)
Breakfast at Tiffany's (1961)
The Children's Hour (1961)
Charade (1963)
My Fair Lady (1964)
Two for the Road (1967)
Wait Until Dark (1967)
Robin and Marian (1976)

Audrey Hepburn won the Academy Award for Best Actress in her first American film, William Wyler's ***Roman Holiday*** (1953). With an Oscar®-winning story by blacklisted writer Dalton Trumbo, *Roman Holiday* also starred Gregory Peck (far right) as a journalist who befriends a young woman on the streets of Rome – not knowing she is a missing European princess.

Once Peck realizes who she is, he does not reveal to her that he is a journalist sent to Rome to cover her tour and takes the princess around the city with cameraman Eddie Albert (left) in tow. The resolution of the film is more European in manner than the usual Hollywood romance but *Roman Holiday* proved to be a stunning Hollywood debut for 24-year-old Hepburn.

Sabrina (1954), Billy Wilder's film adaption of Samuel A. Taylor's play, *Sabrina Fair*, stars Audrey Hepburn as the daughter of a wealthy family's chauffeur who returns home from school in Europe and attracts the interest of two brothers – played by Humphrey Bogart (left) and William Holden (far right). Bogie was perhaps a little too old aged 55 to play a romantic lead but he is actually ideal as the workaholic older brother who gradually realizes he has affections for Sabrina. Holden is well cast as idle playboy David, but it is Hepburn who again comes out on top opposite two of Hollywood's greatest stars in this charming romantic comedy.

27th Academy Awards®

1954

Best Film: *On the Waterfront* (Columbia)

Best Director: Elia Kazan, *On the Waterfront*

Best Actor: Marlon Brando, *On the Waterfront*

Best Actress: Grace Kelly, *The Country Girl*

Best Supporting Actor: Edmond O'Brien, *The Barefoot Contessa*

Best Supporting Actress: Eva Marie Saint, *On the Waterfront*

On the Waterfront (1954) won Marlon Brando his first Best Actor Oscar® in his role as broken down boxer Terry Malloy, who takes on the mobsters who control New York's waterfront and wins back his self-respect. Pictured below, Rod Steiger (below left) and Brando perform the famous 'I could have been a contender' scene, as Terry realises he has been let down his whole life by his older brother.

Viewed as another commentary on McCarthyism, but as an apology of sorts for those (including director Elia Kazan who 'named names), the film won eight Oscars® in all, including Best Film, Best Director and Best Supporting Actress for Eva Marie Saint.

Grace Kelly (1929–1982) won the Academy Award for Best Actress for the largely forgotten *The Country Girl* (1954), which also stars William Holden and Bing Crosby (below right), the latter nominated for his role as an alcoholic entertainer in arguably his best career performance.

Kelly was on a hot streak that year – *Dial M For Murder, Rear Window, Green Fire* and *The Bridges of Toko-Ri* – were all released that year but she retired from movies in 1956 when she married Prince Rainier of Monaco to live out every young girl's dream as a real-life princess.

Alfred Hitchcock
1899–1980

Alfred Hitchcock was a master of cinematic fear and terror. Not content with just scaring his audience with visual tricks or clever plot twists, his real genius was in constructing compelling narratives out of the flimsiest of plot devices merely as a vehicle for delivering his audience the thrills they enjoyed so much.

Creative, innovative and with a dark sense of humor, Hitchcock was a star director of silent films before graduating to 'talkies' in his native England. He came to Hollywood in 1939 and directed some of the most memorable thrillers of the 1940s and 1950s.

In the years after *Marnie* (1964), arguably Hitch's last major success, his career waned as audience tastes changed but he remains an uniquely original film auteur – there was only one Hitchcock.

KEY FILMS

The Lodger: A Story of the London Fog (1927)
The 39 Steps (1935)
The Lady Vanishes (1938)
Jamaica Inn (1939)
Rebecca (1940)
Foreign Correspondent (1940)
Suspicion (1941)
Shadow of a Doubt (1943)
Lifeboat (1944)
Spellbound (1945)
Notorious (1946)
Rope (1948)
Strangers on a Train (1951)
Dial M for Murder (1954)
Rear Window (1954)
To Catch a Thief (1955)
Vertigo (1958)
North by Northwest (1959)
Psycho (1960)
The Birds (1963)
Marnie (1964)
Frenzy (1972)

Rear Window (1954) brings several aspects of human nature – voyeurism, suspicion, obsession – into clear light. Photographer 'Jeff' Jefferies (James Stewart, centre), confined to wheelchair after a sporting injury, observes the comings and goings of the neighbors in his apartment block in New York City.

Cared for by his beautiful girlfriend (Grace Kelly, right) and a sardonic nurse (Thelma Ritter), Jeff tries to convince them that one of his neighbors (Raymond Burr, in an early pre-Perry Mason role) has murdered his wife and disposed of her body.

Director Alfred Hitchcock (left) lets the audience see what Stewart sees, and when Jeff is attacked by the murderer, Hitch traps the audience in the terror Jeff feels as he tries to escape the room with his leg in a plaster.

Filmed entirely on a Hollywood sound stage, Hitchcock builds the tension and succeeds in bringing the outside world crashing in on everyone.

28th Academy Awards®

1955

Best Film: *Marty* (United Artists)

Best Director: Delbert Mann, *Marty*

Best Actor: Ernest Borgnine, *Marty*

Best Actress: Anna Magnani, *The Rose Tattoo*

Best Supporting Actor: Jack Lemmon, *Mister Roberts*

Best Supporting Actress: Jo Van Fleet, *East of Eden*

The success of *Marty* (1955) ushered in a new era for Hollywood in the mid-1950s – glamor was out and realism was in. Paddy Chayefsky's story about a shy butcher looking for someone to love had its origins on television, but with Ernest Borgnine (1917–2012) making the role his own on the big screen, and with Delbert Mann directing, the film was an enormous hit in 1955. All three won Oscars® for their work on the film.

Pictured below, Marty (Borgnine, centre) and pal Angie (Joe Mantell) find it hard going talking to local beauties. Borgnine was a versatile actor, adept at drama or comedy, and sadistic heavies or loveable lugs.

Mister Roberts (1955) was brought to the screen after its successful Broadway run, but not without its problems. The story shows the boredom that eats away at the crew of a US cargo ship in the final months of the War.

Henry Fonda had played the title role for eight years on Broadway but was only signed for the film at the insistence of John Ford. Ford was sensationally replaced after 'artistic' conflicts with Fonda and veteran actor James Cagney by Mervyn LeRoy and original stage director Joshua Logan (uncredited).

Although the film struggles to break loose from its theatrical origins at times, the performances of the four leads – Fonda as Mr Roberts, Cagney as the ship's tyrannical commander, William Powell as Doc (his final film appearance) and Jack Lemmon, in his Oscar®-winning role as Ensign Pulver – manage to touch at the very heart of the story in a stunning climax to the film.

Elia Kazan
1909–2003

Elia Kazan was an outsider from the moment he came to America as the four-year old son of Greek immigrants. He worked hard to overcome his poverty-stricken New York upbringing, attending Yale Drama School, graduating as an actor (he later founded the Actor's Studio), working as a stage director and finally becoming a film director.

Many of his films were about outsiders, and after winning Best Director for *A Gentleman's Agreement* (1947), he found the perfect outsider in Marlon 'Bud' Brando.

Of their three collaborations, *On the Waterfront* (1954) earned them both Oscars®, although Brando later dismissed the powerful film as Kazan's rationale for 'naming names' at the anti-communist hearings by the House Committee for Un-American Activities in the early 1950s.

KEY FILMS

A Tree Grows in Brooklyn (1945)
Gentleman's Agreement (1947)
Panic in the Streets (1950)
A Streetcar Named Desire (1951)
Viva Zapata! (1952)
Man on a Tightrope (1953)
On the Waterfront (1954)
East of Eden (1955)
Baby Doll (1956)
A Face in the Crowd (1957)
Splendor in the Grass (1961)
America, America (1963)
The Last Tycoon (1976)

East of Eden (1955), Elia Kazan's film adaptation of the John Steinbeck novel, is high on drama, and it heralded the birth of a new star in James Dean. In his first major screen role, Dean plays angst-ridden Cal Trask who seeks the approval of his overbearing father (Raymond Massey) in World War I era California.

Under Kazan's guidance Dean improvised many of his emotional reactions in the film, which marked him as a young actor of untapped potential. Although the film was released while Dean was still alive, he was dead by the time he received what was Hollywood's first posthumous Oscar® nomination for Best Actor.

James Dean (1931–1955) only starred in three major films – *East of Eden* (1955), *Rebel Without a Cause* (1955) and *Giant* (1956) (for which he received his second posthumous Best Actor nomination) – before dying in a car accident on 30 September 1955.

Pictured with *Rebel Without a Cause* director Nicholas Ray (right), Dean's performance in the film as a troubled teenager (he was aged 24 at the time) alongside Natalie Wood and Sal Mineo (who both would also die tragically young) captured the world's youth audience and turned the actor into a pop culture icon.

Marilyn Monroe
1926–1962

Marilyn Monroe was born Norma Jean Mortenson in Los Angeles, California. A teenage bride who posed nude for a men's calendar to break into 'show business', Norma Jean changed her name, the color of her hair and her troubled past to forge a remarkable film career and become the sex symbol of the 1950s.

Within two years of her breakout role in *The Asphalt Jungle* (1950), Monroe was a fully-fledged star. More than that, Monroe became a cultural icon. With broken marriages to national sporting hero, Joe DiMaggio and later to playwright, Arthur Miller, she traveled the path to self-destruction.

Several miscarriages and an increasing dependency on pills eroded her on-screen confidence and led to her suicide at age 36. Goodbye Norma Jean.

KEY FILMS

The Asphalt Jungle (1950)
All About Eve (1950)
Monkey Business (1952)
Niagara (1953)
Gentlemen Prefer Blondes (1953)
How to Marry a Millionaire (1953)
River of No Return (1954)
There's No Business Like Show Business (1954)
The Seven Year Itch (1955)
Bus Stop (1956)
The Prince and the Showgirl (1957)
Some Like It Hot (1959)
Let's Make Love (1960)
The Misfits (1961)

Gentleman Prefer Blondes (1953) is based on Anita Loos' 1925 novella, which was the basis of a 1928 silent film before being adapted into a Broadway musical in 1949.

Howard Hawks may have seemed a strange choice as the director of a film musical but in Marilyn Monroe (above) and Jane Russell he found the perfect duo to deliver the story of two gold-digging showgirls.

As Lorelie Lee, Monroe looks amazing and her musical highlight 'Diamonds are a Girl's Best Friend' has become a classic, however Russell is just as great in the role of Monroe's foil, the straight-talking Dorothy.

29th Academy Awards®

1956

Best Film: *Around the World in 80 Days* (United Artists)

Best Director: George Stevens, *Giant*

Best Actor: Yul Brynner, *The King and I*

Best Actress: Ingrid Bergman, *Anastasia*

Best Supporting Actor: Anthony Quinn, *Lust for Life*

Best Supporting Actress: Dorothy Malone, *Written on the Wind*

Around the World in 80 Days (1956) valued entertainment above any allusion to artistic merit, but in the hands of producer Mike Todd (who modestly put his name above the title, like Cecil B. DeMille) the movie boasted a star-studded cast, an Oscar®-winning score from Victor Young and the innovative TODDAO widescreen format.

The charm of David Niven (below, second from left), as Phileas Fogg, and Mexican star Cantinflas (as his manservant Passepartout, left) carried the story a long way (only Shirley MacLaine is badly miscast as an Indian princess), but audiences had fun spotting more than 30 celebrity appearances over the course of more than three hours.

The King and I (1956) made Russian-born Yul Brynner (1920–1985) a star overnight in Hollywood, but he had prepared for the role of a lifetime by playing King Mongkut of Siam (now Thailand) in the Rogers and Hammerstein musical more than 4,000 times during the previous five years.

As was so often the case, Broadway star Mary Martin was overlooked for the film role of British governess Anna Leonowens for Debora Kerr (1921–2006), whose singing voice was nevertheless dubbed by Marnie Nixon.

Margaret Langdon's book *Anna and the King of Siam* had been filmed as a non-musical black and white film in 1946 (and again in 1999), but the musical dispensed with the death of Anna's son in a riding accident and focused on the relationship between the King and Anna.

Brynner, who won Best Actor for his role (the film won five awards in all), was playing the part in London in yet another revival thirty years later when he succumbed to cancer, aged 65.

Everything about ***The Ten Commandments*** (1956) is huge – a star cast headed by Charlton Heston (Moses) and Yul Brynner (Rameses II), thousands of extras, incredible special effects and an expansive biblical story. But the undoubted star of the film is its director Cecil B. DeMille, who introduces the epic remake of his 1923 silent film and even plays the role of the voice of God.

At the time the most expensive film made, *The Ten Commandments* was the highest grossing film of 1956 and has earned more than $2 billion dollars in adjusted earnings over the years.

Apparently Heston was cast primarily for his likeliness to Michelangelo's sculpture. Interestingly, Heston later played Michelangelo in *The Agony and the Ecstasy*, 1965). *The Ten Commandments* was DeMille's last film (he died in 1959) and though critics quibbled about its accuracy and 220-minutes running time, the film remains an extraordinary achievement for the time.

George Stevens

1904–1975

George Stevens was a favorite of Hollywood's acting elite in the 1930s and early 1940s because of the considerable care he took with his actors and his films. Having graduated from B-grade movies to prestige films, Stevens directed several Fred Astaire and Ginger Rogers musicals, and excelled directing movies featuring strong women such as Katharine Hepburn and Jean Arthur.

Serving on a film unit during World War II and witnessing the liberation of Dachau concentration camp changed Stevens. His post-war films had a sharper social edge, earning him Best Director awards for *A Place in the Sun* (1951) and *Giant* (1956) either side of his classic western, *Shane* (1953).

The Diary of Anne Frank (1959) was his film that he was most proud of, but the poor response to *The Greatest Story Ever Told* (1965) saw Stevens drift into retirement.

KEY FILMS

Alice Adams (1935)
Annie Oakley (1935)
Swing Time (1936)
Gunga Din (1939)
Penny Serenade (1941)
Woman of the Year (1942)
The Talk of the Town (1942)
The More the Merrier (1943)
I Remember Mama (1948)
A Place in the Sun (1951)
Shane (1953)
Giant (1956)
The Diary of Anne Frank (1959)
The Greatest Story Ever Told (1965)

George Stevens' magnificent 1956 film **Giant** tackles big themes on a huge scale – racism, women's rights, human rights, class systems and the corruptibility of power – played out on a traditional Texas ranch with the coming of 'big oil'. When 'Bick' Benedict (Rock Hudson) brings his eastern wife Leslie (Elizabeth Taylor) home to the family homestead she challenges the status quo by seeking to improve the living conditions of the local Mexican population and refusing to accept her 'place' in genteel Texan society where women stay silently in the background.

Casting a giant shadow over this film, however, is the character of Jett Rink played by James Dean. As the film wrapped in September 1955, 24-year-old Dean was killed in a car accident.

The film did not open for another year, by which time Dean's pop culture stature had grown to mythic proportions. *Giant* proves what a force he would have been as an actor had he lived.

The Searchers
1956

"What do you want me to do? Draw you a picture? Spell it out? Don't ever ask me! Long as you live, don't ever ask me more."

Ethan Edwards (John Wayne)

Out of circulation for the much of the 1960s, except on TV, *The Searchers* was rediscovered by Hollywood's new wave of directors in the 1970s who not only championed it as director John Ford's masterpiece, but promoted the film as being arguably the best western of all time.

Based on screenwriter Alan Le May's novel, *The Searchers* was set in Texas but shot on location in Ford's favorite setting, Monument Valley in Utah. The Technicolor film, shown in all its glory on the VistaVision widescreen format, was a huge success in 1956 but did not even attract a solitary Oscar® nomination – an incredible statistic considering the film showcases one of John Wayne's most complex and layered screen performances.

Ethan Edwards (Wayne) is a conflicted character – a returning hero from the Civil War who never surrendered; a man with a secret past and an unspoken love for his brother's wife; a man who understands the Indians yet can't help but hate them.

When a band of Comanche warriors murder his brother's family and take away his two young nieces, Edwards spends years hunting them down with the help of Martin Pauley (Jeffrey Hunter), a halfbreed adopted member of the family.

With Ford's direction, so much that is revealed is unspoken. In a beautifully framed scene, Ethan kisses his sister-in-law goodbye as the Captain (Ward Bond) looks the other way. Then there is Ethan's famous look back at the captured white women at the fort; his look a mixture of fear and contempt; and lastly, the final scene when Ethan is framed in the doorway as the others go inside and he slowly walks away. Wayne is simply magnificent.

Note the quiver in his voice when Ethan confirms Lucy's death to her beau Brad (Harry Carey Jr) and step-brother Martin. "What do you want me to do, draw a picture?" Wayne rails. "Spell it out? Don't ever ask me! Long as you live, don't ever ask me more."

As played by Wayne, who was not yet 50 when he made this film, Ethan Edwards is a warrior filled with rage and racism. The audience can see the hate in his eyes. Ethan is poetically obsessive – he shoots out the eyes of a partially buried Indian so the warrior's soul has to wander between the winds – a western Ulysses trying to return to a home where he no longer belongs.

Ethan wants to kill his captured niece Debbie (Natalie Wood) because she is now 'impure' and Martin, her step-brother, has to stop him before he does (in the novel, Martin is in love with Debbie and marries her after the rescue, but that would have been too much for 1950s audiences).

Jeffery Hunter (1925–1969) is excellent alongside Wayne. The humor is broad, as with most Ford films, and women are almost non-people (Martin's treatment of his Indian wife, Look, has come in for post-feminist criticism). Wayne's teenage son Patrick plays young Lieutenant Greenhill for comedic relief, but it is Wayne's performance and Ford's stunning vistas that we remember most about *The Searchers*. Both are monuments to a pioneering and cinematic past.

Warner Bros. / C.V. Whitney Pictures: 119 minutes

Produced by: Cornelius Vanderbilt Whitney

Directed by: John Ford

Screenplay by: Frank S. Nugent, based on the novel by Alan Le May

Original Score by: Max Steiner, title song by Stan Jones

Cinematography by: Winton C. Hoch

Starring: John Wayne (Ethan Edwards), Jeffrey Hunter (Martin Pawley), Vera Miles (Laurie Jorgensen), Ward Bond (Rev. Capt. Samuel Johnson Clayton), Natalie Wood (Debbie Edwards), John Qualen (Lars Jorgensen), Olive Carey (Mrs Jorgensen), Henry Brandon (Chief 'Scar'), Ken Curtis (Charlie McCorry), Harry Carey Jr (Brad Jorgensen), Hank Worden (Mose Harper), Dorothy Jordan (Martha Edwards), Pippa Scott (Lucy Edwards), Lana Wood (Debbie)

30th Academy Awards®

1957

Best Film: *The Bridge on the River Kwai* (Columbia)

Best Director: David Lean, *The Bridge on the River Kwai*

Best Actor: Alec Guinness, *The Bridge on the River Kwai*

Best Actress: Joanne Woodward, *The Three Best Faces of Eve*

Best Supporting Actor: Red Buttons, *Sayonara*

Best Supporting Actress: Miyoshi Umeki, *Sayonara*

The Bridge on the River Kwai (1957), David Lean's epic film about personal obsession and the madness of war, won Oscars® for Best Film, Best Director, Best Actor (Alec Guinness), Best Adapted Screenplay, Music Score, Editing and Cinematography. Guinness (below left) gives an extraordinary performance as the British colonel who sees merit in building the titular bridge, before finally coming to his senses, but his character is more than matched by the equally unbreakable Sessue Hayakawa as the commander of the Japanese prison camp.

Blacklisted Carl Foreman and Michael Wilson wrote the Oscar®-winning screenplay adaptation, which was credited to Pierre Boulle, the author of the novel.

David Lean (1909–1991), who embodies everything that was great about the British film industry, famously progressed from tea boy to editor before directing his first film in 1942 (*In Which We Serve*). Three years later, he followed the classic *Brief Encounter* (1945) with faithful adaptations of two Dickens novels, *Great Expectations* (1946) and *Oliver Twist* (1948).

The Bridge on the River Kwai (1957), however, provided the blueprint for personal epics on a massive canvas and brought him and his frequent star Alec Guinness success at the Academy Awards®. William Holden, Jack Hawkins and Geoffrey Horne (pictured above) are the commandos who go into the jungle to blow up the Japanese transport railway on the fictitious River Kwai. Just over a decade after the end of World War II, Holden's cynicism, Hawkins' sense of duty and Horne's reluctance to kill portray differing insights into the war experience.

A David Lean film was always greatly anticipated because they took so long to damn make, and his next film, *Lawrence of Arabia* (1962), arguably the best of the genre, also swept the Oscars®.

Sweet Smell of Success (1957), starring Burt Lancaster and Tony Curtis, shines a not too bright light on the seedy nightlife of the New York's gossip columnists who once fed salacious titbits about the lives and loves of local actors, musicians and politicians to news outlets.

Lancaster, who plays columnist J.J. Hunsecker (a character loosely based on Walter Winchell) was also the producer of the film and gave former teenage heartthrob Tony Curtis his breakout role when he cast him as PR flunky Sidney Falco.

The film was not that successful at the time but is now regarded as one of the most cynical and sardonic portrayals of the media.

Paths of Glory (1957) is an uncompromising anti-war film, totally out of step of the 1950s mainstream – but that is to be expected from a Stanley Kubrick film, even an early one such as this.

Based on Humphrey Cobb's 1935 novel, there were no happy Hollywood endings for this film which boasts one of Kirk Douglas' most balanced performances. Douglas plays Colonel Dax, a French commander in World War I who defends three of his men on charges of cowardice in the face of a suicidal attack on a German trench.

The trial is a farce – the three men randomly chosen to represent all the men who refused to attack are duly executed but not before Colonel Dax delivers a stinging rebuke of his commanding officers.

Shot in Germany for under $1,000,000, *Paths of Glory* barely broke even (the movie was banned in several European countries including France) but it made Kubrick's reputation and led to him later signing on for Douglas' key project, *Spartacus* (1960).

Vertigo (1958) is director Alfred Hitchcock's most highly-regarded film and can be seen to reveal more and more about the famed director's motivations and relationships with his (female) stars with each passing decade.

The psychological thriller is well-crafted. An old school chum employs vertigo-stricken retired directive Scottie Ferguson (James Stewart) to follow the man's beautiful but suicidal wife (Kim Novak). Scottie rescues her from drowning and then falls in love with her. Unable to stop her from throwing herself off a rooftop because of his vertigo, the guilt-ridden detective later meets a young woman who bears an uncanny resemblance to his friend's dead wife. Obsessed with the young woman, he changes her appearance to make her look like his lost love only to realize that he been played for a fool all along.

Vertigo is so well made with disorientating angles and dream-like qualities, that one can easily overlook the story's flaws or the fact that it did only so-so business on its initial release. It's a film you can enjoy just marveling at the mastery of it all.

31st Academy Awards®

1958

Best Film: *Gigi* (MGM)

Best Director: Vincente Minnelli, *Gigi*

Best Actor: David Niven, *Separate Tables*

Best Actress: Susan Hayward, *I Want to Live!*

Best Supporting Actor: Burl Ives, *The Big Country*

Best Supporting Actress: Wendy Hiller, *Separate Tables*

The Lerner and Lowe musical *Gigi* (1958) was the big hit of 1958, winning a then record-breaking nine Oscars® including Best Film and Best Director (Vincent Minnelli).

Based on the 1944 novella by Colette, Alan Jay Lerner also provided the Oscar®-winning screenplay and co-wrote the songs with partner Frederick Lowe (also *Brigadoon*, *Paint Your Wagon*, *My Fair Lady*, *Camelot*).

Gigi also picked up awards for Art Decoration, Costume Design, Editing and Score (André Previn).

Pictured below, Hermione Gingold, Louis Jourdan and Leslie Caron sing 'The Night They Invented Champagne'.

David Niven (1910–1983) won an Oscar® for Best Actor for his role as a fake major in ***Separate Tables*** (1958), a character a world away from the charming raconteur and humble war hero that he actually was. Niven, with menu in hand is pictured with fellow actors (from left to right) Gladys Cooper, Deborah Kerr, Rita Hayworth, Cathleen Nesbitt and Burt Lancaster.

Niven was neither a classically-trained actor nor a fully-fledged movie star but after returning to England in 1939 to serve in World War II (Niven was originally a soldier), he returned to Hollywood in the late 1940s and resumed his career.

Always a serviceable actor, although more of a screen personality, Niven's career received an enormous boost after the success of *Around the World in 80 Days* (1956).

Veteran actress Susan Hayward (1917–1975) won Best Actress for her portrayal of convicted murderess Barbara Graham in ***I Want to Live!*** (1958). Graham went to the gas chamber in 1955, and though this film argues her innocence of the actual crime (Graham wasn't), it makes a compelling case against the use of the death penalty.

Pictured are actors John Marley (left) and Susan Hayward being directed by Robert Wise (far right).

North by Northwest
1959

"I'm an advertising man, not a red herring. I've got a job, a secretary, a mother, two ex-wives and several bartenders that depend upon me, and I don't intend to disappoint them all by getting myself 'slightly' killed."

Roger Thornhill Cary Grant

Only Alfred Hitchcock could make a classic film about a simple case of mistaken identity with an inconsequential premise (the 'MacGuffin', Hitchcock, called it; the object that drives the movie) and a nonsensical title. *North by Northwest* (1959), of course, is not a direction, nor is it a mistake – it's a pun and you'll have to watch the movie to find out what it actually refers to. However, the final result is a film that is a wonderfully suspenseful, beautifully crafted and lavishly photographed 1950s classic.

Hitchcock allegedly started out with a premise of concluding a chase film with a fight on South Dakota's famous Mount Rushmore with its four presidential faces as a backdrop. Throw in an older idea of a man being chased in an open field by a crop duster, and writer Ernest Lehman (a six-time Oscar® nominee) started to piece together his original story of a man wrongly identified as a government agent by foreign spies. Made between two of Hitchcock's most notable and revered films, *Vertigo* (1958) and *Psycho* (1960), *North by Northwest* might just have become the great director's most satisfying and entertaining thriller.

Originally planned as a vehicle for James Stewart, the lead role was given to Cary Grant who brings a lightness and a hapless believability to his role as New York advertising man Roger Thornhill.

Funny and cynical, Grant's goodwill with movie audiences carries the movie a long away. When Thornhill thinks Eve Kendall (Eva Marie Saint) has seduced him on the train to Chicago at the direction of her superiors, he is not aware that she is the real spy.

Grant, who was married five times in real life, even has some fun with the character when he tells Kendall that his first two wives divorced him because he led "too dull a life". It's all wonderfully ironic.

The story starts in modern day New York (there is a great scene at the United Nations building), travels by train to Chicago and concludes at Mount Rushmore. Grant adopts the fake identity of George Kaplan not only to help the US government agents (led by character actor Leo G. Carroll who reprised his role as the head of a spy agency in the 1960s TV series *The Man from U.N.C.L.E.*) to unmask the villains (who are after a microfilm of government secrets), but also to pursue and punish the beautiful double agent Eve Kendall.

North by Northwest successfully taps into the Cold War paranoia of the 1950s – a time of spies and government agents, of the possibility of mistaken identity and the fear of being unmasked as a traitor.

There is an also interesting sexual undertone to the film, not only between the characters played by Grant and Saint, but also with arch villain Phillip Vandamm (James Mason) and his henchman Leonard (Martin Landau).

In true Hitchcock style, the film's final shot can be viewed as a phallic representation – the train in which Thornhill and Kendall travel in towards their future enters a tunnel.

Only Hitchcock could get away with something so obvious!

MGM: 136 minutes

Produced and Directed by: Alfred Hitchcock

Screenplay by: Ernest Lehman

Music by: Bernard Herrmann

Cinematography by: Robert Burks

Starring: Cary Grant (Roger Thornhill), Eva Marie Saint (Eve Kendall), James Mason (Phillip Vandamm), Jessie Royce Landis (Clara Thornhill), Leo G. Carroll (The Professor), Josephine Hutchinson (Mrs Townsend), Philip Ober (Lester Townsend), Martin Landau (Leonard), Adam Williams (Valerian), Edward Platt (Victor Larrabee).

32nd Academy Awards®

1959

Best Film: *Ben-Hur* (MGM)

Best Director: William Wyler, *Ben-Hur*

Best Actor: Charlton Heston, *Ben-Hur*

Best Actress: Simone Signoret, *Room at the Top*

Best Supporting Actor: Hugh Griffith, *Ben-Hur*

Best Supporting Actress: Shelley Winters, *The Diary of Anne Frank*

'Bigger than Ben-Hur' became a Hollywood idiom after William Wyler's biblical epic *Ben-Hur* (1959) swept the Academy Awards®. The biblical epic which was filmed on location in Rome won a record 11 Oscars® including Best Film, Best Director, Best Actor (Charlton Heston, below) and Best Supporting Actor (Hugh Griffiths), as well as for Cinematography, Art Direction – Set Decoration, Costume Design, Special Effects, Editing, Music and Sound.

The second major adaptation of Lew Wallace's epic tale of the Christ (following the 1925 silent classic), William Wyler delivered a 212-minute masterpiece that went on to become the second-highest grossing film at the time behind *Gone With the Wind* (1939).

William Wyler
1902–1981

William Wyler (far right) coaxed more Oscar®-winning performances out of his stars than any other director and garnered a record 12 directing nominations.

In Wyler's capable hands, a well-written script and a talented cast resulted in classic films across a number of genres.

Born in the Alsace region of Germany (now France), Wyler came to America in the 1920s and went on to win three Best Director Oscars®, starting with *Mrs Miniver* (1942). As his career flourished, he developed a recognizable style which kept actors in check while so much action happening on screen.

After service in World War II, Wyler's films took on a depth of emotion balanced by the drama, no more so than in the 'coming home' film *The Best Years of Our Lives* (1946) and the epic *Ben-Hur* (1959).

KEY FILMS

Dodsworth (1936)
Come and Get It (1936)
Dead End (1937)
Jezabel (1938)
Wuthering Heights (1939)
The Westerner (1940)
The Letter (1940)
The Little Foxes (1941)
Mrs. Miniver (1942)
The Best Years of Our Lives (1946)
The Heiress (1949)
Detective Story (1951)
Roman Holiday (1953)
The Desperate Hours (1955)
Friendly Persuasion (1956)
The Big Country (1958)
Ben-Hur (1959)
The Children's Hour (1961)
The Collector (1965)
Funny Girl (1968)

John Wayne
1907–1979

John Wayne was a cinematic construct who came to embody everything that was idealized in America. Born Marion Robert Morrison, Wayne was on a football scholarship at the University of Southern California when he started working parttime in the local film industry. His breakout role in *The Big Trail* (1930) was a bust, and it was not until the end of the decade, when director John Ford cast him in *Stagecoach* (1939), that Wayne became a star. Ford would be Wayne's lucky totem during his career, the pair working on 14 films together. By the 1960s Wayne was an American icon. Even his right-wing politics could not diminish his popularity in a changing world. Hollywood gave him a Best Actor Oscar® for *True Grit* (1969), but he earned it. Wayne was larger than life.

KEY FILMS

Stagecoach (1939)
Reap the Wild Wind (1942)
They Were Expendable (1945)
Red River (1948)
Fort Apache (1948)
3 Godfathers (1948)
She Wore a Yellow Ribbon (1949)
Sands of Iwo Jima (1949)
Rio Grande (1950)
The Quiet Man (1952)
The Searchers (1956)
The Wings of Eagles (1957)
Legend of the Lost (1957)
Rio Bravo (1959)
The Alamo (1960)
The Comancheros (1961)
The Man Who Shot Liberty Valance (1962)
Hatari! (1962)
McLintock! (1963)
The Sons of Katie Elder (1965)
El Dorado (1966)
True Grit (1969)
The Cowboys (1972)
The Shootist (1976)

Rio Bravo (1959) was Henry Hathaway's and John Wayne's answer to *High Noon* (1952), which they both regarded as an un-American depiction of society.

In *Rio Bravo*, faced with insurmountable odds, a drunken deputy sheriff (Dean Martin), a young gunslinger (Ricky Nelson), an old man (Walter Brennan), and a visiting Texan sheriff (John Wayne) band together to defeat a gang intent on breaking one of their group out of the local jail.

Three years after he split from comedic partner Jerry Lewis (1926–2017), Dean Martin (1917–1995) staked his dramatic screen credentials in this film. Martin and Nelson even share a song, and with Angie Dickinson playing Wayne's love interest, *Rio Bravo* proved extremely popular with audiences.

It was so popular that Hawks and Wayne mined the same material in *El Dorado* (1966) with Robert Mitchum, James Caan and Arthur Hunnicutt, then less successfully in *Rio Lobo* (1970) with Jorge Rivero, Chris Mitchum and Jack Elam.

When the novel *Anne Frank: The Diary of a Young Girl* was published in English in 1952, it became an immediate classic.

The diary of a young Jewess who hides in the small annex of a Dutch building with her family and four neighbors during World War II was turned into a Broadway play and then filmed in 1959. Directed by George Stevens, ***The Diary of Anne Frank*** (1959) recreates the drama of the ten people living in a small space as seen through the eyes of the teenage girl (Millie Perkins).

Shelley Winters won the first of two Best Supporting Actress awards for her role as Mrs Van Daan, while veteran actors Joseph Schildkraut, Ed Wynn and Lou Jacobi all excel. Schildkraut had won Best Supporting Actor for the *The Life of Emile Zola* (1937).

The betrayal of the family and discovery – not shown by Stevens but alluded to by the scurrying of soldiers coming through the annexe's secret door – is made all the more poignant in knowing that Ms Frank perished from typhus along with her sister and mother in Bergen-Belsen concentration camp in 1945. She was just 15. Her diary was published posthumously by her father Otto Frank.

Anatomy of a Murder (1959) is one of Hollywood's more realistic courtroom dramas and more than fills its 160 minutes with great character studies, turns and twists. With an Emmy Award winning jazz score by Duke Ellington and Bill Strayhorn, and stark black and white direction by Otto Preminger, James Stewart and George C. Scott square off in court after a soldier (Ben Gazzara) is accused of shooting a barman who allegedly had raped the soldier's promiscuous wife (Lee Remick). Based on the book by Robert Traver (a pseudonym of former Michigan Supreme Court Justice John Voelker), the language surrounding the rape was considered explicit for the time.

The relationship between Stewart's small town lawyer and his alcoholic assistant Arthur O'Connell is wonderful, but the fact that the role of the judge is played by real-life lawyer Joseph Welch, who represented the Army in the McCarthy hearings (House Committee of Un-American Activities) in the early 1950s, adds a further dimension to this engrossing film.

Billy Wilder

1906–2002

Billy Wilder was born in Austro-Hungary (now Poland) in 1906 and immigrated to America after establishing his directing career in Berlin. The rise of Nazism in the early 1930s, however, made it impossible for Wilder (who was Jewish) to remain there.

In Hollywood, Wilder proved to be a cynical, often comical, observer of American life and by the 1950s he was writing, directing and producing his own films.

Wilder's output during the decade was phenomenal, culminating in *Some Like it Hot* (1959). He followed up with the Academy Award winning *The Apartment* (1960).

Wilder's wry wit, tight scripts and keen social eye sustained him during the next decade and he was still making interesting films in the 1970s.

KEY FILMS

The Major and the Minor (1942)
Double Indemnity (1944)
The Lost Weekend (1945)
Sunset Boulevard (1950)
Ace in the Hole (1951)
Stalag 17 (1953)
Sabrina (1954)
The Seven Year Itch (1955)
Love in the Afternoon (1957)
Witness for the Prosecution (1957)
Some Like It Hot (1959)
The Apartment (1960)
One, Two, Three (1961)
Irma la Douce (1963)
The Fortune Cookie (1966)
The Private Life of Sherlock Holmes (1970)
Avanti! (1972)
The Front Page (1974)
Fedora (1978)

Some Like It Hot (1959) is regarded at the greatest comedy ever made according to the American Film Institute (AFI) in 2000.

Some Like It Hot finds all the key players – producer-writer-director Billy Wilder, co-writer I.A.L. Diamond, star Marilyn Monroe and 'male leads' Tony Curtis and Jack Lemmon – at the absolute top of their form. The story of two Prohibition-era musicians who hide out from gangsters by dressing in drag and touring with an all-woman band is a wonderful comedic premise to start with. When several complications are added – when Curtis' character falls in love with the lead singer Sugar Kane (Monroe) and Daphne (Lemmon) attracts the unwanted attention of an eccentric millionaire (Joe. E. Brown), the plot really gets going.

There are lots of gangster gags, and a clever in-joke when Curtis masquerades as an impotent millionaire with an accent not unlike Cary Grant's (Grant was Curtis' boyhood hero) in order to impress Sugar, but the secret to the film's ever-lasting appeal is in the rhythm of the writing which spits out line after line of great dialogue in a meticulous example of comedic timing.

Some Like It Hot won an Academy Award for Best Costume Design (Black and White) for Orry-Kelly and rightly so. The costumes, like the film, were stunning.

The 1960s

The sensational Sixties found American films in decline and foreign films making their presence felt around the world. The British were coming – kitchen sink dramas, period films and a spy called Bond caught the imagination of the public. After the success of *Lawrence of Arabia* (1962), and the failure of *Cleopatra* (1963), Hollywood lost its fascination with the epic and the western genre was outsourced to Europe.

Four musicals won the Best Picture Oscar® that decade, *West Side Story* (1961), *My Fair Lady* (1964), *The Sound of Music* (1965), and *Oliver!* (1968) but the popularity of musicals was also coming to an end. Hollywood movies started to reflect the mood of the time – isolation, violence and mayhem as featured in *Bonnie and Clyde* (1967), *Cool Hand Luke* (1967), *The Graduate* (1967), *Rosemary's Baby* (1968) and *The Wild Bunch* (1969).

Perhaps director Stanley Kubrick best captured the era with *Dr Strangelove* (1964) and *2001: A Space Odyssey* (1968). There were new faces on the scene too – Paul Newman, Steve McQueen, Sidney Poitier and Dustin Hoffman – but it was the legendary John Wayne who finished the decade on top with a belated Oscar®. The 1960s concluded with *Easy Rider* (1969), one of the most profitable independent films in history, and the success of X-rated *Midnight Cowboy* (1969). What a decade!

Omar Sharif and Peter O'Toole in *Lawrence of Arabia* (1962).

33rd Academy Awards®
1960

Best Film: *The Apartment* (Mirisch / United Artists)

Best Director: Billy Wilder, *The Apartment*

Best Actor: Burt Lancaster, *Elmer Gantry*

Best Actress: Elizabeth Taylor, *Butterfield 8*

Best Supporting Actor: Peter Ustinov, *Spartacus*

Best Supporting Actress: Shirley Jones, *Elmer Gantry*

Billy Wilder's *The Apartment* (1960) stars Jack Lemmon and Shirley MacLaine (pictured below) as New York loners trying to find love in the fast-paced and duplicitous corporate world.

The title refers to the apartment Bud Baxter (Lemmon) lends out to his work colleagues and superiors to use for office dalliances. However, he falls in love with the mistress (MacLaine) of his weasel of a boss (Fred MacMurray).

The Apartment won Oscars® for Best Film, Best Director, Original Screenplay, Editing and Art Direction–Set Decoration (Black and White), with Billy Wilder taking home three statuettes as producer, director and co-writer (the latter with I.A.L. Diamond).

Spartacus (1960) boasts an all-star cast in the epic tale of the famed gladiator who took on the might of Rome. Directed by Stanley Kubrick, after original director Anthony Mann (*El Cid*, 1961) was sacked by producer Kirk Douglas, the film's literate script from blacklisted writer Dalton Trumbo ensured Spartacus succeeded as both epic spectacle and personal drama.

A key scene that combines these two themes is the wonderfully staged battle to the death between Spartacus (Kirk Douglas) and the slave Draba (Woody Strode) at the gladiator school that ultimately leads to rebellion. Peter Ustinov won Best Supporting Actor for his role as an opportunistic slave master, outshining the other acting heavyweights in the cast with the possible exception of Laughton, who died the following year.

Pictured above from left to right in this rare production shot are Charles Laughton as Gracchus, John Dall as Marcus Glabrus, Nina Foch as Helena Glabrus, Peter Ustinov as Batiatus, Laurence Olivier as Crassus, Jean Simmons as Varinia, Kirk Douglas as Spartacus and Tony Curtis as Antoninus.

The Magnificent Seven (1960), a remake of Akira Kurosawa's *Seven Samurai* (1954) set in America's wild west, did not do great business in the US but was an enormous hit in Europe. The film made stars of Steve McQueen, Charles Bronson and James Coburn who reunited with director John Sturges in *The Great Escape* three years later.

The Magnificent Seven (pictured above, from left) were Yul Brynner as Chris Adams, Steve McQueen as Vin, Horst Buchholz as Chico, Charles Bronson as Bernardo O'Reilly, Robert Vaughn as Lee, Brad Dexter as Harry Luck, and James Coburn as Britt. Three sequels followed, although only Brynner reprised his role in the sequel, *Return of the Seven* (1966).

Alfred Hitchcock's ***Psycho*** (1960) is rightly regarded as a horror classic. So entrenched in film culture is Hitchcock's adaptation of the Robert Bloch novel that it even became the basis of another film, *Hitchcock* (2012) which is a behind-the-scenes account of making the original film, as well as a superfluous shot-for-shot remake by Gus van Sant (1998).

From the moment Hitch kills off the central character a third of the way through the film, the audience is thrown off track about who the real killer is. Martin Balsam is great as a snoopy detective, but it is Anthony Perkins who makes the strongest impression as the troubled Norman Bates. Hitchcock traded on Leigh's star quality and the 'boy next door' ordinariness of Perkins to create a gothic thriller. Once again, it appears Hitchcock had enormous fun in terrorizing audiences out of their wits.

34th Academy Awards®

1961

Best Film: *West Side Story* (Mirisch / Seven Arts)

Best Director: Jerome Robbins and Robert Wise, *West Side Story*

Best Actor: Maximilian Schell, *Judgment at Nuremberg*

Best Actress: Sophia Loren, *Two Women*

Best Supporting Actor: George Chakiris, *West Side Story*

Best Supporting Actress: Rita Moreno, *West Side Story*

West Side Story (1961) is a modern day take on Shakespeare's *Romeo and Juliet* set on the streets of New York. Starring Natalie Wood and Richard Beymer as the doomed lovers (their voices were dubbed for the musical numbers), the American gang, The Jets, face off against the Puerto Rican gang, the Sharks, and fight to the death in a showcase of innovative dancing.

The film won a record ten Oscars® for a musical: Best Picture, Best Director, Best Supporting Actor and Supporting Actress; Best Art Direction – Set Decoration, Cinematography, Costume Design, Film Editing, Music Score and Sound; plus an award for 'Brilliant Achievements in the Art of Choreography on Film' for co-director Jerome Robbins.

The Misfits (1961), written by master playwright Arthur Miller (*The Crucible, Death of a Salesman*) for his then wife Marilyn Monroe, was directed by John Huston.

It proved to be Monroe's last finished film as well as the last for veteran actor Clark Gable, who died of a heart attack before the film was released. Montgomery Clift, Thelma Ritter and Eli Wallach complete the excellent cast.

Shot in Nevada, *The Misfits* tells the story of world-weary lovers (Monroe and Gable, pictured with Monty Clift in headband) who come to realize that they belong together because, like the wild horses they seek to capture, they too cannot be tamed.

Few courtroom dramas carry the weight of history and dramatic emotion as well as ***Judgment at Nuremberg*** (1961). This movie began life as a TV drama written by Abby Mann, who later expanded it for the screen under the direction of Stanley Kramer, for which he won Best Adapted Screenplay.

Rather than focusing on Nuremberg war criminals, Mann's script follows the prosecution of four German judges who turned a blind eye to justice in order to serve the Nazi State. Starring Spencer Tracy as Chief Judge Dan Haywood, Burt Lancaster as Ernst Janning, Richard Widmark as Col. Tad Lawson, Maximilian Schell as Hans Rolfe, Marlene Dietrich as Frau Bertholt, a very young pre-*Star Trek* William Shatner, and Montgomery Clift and Judy Garland in Oscar®-nominated supporting roles as victims of Nazi justice, this all-star cast was one of the rare times when so many great actors enhanced an already brilliant script.

31-year-old Maximilian Schell (1930–2014) won Best Actor, but it's hard to go past the performances of Widmark, as the prosecution lawyer refusing to bend to the will of his superiors, Lancaster as the German intellectual wrestling with his conscience, and Tracy as the small-town judge called to Nuremberg to make sense of it all. Watch Tracy's 'value of a single human being' speech – it still resonates today.

Paul Newman

1925–2008

Paul Newman started out in the mid–1950s with a hybrid acting style of Marlon Brando and James Dean, but quickly rid himself of the quirky mannerisms and relied more on his undeniable good looks and film instincts.

His early films, especially *The Hustler* (1961) and *Hud* (1963) explored his moral and sexual vulnerability. Although he never really mastered comedy, Newman found his true persona as a 1960s anti-hero – a Bogart for a new age.

Newman tried directing, worked with wife Joanne Woodward and formed his own production company as he struggled to remain relevant in a changing industry in the late 1970s and early 1980s.

A political activist, car racing enthusiast and philanthropist, he continued to deliver fine, measured performances right up to his death, aged 83.

KEY FILMS

Somebody Up There Likes Me (1956)
The Long, Hot Summer (1957)
The Left Handed Gun (1957)
Cat on a Hot Tin Roof (1958)
The Hustler (1961)
Sweet Bird of Youth (1962)
Hud (1963)
Harper (1966)
Hombre (1967)
Cool Hand Luke (1967)
Winning (1969)
Butch Cassidy and the Sundance Kid (1969)
The Life and Times of Judge Roy Bean (1972)
The Sting (1973)
The Towering Inferno (1974)
Slap Shot (1977)
Absence of Malice (1981)
The Verdict (1982)
The Color of Money (1986)
Nobody's Fool (1994)
Road to Perdition (2002)

Robert Rossen's ***The Hustler*** (1961) marks Paul Newman's move from promising young actor to serious Hollywood player. As 'Fast Eddie' Felson, Newman portrays the moral ambiguity of a hustling pool player who more than meets his match in rival, Minnesota Fats' (Jackie Gleason in a wonderful character role).

Newman was nominated for Best Actor for his role. Gleeson and George C. Scott (as gambler Bert Gordon) were nominated for Best Support Actor and Piper Laurie (Newman's love interest, Sarah) for Best Supporting Actress.

Newman would have to wait 25 years for an Oscar® which he won for the role of the hustler in Martin Scorsese's *The Color of Money* (1986), reprising his role of Fast Eddie.

35th Academy Awards®
1962

Best Film: *Lawrence of Arabia* (Columbia)

Best Director: David Lean, *Lawrence of Arabia*

Best Actor: Gregory Peck, *To Kill a Mockingbird*

Best Actress: Anne Bancroft, *The Miracle Worker*

Best Supporting Actor: Ed Begley, *Sweet Bird of Youth*

Best Supporting Actress: Patty Duke, *The Miracle Worker*

Lawrence of Arabia (1962) won Oscars® for Best Film, Best Director, Art Direction, Cinematography, Music Score, Sound and Editing. David Lean's faithful, almost obsessive dramatization of the life of English military hero T.E. Lawrence (1888–1935) made stars of Irish actor Peter O'Toole (1932–2013) and Egyptian-born Omar Sharif (1932–2015).

The film also stars Alec Guinness (miscast as King Faisal, a small quibble), Arthur Kennedy, Jose Ferrer, Claude Rains, Jack Hawkins, Anthony Quayle (the trio pictured below with O'Toole as Lawrence) and Anthony Quinn, in the key role of Auda abu Tayi.

The Miracle Worker (1962) is Arthur Penn's Oscar®-winning film based on William Gibson's 1959 play about the relationship between teacher Anne Sullivan and Helen Keller (1880–1968), who was left blind, deaf and mute after contracting an unspecified illness as a child. Patty Duke (as Keller) and Anne Bancroft (Sullivan) had both played the roles on the Broadway stage and were retained for the film version.

Bancroft (1931–2005), who had made a number of undistinguished films during the 1950s, won the Best Actress award for her performance, as did Best Supporting Actress, 16-year old Patty Duke (1946–2016). Duke was the youngest Oscar-winner® at that time (later bettered by 10-year-old Tatum O'Neal in 1974) and later starred in her own TV show during the 1960s.

To Kill a Mockingbird
1962

"You never really understand a person until you consider things from his point of view... Until you climb inside of his skin and walk around in it."

Atticus Finch (Gregory Peck)

It's not often that Hollywood can take a publishing phenomenon, let alone a much-loved book like *To Kill a Mockingbird*, and make a classic film from it. Sure, there was *Gone With the Wind*, but Harper Lee's book has none of the sweep of Margaret Mitchell's Civil War potboiler and Lee's book covered much more emotional territory.

A young black man is charged with the rape of a poor white woman. Atticus Finch, a small-town lawyer and the sole parent of two young children, is asked to defend him. A literate script by Horton Foote keeps much of Lee's prose by having Atticus' daughter, Scout, narrate the film as an adult (spoken by Kim Stanley).

Filmed in black and white on Universal's backlot, which had been evocatively dressed with condemned dwellings from a Depression-era town, the fictional Southern town of Maycomb comes to life. The 1960 book published at the height of the civil rights movement in America, gave the film that quickly followed in 1962 an historical and social context that heightened the drama.

The major element working in the film's favor is the casting with Mary Badham (Scout), Phillip Alford (Jem) and John Megna (Dill Harris). The Harris character is based on Harper Lee's cousin, author Truman Capote as a child.

The film beautifully illustrates a child's world played out against a backdrop of adult racial tension and injustice. The children's fears and misunderstandings, their hurts and little triumphs, their disappointment after the trial – made all the worse by the accused, Tom Robinson's (Brock Peters) death while trying to escape – is wonderfully realized by director Robert Mulligan. At the end of the film, the emergence of neighbor Boo Radley, played by future Oscar®-winner Robert Duvall, is an epiphany to us all. The person the children most feared becomes their savior.

At the core of the film, however, is the Oscar®-winning performance by Gregory Peck. Atticus Finch gave Peck the opportunity to play perhaps his greatest role on film – himself. Harper Lee has said that Peck was the perfect actor for the role, which was based on her lawyer father. Peck gives one of the greatest performances on film, oozing the integrity that we all wished we possessed. When the black pastor tells Scout and her brother to stand to attention when her father Atticus leaves the courtroom, we all want to stand.

As good as Peck is, the scene when the Prosecutor (William Windom) exposes Tom Robinson's real crime is riveting. Tom, a poor black sharecropper with only one good arm, admits he felt sorry for the plight of a young white woman. The look at Atticus' face when he realizes the case is lost right there and then, is shattering.

Only evil Bob Ewell (James Anderson) comes close to caricature, but the explosive performance by Collin Wilcox as his daughter Mayella Violet Ewell on the witness stand still packs a jolt.

Brock Peters as the doomed defendant is equally impressive, and it's heartening to note that the cast remained lifelong friends until the deaths of the adult players and the younger children had grown to adulthood. That all film experiences should have such a lifelong influence on us all.

Universal / Pakula-Mulligan Brentwood Productions: 129 minutes

Produced by: Alan J. Pakula

Directed by: Robert Mulligan

Screenplay by: Horton Foote, based on the novel by Harper Lee

Music by: Elmer Bernstein

Cinematography by: Russell Harlan, A.S.C.

Starring: Gregory Peck (Atticus Finch), Mary Badham (Scout), Phillip Alford (Jem), John Megna ('Dill' Harris), Frank Overton (Sheriff Heck Tate), Rosemary Murphy (Miss Maudie), Brock Peters (Tom Robinson), Estelle Evans (Calpurnia), Paul Fix (Judge Taylor), Collin Wilcox (Mayella Violet Ewell), James Anderson (Bob Ewell), Alice Ghostley (Aunt Stephanie), Robert Duvall (Arthur 'Boo' Radley), William Windom (District Attorney). Narrated by Kim Stanley.

A measure of the power of the McCarthy era (House Committee on Un-American Activities) on American politics is that it could produce such a brilliantly paranoid film as *The Manchurian Candidate* (1962). Based on Richard Condon's 1959 novel, John Frankenheimer made the film in an economical 39 days and elicited arguably Frank Sinatra's finest screen performance of his career.

From its opening scenes showing American soldiers (pictured above left to right: Frank Sinatra, Laurence Harvey and Tom Lowell) captured during the Korean War and brainwashed by their communist captors, *The Manchurian Candidate* is a cleverly structured and provocatively written political thriller.

Brilliantly staged and photographed by director John Frankenheimer, with the soldiers believing they are at a flower show, the success of this scene establishes the premise that one of the group, Raymond Shaw (Laurence Harvey), has been programmed as a political assassin.

While top billing was given to Janet Leigh playing Eugenie Rose Cheyney, Angela Lansbury was nominated for Best Supporting Actress for her performance as Shaw's malevolent mother (Lansbury was only 37 years old at the time, just three years older than Lawrence Harvey who played her son, Raymond).

The Man Who Shot Liberty Valance (1962) exposes the penchant for myth-making when it comes to the American west yet this film doesn't gloss over the arbitrary violence of frontier life. Director John Ford abandoned Monument Valley and VistaVision to make the film on the Paramount backlot in black and white and delivered one of his most thoughtful and reflective movies.

Idealist lawyer Ranse Stoddard (James Stewart) tries to change the 'Wild West' with a law book, which brings him into conflict with hired gun Liberty Valance (Lee Marvin). Tom Doniphon (John Wayne) steps in to save Stoddard and loses his girl Hallie (Vera Miles) to the 'pilgrim' lawyer.

Although Stewart was patently too old for the role, it is wonderful to see him match wits with Wayne – pictured here with Strother Martin and Lee Van Cleef (left) who play Valance's henchmen. Wayne, as always, is superb. As Valance, Marvin creates one of the most repulsively charismatic killers on screen, and his death in the street is as beautifully staged as any ballet.

The Longest Day (1962) was producer Darryl F. Zanuck's last hurrah in Hollywood but he did the impossible and made a great war film out of what could easily have been a bunch of cameo appearances.

Based on Cornelius Ryan's 1959 book about World War II's Normandy invasion, the film features 42 international stars including John Wayne, Kenneth More, Richard Todd, Robert Mitchum, Richard Burton, Sean Connery, Henry Fonda, Red Buttons, Peter Lawford, Eddie Albert, Jeffrey Hunter, Stuart Whitman, Rod Steiger, Sal Mineo, Gert Fröbe, Curt Jürgens, Robert Wagner and Paul Anka.

The film succeeds in showing the heroic sacrifice on D-Day, as well as putting a personal face on many of the events of that day, and was credited to three directors – Ken Annakin (British and French sequences), Andrew Marton (American) and Bernhard Wicki (German).

36th Academy Awards®

1963

Best Film: *Tom Jones* (United Artists)

Best Director: Tony Richardson, *Tom Jones*

Best Actor: Sidney Poitier, *Lilies of the Field*

Best Actress: Patricia Neal, *Hud*

Best Supporting Actor: Melvyn Douglas, *Hud*

Best Supporting Actress: Margaret Rutherford, *The V.I.P.s*

The period comedy ***Tom Jones*** (1963) was a surprise winner for Best Film in 1963, but it was a sign of the times. The British were coming and the 'Swinging Sixties' were officially underway.

The film starring Albert Finney and Susannah York (shown below), won for Best Director, Original Score and Adapted Screenplay (by playwright John Osborne).

Albert Finney (b. 1936), pictured left, came to prominence in British 'kitchen sink' dramas earlier in the decade, *The Entertainer* and *Saturday Night and Sunday Morning*, both 1960) before receiving the first of his five career Oscar® nominations for *Tom Jones*.

A 'modern' western about broken dreams and unrealized potential, **Hud** (1963), based on Larry McMurtry's novel *Horseman, Pass By*, shows that heartthrob actor Paul Newman (right with Patricia Neal) wasn't so image conscious that he wouldn't play a cad lacking a soul.

It was Melvyn Douglas (above left) and Patricia Neal (above right), however, who took home Oscars® for their roles in the film. Also pictured (above centre) is Brandon deWilde (1942–1972), who played the little boy in *Shane* (1953), "all growed up" a decade later. Sadly, he was not to live more than nine years more in his short life.

Steve McQueen
1930–1980

Steve McQueen stepped out of 1950s' TV into the gap left by the death of James Dean – the troubled loner, the rugged individualist, the doomed hero.

McQueen excelled in action films, and his scene-stealing performance in *The Magnificent Seven* (1960) made him a bankable star in his own right.

Always selective of his films, McQueen was a standout in *The Great Escape* (1963) which cemented his on-screen persona as the 'King of Cool.'

By the early 1970s, however, the uncompromising actor had burnt through many of his relationships in Hollywood and when he took several years off to spend time with his second wife, Ali McGraw, it effectively stopped his career in its tracks.

He came back at the end of the decade only to succumb to cancer, aged 50.

KEY FILMS

The Blob (1958)
Never So Few (1959)
The Magnificent Seven (1960)
Hell Is for Heroes (1962)
The Great Escape (1963)
Love with the Proper Stranger (1963)
The Cincinnati Kid (1965)
Nevada Smith (1966)
The Sand Pebbles (1966)
The Thomas Crown Affair (1968)
Bullitt (1968)
Le Mans (1971)
On Any Sunday (1971)
Junior Bonner (1972)
The Getaway (1972)
Papillon (1973)
The Towering Inferno (1974)
Tom Horn (1980)
The Hunter (1980)

The Great Escape (1963) was based on Paul Brickhill's 1950 novel about the mass escape of allied POWs from Stalag Luft III in Poland in 1944. The prison was also the scene of an earlier escape, which was portrayed in the 1950 film, *The Trojan Horse,* but this is superior popcorn fare from director John Sturgess.

With an all-star cast including Steve McQueen as Hilts ('The Cooler King'), James Garner as Hendley ('The Scrounger'), Richard Attenborough as Bartlett ('Big X'), James Donald as Ramsey ('The SBO'), Charles Bronson as Danny ('Tunnel King'), Donald Pleasence as Blythe ('The Forger'), James Coburn as Sedgwick ('Manufacturer'), David McCallum as Ashley-Pitt ('Dispersal') and Gordon Jackson as MacDonald ('Intelligence'), the film works on every level – war drama, escape thriller and mass entertainment.

McQueen rides away with the film (literally, on a Triumph TR6, no less), and while James Coburn's Australian accent is a crock, the film is tremendous fun right up to the execution of 50 of the 76 escapees. Then, all of a sudden, the story becomes very real.

37th Academy Awards®

1964

Best Film: *My Fair Lady* (Warner Bros.)

Best Director: George Cukor, *My Fair Lady*

Best Actor: Rex Harrison, *My Fair Lady*

Best Actress: Julie Andrews, *Mary Poppins*

Best Supporting Actor: Peter Ustinov, *Topkapi*

Best Supporting Actress: Lila Kedrova, *Zorba the Greek*

Jack Warner's film version of the Frederick Loewe and Alan Jay Lerner musical *My Fair Lady* (1964) won eight Oscars®, for Best Film, Best Director, Best Actor (Rex Harrison, left), Best Director (for veteran George Cukor), Cinematography, Music Score, Sound and Costume Design.

Audrey Hepburn, however, in the title role of Eliza Doolittle did not get a nomination. Best Actress that year went to Julie Andrews for Disney's *Mary Poppins*, the irony being that Andrews had played the role of Eliza Doolittle in the Broadway version of My Fair Lady, only to lose it to the ever-elegant Hepburn, whose singing voice was dubbed by Marnie Nixon.

Mary Poppins was nominated for 13 Academy Awards®, eventually winning five including Best Actress (Julie Andrews, above), Best Editing, Visual Effects, Score and Song, 'Chim Chim Cher-ee' by songwriter brothers Richard and Robert Sherman.

Walt Disney's grand mixture of live action drama, animated sequences and musical sequences brings P.L. Travers' eccentric English nanny to life with great doses of sugar "to make the medicine go down".

Audiences embraced Disney's vision, even if the original author never did. Travers' battle with studio head Walt Disney was portrayed in the 2013 film, *Saving Mr Banks*, starring Oscar® winners Emma Thompson and Tom Hanks.

Stanley Kubrick

1928–1999

Stanley Kubrick was a technically brilliant but infuriatingly obsessive director who turned his back on Hollywood in order to completely control his projects.

Following the critical success of *Paths of Glory* (1957), Kirk Douglas brought Kubrick on board as a replacement for director Anthony Mann for his production of *Spartacus* (1960). Unhappy with studio interference in the film, Kubrick relocated to England and tackled more controversial fare such as Nabokov's *Lolita* (1962), the dark comedy *Dr. Strangelove* (1964) and the sci-fi classic *2001: A Space Odyssey* (1968).

Only someone with Kubrick's bravado would attempt film adaptations of *A Clockwork Orange* (1971), *Barry Lyndon* (1975) and *The Shining* (1980), but the 12 years between his final two films left the veteran director sadly out of touch with audiences and critics.

KEY FILMS

Killer's Kiss (1955)
The Killing (1956)
Paths of Glory (1957)
Spartacus (1960)
Lolita (1962)
Dr. Strangelove or: How I Learned to Stop Worrying and Love the Bomb (1964)
2001: A Space Odyssey (1968)
A Clockwork Orange (1971)
Barry Lyndon (1975)
The Shining (1980)
Full Metal Jacket (1987)
Eyes Wide Shut (1999)

Fail Safe and ***Dr. Strangelove or: How I Learned to Stop Worrying and Love the Bomb*** were both released in 1964 by Columbia Studios and had eerily similar story lines.

The Cold War political thriller *Fail Safe*, based on the 1962 novel of the same name, has the US President (Henry Fonda, above) grappling with the decision whether to drop an atomic bomb on New York City after Moscow has been leveled after an unprovoked, but accidental, attack by US bombers.

Dr Strangelove, loosely based on a novel called *Red Alert*, was turned into a black comedy by director Stanley Kubrick and writer Terry Southern. Phallic symbols abound.

When both films were being made the team behind *Dr Strangelove* sued the producers of *Fail Safe* (which included director Sidney Lumet), and a court settlement resulted in the latter film being bought by Columbia so it could better manage the release dates. *Dr Strangelove* became an immediate classic, largely thanks to Peter Sellers' performance in three different roles (the US President, Group Captain Mandrake and Dr Strangelove).

Fail Safe is just a good a film which has continued to grow in stature over the years. The actor George Clooney believes so too. He turned the drama into a live TV broadcast in 2000, heightening the tension of the piece, if that was at all possible.

A Hard Day's Night
1964

"We've broken out! Ah, the blessed freedom of it all! Have you got a nail file, these handcuffs are killin' me! I was framed, I'm innocent, I don't want to go!"

<div align="right">John (John Lennon)</div>

Liverpool 'mop tops' The Beatles had not yet conquered the world when Hollywood came calling at the end of 1963. England-based US producer Walter Shenson had watched the group become a pop culture sensation in their native Britain and had his eye on the lucrative US market by way of selling the film soundtrack. Expectations for a film loosely based on band's hectic touring schedule were not very high – think Elvis Presley's films or even worse, Cliff Richard – but what ultimately shone through were the unique talents and personalities of the band, songwriters John Lennon and Paul McCartney, guitarist George Harrison and drummer Ringo Starr.

To ensure a successful film, Beatles' manager Brian Epstein, a one-time Royal Academy of Dramatic Art (RADA) student, surrounded the group with the best available talent including music producer George Martin, successful Liverpool writer Alun Owen and ex-pat American director Richard Lester.

A talented director of commercials, Lester had completed *The Running, Jumping & Standing Still Film* (1959) starring Peter Sellers and Spike Milligan, which The Beatles loved. With a modest budget of under $1 million, the team behind *A Hard Day's Night* (1964) made a film that not only was an enormous financial success but also an artistic cinematic breakthrough.

Writer Owen spent some time with the four pop stars and channeled aspects of their personalities into his witty script providing each member of the group with a comedic vignette in the finished film.

Surrounded by some of the best talent in English comedy at the time (Brambell, Rossington and Spinetti are all standouts), The Beatles came across as natural entertainers with a youthful exuberance that was impossible to dislike. Together with Lester's inventive and impressionistic direction, the film surprised critics quick to dismiss The Beatles as just another fad.

The Beatles play themselves in the film (who else?) or, more exactly, heightened versions of their personalities in a hectic 24-hour period leading up to yet another show.

Ringo received praise for his 'Chaplinesque' scene with a young boy playing hooky from school. John's running jokes ("you're a swine, Norm") portrayed him as a young man with a sharp intelligence. Paul was keen to please and it was obvious he had a big future in show business. A hilarious scene involves George's encounter with a PR hack (Kenneth Haigh) intent on telling the 'quiet Beatle' that he would like a certain product in a shirt commercial – "I won't," Harrison deadpans, "they're grotty".

And then of course there was the music. For the album of the same name, Lennon and McCartney penned 13 original songs – a rare achievement for the time – many which featured in a wonderfully filmed concert sequence in a London theater in front of hundreds of screaming fans.

Watching *A Hard Day's Night* in the years since has led to outbreaks of Beatlemania for subsequent generations of music fans, but 1964 was a watershed year for the group before success, controversy and personal animosity soured the dream.

United Artists / Proscenium Films / Walter Shenson Films / Maljack Productions: 87 minutes

Produced by: Walter Shenson

Directed by: Richard Lester

Screenplay by: Alun Owen

Music by: George Martin (score); John Lennon & Paul McCartney (songs)

Cinematography by: Gilbert Taylor

Starring: John Lennon (himself), Paul McCartney (himself), George Harrison (himself), Ringo Starr (himself), Wilfrid Brambell (Paul's grandfather), Norman Rossington (Norm), John Junkin (Shake), Victor Spinetti (TV director), Richard Vernon (Gentleman on train), Anna Quayle (Millie), Kenneth Haigh (Simon Marshall), David Janson (Young boy), Pattie Boyd (Schoolgirl on train).

38th Academy Awards®

1965

Best Film: *The Sound of Music* (20th Century Fox)

Best Director: Robert Wise, *The Sound of Music*

Best Actor: Lee Marvin, *Cat Ballou*

Best Actress: Julie Christie, *Darling*

Best Supporting Actor: Martin Balsam, *A Thousand Clowns*

Best Supporting Actress: Shelley Winters, *A Patch of Blue*

The Sound of Music (1965) won Oscars® for Best Film, Best Director, Best Editing as well as Sound and for the Music Score.

Robert Wise's film adaptation of the Rogers and Hammerstein musical stars Julie Andrews as the young woman studying to be a nun who becomes a governess for the children of a naval captain (Christopher Plummer) and eventually falls in love with him.

The Sound of Music was not just a success, it was a pop culture sensation when it was released in the middle of the 1960s and has continued to be enjoyed by subsequent generations.

In **Doctor Zhivago** (1965), director David Lean sought to create an epic in the mold of *Lawrence of Arabia* (1962). Boris Pasternak's novel of a doomed love affair during the Russian Revolution of 1917 certainly had the historical sweep of *Lawrence of Arabia* but the movie lacked a central character as charismatic or driven as T.E. Lawrence. Omar Sharif (above right), fresh from his success as Ali in *Lawrence of Arabia*, took the central role as Zhivago while the beautiful Julie Christie played Lara. While certain scenes stay in the memory – the attempted assassination of Komarovsky (Rod Steiger), the death of the Russian military leader, and the beautiful scenes in the cottage at Varykino (to the strains of the Oscar®-winning 'Lara's Theme' by Maurice Jarre) – the film does not make you care enough about the central characters.

Nominated for ten Academy Awards®, it missed out on the big ones but won for Art Direction, Cinematography, Adapted Screenplay, Costume Design and Original Score.

The same year **Julie Christie** (b. 1940) starred in *Doctor Zhivago*, she won Best Actress for *Darling* (1965), John Schlesinger's film about a shallow model who chases the comfortable life that a series of increasingly wealthy men promise her. Christie could easily have cast as the face of the Sixties, but rebelled against taking safe choices and took on roles as diverse as *Fahrenheit 451* (1966), *Far From the Madding Crowd* (1967) and *Petulia* (1968).

Scottish actor **Sean Connery** (b. 1930) starred in seven films as James Bond: *Dr. No* (1962), *From Russia with Love* (1963), *Goldfinger* (1964), *Thunderball* (1965), *You Only Live Twice* (1967), *Diamonds Are Forever* (1971) and *Never Say Never Again* (1983) – the last was not technically a 'Bond' franchise film but based on the same source material as Fleming's 1961 novel *Thunderball*. For many 'Bond' devotees, Connery, as the original was the best.

Connery started his career as a body-builder before coming to stage and film, but his selection as Ian Fleming's iconic spy catapulted him to another level of success which he maintained in a varied and eclectic career until his retirement in 2005.

Thunderball (1965) was the fourth James Bond spy film made in four consecutive years, following the success of *Dr No* (1962), *From Russia With Love* (1963) and *Goldfinger* (1964). In this episode of the successful James Bond franchise, MI6 agent '007' matches wits with Emilio Largo (Adolfo Celi), SPECTRE's Number Two (you can easily see where comedian Mike Myers got much of his inspiration for his *Austin Powers* spy parodies).

Alfie (1966) was readymade for the cockney charm of Michael Caine (b. 1933), coming as it did in the midst of the 1960s' sexual revolution.

As Alfie Elkins, Caine beds a bevy of young women, including the lovely Jane Asher (above), only to be spurned by his older lover (Shelley Winters). He realizes the folly of his ways far too late.

Caine contributed heavily to the British invasion of Hollywood in the 1960s and '70s, and was still making important films at the turn of the millennium after winning Supporting Actor Oscars® for *Hannah and Her Sisters* (1986) and *The Cider House Rules* (1999).

39th Academy Awards®
1966

Best Film: *A Man for All Seasons* (Columbia Pictures)

Best Director: Fred Zinnemann, *A Man for All Seasons*

Best Actor: Paul Scofield, *A Man for All Seasons*

Best Actress: Elizabeth Taylor, *Who's Afraid of Virginia Woolf?*

Best Supporting Actor: Walter Matthau, *The Fortune Cookie*

Best Supporting Actress: Sandy Dennis, *Who's Afraid of Virginia Woolf?*

A Man for All Seasons (1966) is close to perfection as far as production, direction, acting and writing are concerned. These elements come together in Fred Zinnemann's film version of the Robert Bolt play. Paul Scofield (1922–2008) plays Sir Thomas Moore for which he was awarded Best Actor.

The story of Moore's religious battle with King Henry VIII (Robert Shaw) which resulted in Moore's eventual decapitation and martyrdom (below) also won Oscars® for Best Film, Best Director, Best Adapted Screenplay, Best Cinematography and Best Costume Design.

Who's Afraid of Virginia Woolf? (1966) is an Oscar®-winning film based on American playwright Edward Albee's stage play. Richard Burton and Elizabeth Taylor (above), star as a history professor and his volatile wife (the daughter of the university president), who entertain a young couple (George Segal and Sandy Dennis) with violent stories of a loveless marriage

Luminous beauty Taylor is almost unrecognizable in her Oscar®- winning role as Martha. Burton, her then husband playing her on-screen husband, gives a frightening insight into the disintegration of a marriage in what is arguably the last great role of his troubled career.

The film won five Oscars®, including Sandy Dennis for Best Supporting Actress as the petrified houseguest, as well as Best Cinematography (black and white), Art Direction – Set Decoration and Costume Design (black and white).

The Sand Pebbles (1966) garnered Steve McQueen his only Oscar® nomination during his career. Produced and directed by Robert Wise, fresh from his success with *The Sound of Music*, *The Sand Pebbles* was based on Richard McKenna's 1962 book about a US gunboat's confrontation with Chinese nationalists in the 1920s.

McQueen was perfectly cast as the rebellious crewman Jake Holman and was reunited with his *Great Escape* co-star Richard Attenborough in this film.

Candice Bergen (b. 1946), pictured with McQueen (left), plays a missionary trapped in China. However, it is McQueen's scenes with the Japanese-born American actor Mako (1933–2006) that go to the very heart of the film.

As a film, *The Sand Pebbles* has no neat ribbon to tie off at the end but is well worth the time to see McQueen as the very top of his craft.

The Fortune Cookie (1966), directed by Billy Wilder, opened up a whole new comedic career for character actor Walter Matthau (1920–2000), who won Best Supporting Actor for his role as shonky insurance lawyer 'Whiplash Willie' Gingrich.

In Jack Lemmon, Matthau also found the perfect comedic partner and the pair worked together in ten films over the next three decades including two more with director Billy Wilder, *The Front Page* (1974) and *Buddy Buddy* (1981).

The Graduate (1967) perceptively tapped into a malaise facing comfortable white families in America in the 1960s – the increasing generation gap and a suffocating sense of isolation – with comical and dramatic implications.

Newcomer Dustin Hoffman (aged 30) is cast as 21-year-old college graduate Benjamin Braddock who is seduced by neighbor Mrs Robinson (Oscar®-winner Anne Bancroft) only to fall in love with her daughter, Elaine (Katherine Ross).

The Graduate (1967) greatly benefited from the music of Simon and Garfunkel, 'Mrs Robinson' and direction from Mike Nichols (1931–2014) (pictured right) who won Best Director for the film. When Benjamin crashes Elaine's wedding to declare his love for her, a whole generation cheered.

40th Academy Awards®

1967

Best Film: *In the Heat of the Night* (United Artists)

Best Director: Mike Nichols, *The Graduate*

Best Actor: Rod Steiger, *In the Heat of the Night*

Best Actress: Katharine Hepburn, *Guess Who's Coming to Dinner*

Best Supporting Actor: George Kennedy, *Cool Hand Luke*

Best Supporting Actress: Estelle Parsons, *Bonnie and Clyde*

In the Heat of the Night (1967) is a film very much of its time that still has something to say about racial politics today. At the height of the American Civil Rights movement, a black detective (Sidney Poitier, below left) visits the Deep South and reluctantly helps a bigoted police chief (Rod Steiger (1925–2002), right) to solve a murder.

The actual crime is not central to the story. The film is about the tense relationship between Poitier and Steiger (with Warren Oates in a supporting role) that warms during the course of events.

The film won Oscars® for Best Film, Best Actor for Rod Steiger, Best Editing, Cinematography and Adapted Screenplay. Norman Jewison was nominated for Best Director but was beaten to the award by Mike Nichols for *The Graduate*.

Guess Who's Coming to Dinner (1967) proves that timing, and casting, is everything in filmmaking. Produced and directed by Stanley Kramer (1913–2001), Spencer Tracy (in his final film) and Katharine Hepburn play a liberal couple preparing to meet their prospective son-in-law for the first time without knowing he is black.

Sidney Poitier was the obvious choice as the black professional who has one afternoon to win over his in-laws, while Hepburn's niece Katharine Houghton plays Poitier's headstrong fiancé, Joanna.

Making the characters lawyers and doctors may have softened the impact of the story (it would have been interesting to see what happened if all the people involved were cleaners and factory workers), but the film remains an interesting period piece, coming as it did at the height of the civil rights movement in the US. It earned Katharine Hepburn her second Best Actress award after a gap of thirty years.

The first African American actor to win a Best Actor Oscar® (*Lilies of the Field*, 1963) **Sidney Poitier** (b. 1927) was at the peak of his career in 1967 when three films in which he starred were released – *To Sir with Love*, *In the Heat of the Night* and *Guess Who's Coming to Dinner*.

Bonnie and Clyde (1967) was produced by Warren Beatty as a vehicle for him to star in with then girlfriend Leslie Caron. However, Beatty eventually realized an American had to play the role of Bonnie, and cast platinum blonde Faye Dunaway (b. 1941).

Beatty had Robert Towne (*Chinatown*, 1974) help David Newman and Robert Benton rework the story to make Clyde Barrow an impotent lover rather than gormless bi-sexual as in the original script.

Directed by Arthur Penn, *Bonnie and Clyde* was imaginatively edited, with a memorable soundtrack and Oscar®-winning cinematography. It portrayed sexual tension and explosive violence with unique style. The film also won Best Supporting Actress for Estelle Parsons, made the quirky Michael J. Pollard a short-lived star, and brought actor Gene Hackman the career he deserved.

In Cold Blood (1967) is based on Truman Capote's ground-breaking novel about the 1959 murders of a Kansas family by two drifters.

As brought to the screen by Richard Brooks (*Elmer Gantry*, 1960), *In Cold Blood* was filmed in almost documentary style, with Robert Blake as Perry Smith and Scott Wilson as Dick Hickock playing the dysfunctional killers.

Brooks cleverly structures the chronology of the film, showing the effect of the murders first before walking the two killers through the crime scene after their capture and then finishing the film with their shockingly effective execution.

Point Blank (1967) is the first of two collaborations between British director John Boorman (b. 1933) and actor Lee Marvin (the other being *Hell in the Pacific*, 1968).

Marvin (pictured with Angie Dickinson) plays a killer seeing revenge on a friend (John Vernon) who double-crossed him after a robbery. Director Boorman uses slow-motion cameras, a disjointed timeline and visual metaphors to tell his story in an original, uncompromising film.

The story was remade by Mel Gibson in 1999 (as *Payback*), but not even the Road Warrior could make a film about a killer without any sense of humanity, so he had the director soften the role. Lee Marvin would have turned in his grave.

Cool Hand Luke
1967

"Yeah, well... sometimes nothin' can be a real cool hand."

Lukas Jackson (Paul Newman)

Returned war hero Lucas Jackson (Paul Newman) is sentenced to a stint on a Southern chain gain for destroying municipal property (cutting the heads off parking meters) while drunk and disorderly. Not one to follow the rules and do his time quietly, 'Cool Hand Luke', as he is called by his fellow inmates, not only bucks the system but tears it down piece by piece.

After winning over prison bully Dragline (George Kennedy who won Best Supporting Actor for the role), Luke proves his fidelity with the rest of the men in a memorable egg-eating contest. Following the death of his mother, in which he is punished with a stint in the sweat box least he entertain thoughts of home and tries to escape, Luke hatches a plan.

Paul Newman (1925–2008), who was at the peak of his box-office success, secures his anti-hero persona in this film. Released in 1967 at the height of the 1960s youth movement, never has a generation gap been better explained than by the now-famous line uttered by the prison captain (Strother Martin in another film-stealing performance) after Luke is captured for the first time. "What we have here is failure to communicate," the captain declares, almost apologetically, before beating Luke to the ground. Newman even parodies the line during his final escape, but there is no failure to communicate the rebelliousness and nonconformity of a generation here.

The reverence shown to Cool Hand Luke by the other men is almost Christ-like in their devotion – there are numerous scenes that allude to Luke's role as prison messiah and confirm the devotion of his followers – although there would be no resurrection at the end of our story.

Displaying their admiration, disappointment and finally their exhilaration in Luke's escape for the last time, supporting roles feature some of the best character actors of the '60s counterculture era – Dennis Hopper, Harry Dean Stanton, a young Wayne Rogers (*MASH*), Ralph Waite (*The Waltons*) and the quirky Anthony Zerbe as the prison guard in charge of the bloodhounds.

The music of Lalo Schifrin (also *Mission Impossible*) plays an important role in the film featuring strongly in the road-sealing scene where the prisoners seal a dirt road with tar in double-quick time in the searing heat to bamboozle the prison guards who lord it over the prisoners. That music has been used by news services around the world and never fails to send a shiver up the spine.

Newman's simple banjo rendition of 'Plastic Jesus' in the wake of his mother's death has also become a cult favorite with movie fans over the years. The scene was the last to be filmed so as to give Newman enough time to learn to play the instrument so he could sing it live to camera.

Written by Donn Pearce (who had served time on a Southern chain gang in the 1950s) and Frank R. Pierson (*Dog Day Afternoon*, 1975), *Cool Hand Luke* exudes such a realistic air of authenticity under the direction of Stuart Rosenberg, you can almost smell the sweat on the men. Newman makes the whole thing look effortless in one of his least self-conscious performances.

Warner Bros. / Seven Arts: 126 minutes

Produced by: Gordon Carroll

Directed by: Stuart Rosenberg

Screenplay by: Donn Pearce and Frank R. Pierson, based on the novel by Donn Pearce

Music by: Lalo Schifrin

Cinematography by: Conrad Hall

Starring: Paul Newman (Lucas 'Luke' Jackson) George Kennedy (Dragline), Strother Martin (the Captain), Jo Van Fleet (Luke's mother), J.D. Cannon (Society Red), Lou Antonio (Koko), Richard Davalos (Blind Dick), Dennis Hopper (Babalugats), Wayne Rogers (Gambler), Harry Dean Stanton (Tramp), Ralph Waite (Alibi), Anthony Zerbe (Dog Boy), Joe Don Baker (Fixer)

41st Academy Awards®

1968

Best Film: *Oliver!* (Columbia)

Best Director: Carol Reed, *Oliver!*

Best Actor: Cliff Robertson, *Charly*

Best Actress: Katharine Hepburn, *The Lion In Winter*; Barbra Streisand, *Funny Girl*

Best Supporting Actor: Jack Albertson, *The Subject Was Roses*

Best Supporting Actress: Ruth Gordon, *Rosemary's Baby*

Oliver! (1968), Lionel Bart's musical version of Charles Dickens' novel *Oliver Twist*, was nominated for 11 Oscars® and won five awards including Best Film and Best Director. In addition, choreographer Onna White was awarded an honorary Oscar® for her brilliant dance achievements in the film.

Oliver! won both popular and critical acclaim, not least for veteran director Carol Reed's work with child actors Mark Lester (pictured below with Harry Secombe) as Oliver and Jack Wild as the Artful Dodger but also the wonderfully staged musical numbers.

Barbra Streisand (b. 1942) won the Best Actress Oscar® in her film debut, the 1968 musical ***Funny Girl***. Streisand had played the role of vaudeville comedienne Fanny Brice (1891–1951) on Broadway and had already conquered the musical theater world when she signed on for William Wyler's film adaptation.

Streisand (above centre) shared the award with veteran Katharine Hepburn in an historic 'tie'. The poll was not an exact tie, however, because under Academy rules two members can share the Oscar® if there is a difference of one vote. It is unknown which of the two actresses topped that poll.

The year after the death of her long-time partner Spencer Tracy, a still grieving Katharine Hepburn accepted Peter O'Toole's invitation to travel in England and star alongside him in an adaptation of the play ***The Lion in Winter*** (1968).

Focusing on the estrangement between King Henry II and his surly wife Eleanor of Aquitaine as their sons manoeuvre for the throne, the film also introduced Anthony Hopkins (as Richard the Lionheart) to a world audience.

Hepburn won her third Best Actress Oscar®, a year after winning the award for *Guess Who's Coming to Dinner* (1967).

2001: A Space Odyssey (1968) is a brilliantly conceived and constructed film by director Stanley Kubrick from *The Sentinel*, a short story by famed science fiction author Arthur C. Clarke, who later novellised the film.

At the dawn of man, apes are confronted by a black, rectangular monolith which appears to signal their next level of existence – communication, using tools, waging war. Thousands of years later, in 2001 (at the time, the not too distant future), a similar monolith is found under the surface of the moon. Again, the monolith appears to be propelling man to the next level of existence, and a team of US astronauts are sent to Jupiter on a secret mission. On the way, the spaceship's computer kills two of the astronauts, but Dr David Bowman (Keir Dullea, pictured above left with Gary Lockwood) is able to disable the computer and continue the mission. Traveling in a space pod, Bowman is pulled into a beam of light, enters a bright room and sees himself as an old man. As Bowman touches the monolith, he is now a fetus in a womb drifting towards earth.

Beautifully realized with a stunning music score and special effects decades ahead of their time, *2001: A Space Odyssey* created much discussion when it was released and has continued to do so. Only one question remains unanswered, but it's a big one. What the hell does it all mean?

Planet of the Apes (1968) is based on the 1963 satirical novel by Pierre Boulle (who also wrote *The Bridge Over the River Kwai*) with a great script from Rod Serling (*The Twilight Zone*) and Michael Wilson (*Lawrence of Arabia*). Charlton Heston had wanted to make the film in the early 1960s but it wasn't until a special effects team solved the problem of making prosthetic masks in which apes could appear to talk that the film got underway. John Chambers won an Academy Award for Outstanding Achievement in Make Up for his work.

Heston holds the film together as an astronaut who finds himself marooned on a planet where the apes are in charge.

The film spawned four sequels and two reboots, but missed the point of the original film, which succeeded as a cynically harsh and sometimes ironic commentary of the destructive nature of man.

Roman Polanski's chilling film of Ira Levin's novel ***Rosemary's Baby*** (1968) made the Polish director's reputation in Hollywood.

The story of a struggling actor (John Cassavetes) who procures his naïve wife (Mia Farrow) for a New York coven of witches, works because many of the people involved are so ordinary – the little old lady next door (Ruth Gordon in her Oscar®-winning role), Ralph Bellamy as the friendly doctor and Elisha Cook Jr. as Mr Nicklas. Farrow gives birth to a child, but who is the father? Well, he does have his father's eyes. Listen carefully for a cameo from Tony Curtis.

The Producers
1968

> "How could this happen? I was so careful. I picked the wrong play, the wrong director, the wrong cast. Where did I go right?"
>
> Max Bialystock (Zero Mostel)

It's hard to believe that *The Producers* (1968) could remain a cult classic for thirty years before finding a mass audience as a stage play. Originally imagined for the stage by writer-director Mel Brooks, the completed movie was championed by comedian Peter Sellers in Hollywood and won Brooks the 1968 Academy Award for original screenplay. The film did modest business on release but for a devoted army of fans, it remained an experience of sheer serendipity before later achieving a second life, ironically, on the Broadway stage.

Following the success of his TV series *Get Smart*, Mel Brooks (b. 1926) wrote *The Producers* as an ode to bad taste. Failed Broadway producer Max Bialystock (Zero Mostel) and his timid accountant, Leo Bloom (Gene Wilder), devise a plan to stage the worst play in the world and pocket the money they raise from overselling company shares in the production to a long line of little old ladies (that Max has to seduce).

The producers, who are both overtly Jewish, choose 'Springtime for Hitler' written by a crazed Nazi, and select a faux hippie named LSD (Dick Shawn) to play the Führer in a show they feel sure will close on opening night.

Veteran Zero Mostel is at his very best here – and so light on his feet – while Wilder (in his second film) is literally hysterically funny as he clutches on to his blue security blanket. The standout, however, is Kenneth Mars as the Nazi soldier turned playwright Franz Liebkind. Mars delivers an original comedy performance in this film. "You will be quiet now!" he orders the audience who dares laugh at his play after Christopher Hewitt (Roger De Bris) turns it into a Busby Berkley style musical spectacular of bad taste. "Hitler was a great painter, " he tells the producers. "He could paint a room in one afternoon … two coats!" When the trio blow up the theater, try to watch Franz's explanation of the relative merits of the "long fuse versus the short fuse" without bursting into laughter.

The relationship between Max and Leo is the heart of the film – Mostel's funny asides and Wilder's wildly erratic reactions make them cinema's most unlikely couple. There is sweetness and pathos among the laughs too.

The sight of Leo Bloom skipping with joy around a New York fountain after being liberated from his humdrum job by Max's grand plans is so good it is repeated for added affect at the end of the film.

The wonderful mind of Mel Brooks also conceived the musical numbers (Brooks wrote the lyrics and sang the songs to music coordinator John Morris) including the blissful 'Love Power' (Dick Shawn's showpiece); the stage centerpiece 'Springtime for Hitler' and 'Prisoners of Love' which endnotes the film after the hapless producers end up in jail.

Is it just a coincidence that Max Bialystock shares the same initials as Mel Brooks? But then, Brooks put his comedic stamp all over *The Producers*. Having conquered the world of writing and directing Brooks, forever the ham, starred in his next film, *The Twelve Chairs* (1970) before reuniting with Wilder in 1974 for two classic comedies, *Blazing Saddles* and *Young Frankenstein*.

Embassy Pictures: 88 minutes

Produced by: Sidney Glazier

Directed by: Mel Brooks

Screenplay by: Mel Brooks

Music by: John Morris

Cinematography by: Joseph Coffey

Starring: Zero Mostel (Max Bialystock), Gene Wilder (Leo Bloom), Kenneth Mars (Franz Liebkind), Dick Shawn (LSD), Lee Meredith (Ulla), Estelle Winwood (Old Lady), Christopher Hewett (Roger De Bris), Andreas Voutsinas (Carmen Ghia), William Hickey (Drunk in bar).

42nd Academy Awards®

1969

Best Film: *Midnight Cowboy* (United Artists)

Best Director: John Schlesinger, *Midnight Cowboy*

Best Actor: John Wayne, *True Grit*

Best Actress: Maggie Smith, *The Prime of Miss Jean Brodie*

Best Supporting Actor: Gig Young, *They Shoot Horses, Don't They?*

Best Supporting Actress: Goldie Hawn, *Cactus Flower*

Midnight Cowboy (1969) is the first 'X-rated' film (18+ years only) to win Best Film, but 'new wave' stars Jon Voight (below left, b. 1938) and Dustin Hoffman (b. 1937) had to wait in line for their Oscars® when Hollywood rightfully rewarded John Wayne for his role in *True Grit* (1969).

Midnight Cowboy was a totally original, if not a little too gimmicky, late-1960s look at the sleazy side of New York City as seen through the eyes of Oscar®-winning English director John Schlesinger. It remains a daring film, but one that Hollywood embraced in the final year of the 'Swinging Sixties'.

After the success of *The Searchers* (1956) and *Rio Bravo* (1959), John Wayne spent most of the 1960s making 'comfort' westerns where he played essentially the same character surrounded by a familiar group of actors and filmmakers with whom he felt comfortable.

It is a measure of his immense talent, the great affection of film audiences and the generosity of Academy voters that 'The Duke' could overcome the backlash from the politically insensitive *The Green Berets* (1968) to win Best Actor for his performance in Henry Hathaway's *True Grit* (1969).

An older, fatter, meaner, more gravelly-voiced Wayne instills US Marshall 'Rooster' Cogburn with real frontier spirit and western charm as he pursues an outlaw wanted for the murder. In short, in this film, he acts.

Maggie Smith (b. 1934) won the Oscar® for Best Actress playing the title role of the dangerously influential teacher (pictured below with co-star Robert Stephens, her then husband) in *The Prime of Miss Jean Brodie* (1969).

When Smith beat Geneviève Bujold (*Anne of the Thousand Days*), Jane Fonda (*They Shoot Horses, Don't They?*), Liza Minnelli (*The Sterile Cuckoo*) and Jean Simmons (*The Happy Ending*) for the Oscar®, fellow actress Elizabeth Taylor famously remarked that the Academy had achieved a rare feat and rewarded talent over glamour.

Robert Redford

b. 1936

Robert Redford worked hard during the 1960s to dispel the easy accusation that he was nothing more than a pretty face in movies. After his breakthrough success in *Butch Cassidy and The Sundance Kid* (1969), Redford stretched his range playing less-than likeable characters and morally ambiguous heroes in such films as *Downhill Racer* (1969) and *The Candidate* (1972). The Oscar®-winning film, *The Sting* (1973) proved Redford could carry a big film, but it was his decision to produce *All the President's Men (1976)*, after buying the film rights to the bestselling book, that opened up his career. Four years later he won the Oscar® for directing *Ordinary People* (1980), and spent the ensuing decades invariably acting, directing and producing pet film projects. Not bad for a pretty face!

KEY FILMS

Barefoot in the Park (1967)
Butch Cassidy and The Sundance Kid (1969)
Jeremiah Johnson (1972)
The Candidate (1972)
The Sting (1973)
The Way We Were (1973)
The Great Gatsby (1974)
Three Days of the Condor (1975)
All the President's Men (1976)
The Electric Horseman (1979)
*Ordinary People** (1980)
The Natural (1984)
Out of Africa (1985)
*A River Runs Through It** (1992)
*Quiz Show** (1994)
Up Close & Personal (1996)
*The Horse Whisperer*** (1998)
The Last Castle (2001)
*Lions for Lambs*** (2007)
All Is Lost (2013)
** Director only ** Actor and director*

Butch Cassidy and The Sundance Kid (1969) was the feel-good movie of 1969; a 'buddy' movie with often anachronistic humor between the male leads Paul Newman as Butch Cassidy and Robert Redford as The Sundance Kid.

Writer William Goldman (b. 1931) sold his comedy-drama script of the exploits of the 'Hole in the Wall Gang' in the early part of the 20th century for a record $400,000. Paul Newman was the successful bidder, and with George Roy Hill directing, Robert Redford was cast as Butch's partner after Marlon Brando, Jack Lemmon, Steve McQueen and Warren Beatty were considered.

Katharine Ross completed the central charismatic trio, and with a winning soundtrack by Burt Bacharach, 'Raindrops Keep Fallin' on My Head', *Butch Cassidy and The Sundance Kid* became the biggest hit of the year.

Easy Rider (1969) was made by its two stars, Peter Fonda (producer) and Dennis Hopper (director), for just $400,000. It grossed more than $60 million worldwide, making it one of the most successful independent films in cinematic history.

It would be easy to dismiss the film today as a stoner's view of late 1960s' counterculture except that the film still packs a punch with its iconic ending and generally downbeat theme that bikers Wyatt (Fonda) and Billy (Hopper) "blew it, man".

The film hits another gear when Jack Nicholson enters the story as disillusioned lawyer George Hanson.

With a wonderfully evocative '60s soundtrack *Easy Rider* ushered in a new era of filmmaking.

They Shoot Horses, Don't They? (1969) used Depression-era dance marathons to show how needy people were stripped of their humanity during the 1930s. Jane Fonda, Michael Sarrazin, Susannah York, Bruce Dern, Bonnie Bedelia and Red Buttons played the doomed dancers, with veteran character actor Gig Young (1913–1978) excelling in his Oscar®-winning role as Rocky, the ruthless dancehall MC. Jane Fonda gives a glimpse of the talent that would win her an Oscar® two years later, while Canadian actor Michael Sarrazin (1940–2011) conveys the weariness of the era with one soulless look from his eyes.

Director Sam Peckinpah's revisionist western, *The Wild Bunch* (1969), is a completely different type of 'buddy' movie than the imminently more popular *Butch Cassidy and the Sundance Kid*, which was also released in 1969.

The gunslingers, who comprise 'The Bunch' live by a code of loyalty that is disappearing in the west, put aside their disagreements to take on the might of the Mexican Army to rescue their friend Angel (Jaime Sánchez).

Ben Johnson, Warren Oates, William Holden and Ernest Borgnine (above from left) are outstanding as the outlaws, as is Robert Ryan as their former colleague and pursuer Deke Thornton.

Strother Martin and L.Q. Jones add to their résumés as despicable types, while Bo Hopkins has a memorable turn in the opening scenes that sets the violent tone for the rest of the film.

Peckinpah uses slow motion film, deep focus camera effects and multiple edits to stylize the violence and create his masterpiece. The West was never the same after *The Wild Bunch*.

Clint Eastwood

b. 1930

Clint Eastwood continues to surprise more than 60 years into his film career. A TV star in the early 1960s (*Rawhide*), Eastwood starred in a series of 'spaghetti westerns' during the decade which reintroduced him to America as a film star. Eastwood blew audiences away with *Dirty Harry* (1971), the same year he made his directorial debut with *Play Misty for Me,* setting the stage for a multifaceted career of acting roles and directing projects, often combining the two. *Unforgiven* (1992) redefined the western film for a modern generation and earned his first Oscar® as director. *Mystic River* (2003) was a welcome return to form after a decade of modest success, but just as his acting appeared to be winding down, he won his second directing Oscar® for *Million Dollar Baby* (2004). Eastwood is a filmmaking machine, and continues to turn out great films as a director well into his '80s.

KEY FILMS

A Fistful of Dollars (1964)
The Good, the Bad and the Ugly (1966)
Hang 'Em High (1968)
Paint Your Wagon (1969)
Kelly's Heroes (1970)
Dirty Harry (1971)
*Play Misty for Me*** (1971)
*High Plains Drifter*** (1973)
*The Outlaw Josey Wales*** (1976)
Every Which Way but Loose (1978)
Escape from Alcatraz (1979)
*Bronco Billy*** (1980)
*Pale Rider*** (1985)
*Bird** (1988)
*Unforgiven*** (1992)
*The Bridges of Madison County*** (1995)
*Mystic River** (2003)
*Million Dollar Baby*** (2004)
*Flags of Our Fathers** (2006)
*Letters from Iwo Jima** (2006)
*Gran Torino*** (2008)
*J. Edgar** (2011)
*American Sniper** (2014)
*Jersey Boys** (2014)
*Director **Actor and director

Hang 'Em High (1968) was Clint Eastwood's first American film after his success in Sergio Leone's western trilogy in the mid-1960s, *A Fistful of Dollars* (1964), *A Few Dollars More* (1965) and *The Good, the Bad and the Ugly* (1966).

Many of Eastwood's trademark characteristics are already evident – the squinting eyes, the blank asides and the spitting out of salient truths through gritted teeth – in this story of rough justice and redemption.

Strung up on a tree after being falsely accused of cattle rustling, Jed Cooper (Eastwood) is cut down by a visiting marshal (Ben Johnson) and takes on a lawman's badge to hunt down the men who tried to kill him.

Pat Hingle, who later became a frequent collaborator, plays the bad guy. Produced by Eastwood's newly-formed Malpasso Company, *Hang 'Em High* set Eastwood on the road to stardom.

Kelly's Heroes (1970) is an oddly satisfying movie experience. A heist film set during World War II but with a 1960s counterculture sensibility, the film brilliantly balances drama and humor in a life and death war context.

A group of US infantry soldiers during the Normandy invasion go behind military lines in France to rob a German-held bank of millions of dollars in gold bullion.

Eastwood as Kelly (pictured centre) Don Rickles (left), Donald Sutherland (right), Telly Savalas, Harry Dean Stanton, Perry Lopez and Gavin McLeod play just some of the actors in the heist. Carroll O'Connor – a year before he found fame on TV's *All in the Family*, is a wonderfully gung-ho general.

Kelly's Heroes is so well staged that one can easily forget the anachronisms (Sutherland as a hippie?) and enjoy the ride that ends in a showdown with a German Panzer unit and a nod to Eastwood's spaghetti westerns.

The 1970s

There was a new Hollywood in the 1970s, with young directors Francis Ford Coppola, Steven Spielberg, George Lucas, Hal Ashby and Martin Scorsese emerging as new talents, and actors Jack Nicholson, Al Pacino, Jane Fonda, Barbra Streisand and Warren Beatty dominating the screen.

It was a decade of realistic, increasingly violent, socially-aware films. *The French Connection* (1971), *Deliverance* (1972) and *Dog Day Afternoon* (1975) were among the decade's best, but there were also Mel Brooks comedies, 'buddy' films and disaster movies. *The Godfather* (1972, and its 1974 sequel) was a pop culture sensation, *Rocky* (1976), a worldwide phenomenon and *The Deer Hunter*, *Coming Home* (both 1978) and *Apocalypse Now* (1979) bought the Vietnam War into focus. In the '70s, the summer 'blockbuster' was born, with the release of *Jaws* (1975) in over 1000 theaters changing the ways films were marketed. The success of *Star Wars* and *Close Encounters of the Third Kind* (both 1977) reignited the science fiction genre and horror films found a willing teen audience.

Two actors who successfully broke into directing that decade were Clint Eastwood and Woody Allen. After the success of *Dirty Harry* (1971), Eastwood made his directorial debut the same year with *Play Misty for Me* and never looked back.

Woody Allen took charge of his comedies and proved a uniquely gifted filmmaker with *Annie Hall* (1977), which won Best Film and Best Director Oscars® and *Manhattan* (1979), which was nominated for two Oscars®.

Diane Keaton and Woody Allen in *Manhattan* (1979)

43rd Academy Awards®

1970

Best Film: *Patton* (20th Century Fox)

Best Director: Franklin J. Schaffner, *Patton*

Best Actor: George C. Scott, *Patton*

Best Actress: Glenda Jackson, *Women in Love*

Best Supporting Actor: John Mills, *Ryan's Daughter*

Best Supporting Actress: Helen Hayes, *Airport*

Franklin J. Schaffner's film of the career of US General George S. Patton (1885–1945), *Patton* (1970), was a salute to a rebel. The film won seven Oscars®, including Best Film, Best Director, Best Actor, Best Original Screenplay (for Edmund H. North and Francis Ford Coppola), Best Editing, Best Sound and Best Art Direction – Set Decoration.

Actor George C. Scott (1927–1999), pictured below left as Patton with Karl Malden as Major General Omar Bradley, famously declined the Academy Award for this role, citing his dislike for 'acting competitions' and told the Academy in advance that he would not be attending the ceremony. Marlon Brando followed Scott's lead two years later.

Airport (1970), Universal's film adaptation of Arthur Hailey's bestselling book, features actors Burt Lancaster, Dean Martin, Jean Seberg, Jacqueline Bisset (pictured above right), George Kennedy, Lloyd Nolan, Van Heflin, Maureen Stapleton, and veteran Helen Hayes (top centre) as a stowaway con-woman.

The result from writer-director George Seaton was sheer entertainment that was not only a huge commercial success but helped launch the 'disaster movie' franchise and spawned three 'airport' sequels (*Airport 1975*, *Airport '77* and *The Concorde: Airport '79*).

Hayes won the Oscar® for Best Supporting Actor for *Airport*, almost four decades after winning the Best Actress award for *The Sin of Madelon Claudet* (1931).

Five Easy Pieces
1970

"Now all you have to do is hold the chicken, bring me the toast, give me a cheque for the chicken salad sandwich, and you haven't broken any rules."

Bobby Dupre (Jack Nicholson)

Following the success of *Easy Rider* in 1969, independent studio BBS Productions (director Bob Rafelson and producers Bert Schneider and Stephen Blauner) turned their attention to developing a starring vehicle for Jack Nicholson. The trio had encountered Nicholson years before and had brought him on board to write the screenplay for their first production, The Monkees' 1968 film *Head*. Working with a script by Adrien Joyce (a pen name of Carole Eastman, 1934–2004), the team produced a modern American classic.

'Bobby' Dupea (Nicholson) swaps his comfortable upper-class life as a budding concert pianist for a working-class oil rigger and enjoys being an aimless drinker and womanizer. Called back to his old life following his father's illness, Bobby reluctantly returns home with girlfriend Rayette (Karen Black) in tow. Leaving her behind in a hotel room, Bobby quickly encounters the snobbery and aloofness that saw him leave the family home years before (the inability to communicate is best symbolized by Bobby's mute, wheelchair-bound father). He has an affair with his brother's girlfriend Catherine (Susan Anspach), but when Rayette gatecrashes events, he is torn between the life he now leads and the future that he wants with Catherine.

Five Easy Pieces is the title of a piano book Bobby had as a child, but it may also refer to the women he encounters as an adult – Rayette, his girlfriend, Betty (Sally Struthers), a one-night stand, Catherine, his brother's girlfriend, Tita, his sister who is in a dangerous relationship with their father's carer, and the unforgettable hitchhiker Palm Apadaca (Helena Kallianiotes). Her lesbian friend Terry is played by singer-dancer Toni Basil, of future 'Mickey' fame.

There are so many great set pieces in this film: Nicholson jumping on the back of an open truck transporting a piano during a traffic jam and promptly playing Chopin, and the violent tantrum he throws in his car after trying to leave Rayette behind when he has to visit his family. The tour de force however, is the 'chicken salad sandwich' scene in which Nicholson outwits an unaccommodating waitress in a diner to get the side order he wants, and then destroys the table with one sweep of his hand when he doesn't get it.

Beautifully photographed by László Kovács, Rafelson's 'modernist' direction keeps the film moving along with a heavy air of cynicism and disconnection. Country music fan Rayette garners the most sympathy with her startling naiveté. Gallantly, Bobby defends her in front of his family but then, after they leave the family home following Catherine's refusal to continue their affair, Bobby dumps Rayette at a service station and secretly catches a ride to Alaska. Never has a generation's restlessness and social irresponsibility been so eloquently expressed than in the final minutes of this film.

The film did great business in America for its modest budget and earned a swag of Oscar® nominations (Nicholson, Black, Rafelson, Joyce and for Best Film). It launched Nicholson on the road to superstardom, but remains one of his most personal and sustained performances.

Columbia / BBS Productions: 96 minutes

Produced by: Bob Rafelson and Richard Wechsler

Directed by: Bob Rafelson

Screenplay by: Bob Rafelson and Adrien Joyce (aka Carole Eastman)

Cinematography by: László Kovács

Starring: Jack Nicholson (Robert Dupea), Karen Black (Rayette Dipesto), Susan Anspach (Catherine Van Oost), Lois Smith (Partita 'Tita' Dupea), Ralph Waite (Carl Dupea), Billy 'Green' Bush (Elton), Irene Dailey (Samia Glavia), Toni Basil (Terry Grouse), Helena Kallianiotes (Palm Apodaca), William Challee (Nicholas Dupea), John Ryan (Spicer), Fannie Flagg (Stoney), Sally Ann Struthers ('Betty')

Robert Altman
1925–2006

Robert Altman was a 45-year old veteran TV director when he had his breakthrough hit with *MASH* in 1970. The finished film, which had little in common with Richard Hooker's novel or even Ring Lardner's Oscar®-winning script, was Altman's vision of an antiwar film.

Altman broke almost every filmmaking rule in the book, so much so that his stars Elliott Gould and Donald Sutherland tried to have him fired during filming.

Thankfully, Altman stayed true to his vision and produced an American classic. His subsequent films remained uniquely 'Altmanesque' – some more successful than others – before he returned to form with *The Player* (1992), one of the best films about Hollywood morals or the lack thereof.

KEY FILMS

MASH (1970)
McCabe & Mrs. Miller (1971)
The Long Goodbye (1973)
California Split (1974)
Nashville (1975)
3 Women (1977)
A Wedding (1978)
Popeye (1980)
The Player (1992)
Short Cuts (1993)
Prêt-à-Porter (1994)
Dr. T & the Women (2000)
Gosford Park (2001)
A Prairie Home Companion (2006)

MASH is an original, a black comedy set in the Korean War (1950-53) but directly commenting on the absurdity of the then Vietnam War. Altman encouraged his actors to improvise freely, even to the point of talking over the top of each other, to hammer home the point that war is crazy as hell. Altman's inventive direction and novel use of narration (the camp PA acts as an informal commentator on all the action) surreally depicts the work of mobile army surgeons and their fight against boredom and officialdom on the frontlines of Korea.

Starring Donald Sutherland (right) as Dr 'Hawkeye' Pierce and Elliott Gould (far right) as Dr 'Trapper John' McIntyre, Tom Skerritt, Sally Kellerman, Robert Duvall and Gary Burghoff (the only member of the cast to reprise his role in the hugely popular TV series that followed), *MASH* captured the zeitgeist at the beginning of the decade and was embraced by critics, the counterculture and mainstream audiences alike.

McCabe & Mrs. Miller (1971) is Robert Altman's unique take on the western genre – a gambler and a prostitute become business partners in a frontier mining town, only to fall foul of big business interests that try and muscle in on the boom.

McCabe, underplayed as a bumbling opportunist by Warren Beatty, is totally out of his depth in confronting the dangers that descend on the town, while Mrs Miller (Julie Christie) is the rock on which the town stands.

Filled with many of Altman's favorite stock actors (John Shuck, René Aberjonois, Michael Murphy and Shelley Duvall), life in the old west had rarely been portrayed so starkly.

The death of a young cowboy (Keith Carradine) as he leaves a whorehouse and encounters the henchmen who have been sent to the town to get rid of McCabe, remains one of the most shocking demises committed to film.

For the soundtrack, Altman used three of his favourite tracks from the album *Songs of Leonard Cohen*.

44th Academy Awards®

1971

Best Film: *The French Connection* (20th Century Fox)

Best Director: William Friedkin, *The French Connection*

Best Actor: Gene Hackman, *The French Connection*

Best Actress: Jane Fonda, *Klute*

Best Supporting Actor: Ben Johnson, *The Last Picture Show*

Best Supporting Actress: Cloris Leachman, *The Last Picture Show*

The French Connection (1971), directed by William Friedkin, was a new style of 'cop' movie for a new generation – tough, realistic and uncompromising, with a dynamite chase scene and a memorable shootout on the steps of a railway station.

Based on real events, New York cops 'Popeye' Doyle (Gene Hackman) and his partner 'Buddy' Russo (Roy Scheider) investigate the source of a shipment of cocaine from France, and try to trap the elusive criminal Alain Charnier (Spanish actor Fernando Rey) on their own turf in the US.

The French Connection won Oscars® for Best Film, Best Director and Best Actor and also won for Writing and Editing.

It also made a star of Gene Hackman (b. 1930) after the best part of decade in supporting roles.

The Last Picture Show (1971), based on a Larry McMurtry novel set in a Texan backwater in the early 1950s, was filmed in unfashionable black and white by erstwhile film historian Peter Bogdanovich.

The film was an important signpost of the start of a 'new Hollywood' era of young directors infused with a knowledge and understanding of film history but with a bold vision for the 1970s.

Bogdanovich assembled a talented group of young actors – Timothy Bottoms, Jeff Bridges and model Cybill Shepherd, all making their major film debuts – alongside veterans Ben Johnson, Cloris Leachman and Ellen Burstyn in this personal film of the sexual anxieties of small-town America.

Ben Johnson and TV actress Cloris Leachman (*The Mary Tyler Moore Show*) won Oscars® for their supporting roles, but of the group Ellen Burstyn (1974 Best Actress winner for *Alice Doesn't Live Here Anymore*) and Jeff Bridges (2009 Oscar® winner for *Crazy Heart*) enjoyed further film success while Shepherd and Bottoms went on to make their careers in TV.

Jane Fonda

b. 1937

Jane Fonda rode the fame rollercoaster throughout her career and came out as one of the most successfully independent women in Hollywood.

Not too much was expected of the pretty daughter of screen star Henry Fonda, but her early 1960s efforts marked her as a capable light comedienne and sensual love interest. Fonda ventured into sex kitten territory with the cult classic *Barbarella* (1968).

She moved to Europe marrying Roger Vadim, but when she returned to Hollywood in the early 1970s it was as an outspoken peace activist.

She won her first Oscar® playing a prostitute in *Klute* (1971) and overcame a mid-decade slump to capture a second award with the post-Vietnam War drama *Coming Home* (1978).

Thrice-married, Fonda took control of her career in the 1980s, even trying her hand at producing, before going into semi-retirement from 1990 to 2004. Fonda has since returned to acting starting with *Monster-in-Law* (2005).

KEY FILMS

Sunday in New York (1963)
Cat Ballou (1965)
Any Wednesday (1966)
Barefoot in the Park (1967)
Barbarella (1968)
They Shoot Horses, Don't They? (1969)
Klute (1971)
Steelyard Blues (1973)
Fun with Dick and Jane (1977)
Julia (1977)
Coming Home (1978)
Comes a Horseman (1978)
California Suite (1978)
The China Syndrome (1979)
The Electric Horseman (1979)
Nine to Five (1980)
On Golden Pond (1981)
Agnes of God (1985)
The Morning After (1986)

Klute (1971) was an atmospheric thriller from Alan J. Pakula, who cast Donald Sutherland as a small-town detective protecting big city prostitute Bree (Jane Fonda) who is being targeted by an unknown killer. Fonda won an Oscar® for the role, playing against type with brunette hair, a tough edge and a sharp mouth. At the time, Fonda was persona non grata with the Hollywood establishment who disapproved of her women's liberationist and anti-Vietnam War views, but you cannot deny talent – and the daughter of veteran actor Henry Fonda had that in spades.

Canadian actor Donald Sutherland (b. 1935) as the unflappable Detective Klute developed into cinema's most versatile leading men in the 1970s and 1980s.

Dirty Harry (1971) was criticized for its violence and seemingly right-wing political agenda (shoot the bad guys with bigger guns) when it was released in the early 1970s but the film proved an enormous commercial success.

Audiences connected with rogue San Francisco cop Harry Callahan, who dishes out his own brand of street justice as he tracks down serial killer 'Scorpio' (modelled on the real-life 'Zodiac Killer' who murdered at least five people in the Bay area and was never captured).

Eastwood took no prisoners as Callahan, and under the watchful eye of veteran director and film collaborator Don Siegel, *Dirty Harry* was the first of five films Eastwood made in the role. Andy Robinson is a memorable crazed killer and his scenes with Eastwood, including the exciting conclusion, sets this film above its many imitators.

In *Deliverance* (1972), British director John Boorman brings James Dickey's 1970 story of four Atlanta businessmen taking on nature as they canoe down the fictional Cahulawassee River to the screen.

An uncompromising commentary on the nature of violence, and the violent nature of man, *Deliverance* is memorable not only for its dueling banjos theme song introduced at the beginning of the film and its confronting male rape scene in the woods.

The four main players are all excellent – Ed (Jon Voight), Lewis (Burt Reynolds), Bobby (Ned Beatty) and Drew (Ronnie Cox). Voight plays against type as the cultured Ed, while Reynolds gives arguably the best performance of his career as alpha male Lewis. Bill McKinney makes a remarkable impact as one of the 'mountain men' the quartet encounter as they head downstream, but the film did little to promote the positive attributes of hillbillies.

Deliverance remains a startling adventure film that is well worth the journey downstream.

If Dirty Harry portrayed a right-wing view of film violence, ***A Clockwork Orange*** (1971) was surely the left wing. Based on Antony Burgess' controversial but ground-breaking 1962 novel, *A Clockwork Orange* prophesized the advent of permissive social violence. The irony was – and this was one of the points Burgess was making – that violence had always been a part of society.

As imagined by director Stanley Kubrick, the world inhabited by the group of young 'droogs' who dedicate themselves to random acts of 'ultra-violence' is frightening enough. The leader of the group, Alex (Malcolm McDowell) is later captured and is exposed to a government-sponsored program of equally violent 'cures' in order to return him to society.

The scene where the droogs break into a house and rape and murder the wife of a writer – as their leader Alex sings and dances to 'Singin' in the Rain' – fired the controversy that resulted in the film being withdrawn from circulation at the request of Kubrick for much of the 1970s, but not before it became an important part of film pop culture and rightly hailed as another Kubrick classic.

45th Academy Awards®

1972

Best Film: *The Godfather* (Paramount)

Best Director: Bob Fosse, *Cabaret*

Best Actor: Marlon Brando, *The Godfather*

Best Actress: Liza Minnelli, *Cabaret*

Best Supporting Actor: Joel Grey, *Cabaret*

Best Supporting Actress: Eileen Heckart, *Butterflies Are Free*

The Godfather (1972) wasn't just a hit in 1972, it was a phenomenon. So successfully did director Francis Ford Coppola recreate the world of the New York crime family that you could almost smell the garlic in the spaghetti sauce the gangsters make while they wait for word from their stricken Don (Marlon Brando).

Based on Mario Puzo's bestselling novel, *The Godfather* was hailed as Marlon Brando's comeback after a decade in the film wilderness.

Brando declined to accept his Oscar® for Best Actor, while Coppola was sensationally beaten for Best Director by Bob Fosse for *Cabaret*. *The Godfather* won only three Oscars® for Best Film, Best Actor and Best Writing. However, Coppola only had to wait a few years to be rewarded with the sequel, *The Godfather Part II* (1974).

Cabaret (1972) is one of Hollywood's most original and provocative musicals, with a narrative and dramatic performances to match its Oscar®-winning score (by Ralph Burns) and innovative dance sequences. Loosely based on the 1966 Broadway musical by John Kander and Fred Ebb (which was adapted from Christopher Isherwood's 1939 novel *Goodbye to Berlin*) director Bob Fosse (*Sweet Charity*, 1968) recreates Berlin's decadent world of the early 1930s as the Nazis come to power.

Liza Minnelli (b. 1946), the daughter of Judy Garland and Vincente Minnelli, gives a career-defining performance as Sally Bowles. Joel Grey as the cabaret's MC provides the film with its bite and sting, while Fosse's inventive direction and wonderfully staged dance and musical sequences provide a context for the three-way love affair at the centre of the film.

The threat of Nazism – with the looming war (and Holocaust) – which is brilliantly foreshadowed in the song 'Tomorrow Belongs to Me' and in the final number, 'Cabaret', hangs menacingly throughout the entire film.

American Graffiti
1973

"Rock and roll's been going downhill ever since Buddy Holly died."

John Milner (Paul Le Mat)

American Graffiti, George Lucas' homage to a simpler time ('Where were you in '62?') was released in 1973 as the US struggled under the combined weight of a protracted end to the Vietnam War and the Watergate scandal which would result in the resignation of President Richard Nixon. American Graffiti returned audiences, young and old, to the days of 'sock hops', 'do wops' and drive-ins – barely a decade before – and the result was an enormous cultural and financial success. Filmed in the California town of Petaluma, largely at night, American Graffiti tapped into the zeitgeist which saw the world embrace nostalgia.

Lucas had tried for several years to get his final script together and financed, and it wasn't until the success of Francis Ford Cappola's The Godfather that his film friend came on board as producer that the project was underway.

The story centers on school friends Curt (Richard Dreyfuss) and Steve (Ronny Howard), and their final night in town with loser buddy 'Toad' (Charles Martin Smith) and older mentor John Milner (Paul le Mat), before the pair head off to college. All were relatively unknown (except for Howard who had been a child actor), but the real stars of the film were the cars and the beat of late '50s and early '60s songs that provide a background for the film.

Dreyfuss is the heart of the film, displaying the loneliness of the lost teenager (he was 24 at the time) who doesn't quite fit in but doesn't want to leave home. He spends much of the film searching for a date, becomes a reluctant gang member of The Pharaohs, and encounters D.J. 'Wolfman' Jack – in an almost 'Wizard of Oz' role – at the end of the film. Pop culture references ("Rock and roll has really gone downhill since Buddy Holly died," laments the Milner character) help give the simple narrative a deeper context, as do the evocative songs of the era.

Their pursuit of various girls is central to the story – Curt is searching for his dream date, Steve is trying to consummate his relationship with Curt's sister Laurie, Toad forms an unlikely friendship with the beautiful Debbie and John is hamstrung 'babysitting' a precocious pre-teen (Mackenzie Phillips).

It has been suggested that American Graffiti spawned the successful TV show Happy Days, also starring Ron Howard, but this was not the case. Cindy Williams, who played Howard's girlfriend would later star in her own Happy Days spin-off, Laverne and Shirley.

When Curt goes off to college and Steve remains in town to stay with Laurie, there is already a huge sense of lost opportunity there without Lucas adding a final card of the fates of the four friends.

American Graffiti made stars of most of its main players (whatever happened to Candy Clark?), not least of all the young actor who played John Milner's drag car rival Bob Falfa (Harrison Ford). Harrison Ford did not have much to do in this film, but would become a superstar as a space cowboy in Lucas's next outing, Star Wars (1977). Ron Howard went on to a very successful career as a film director.

Universal / Lucasfilm / Coppola Company: 112 minutes

Produced by: Francis Ford Coppola

Directed by: George Lucas

Written by: George Lucas, Gloria Katz and Willard Huyck

Music by: various pop acts of the 1950s and 1960s

Cinematography by: Ron Eveslage and Jan D'Alquen

Starring: Richard Dreyfuss (Curt Henderson), Ron Howard (Steve Bolander), Paul Le Mat (John Milner), Charles Martin Smith (Terry 'The Toad' Fields), Cindy Williams (Laurie Henderson), Candy Clark (Debbie Dunham), Mackenzie Phillips (Carol Morrison), 'Wolfman' Jack (himself, XERB Disc Jockey), Bo Hopkins (Joe Young), Harrison Ford (Bob Falfa), Suzanne Somers ('The Blonde' in T-Bird), Flash Cadillac & the Continental Kids (Herbie and the Heartbeats)

46th Academy Awards®

1973

Best Film: *The Sting* (Universal)

Best Director: George Roy Hill, *The Sting*

Best Actor: Jack Lemmon, *Save the Tiger*

Best Actress: Glenda Jackson, *A Touch of Class*

Best Supporting Actor: John Houseman, *The Paper Chase*

Best Supporting Actress: Tatum O'Neal, *Paper Moon*

The Sting (1973) reunited Paul Newman and Robert Redford with their *Butch Cassidy and the Sundance Kid* (1969) director George Roy Hill. The film won seven Oscars®, for Best Film, Best Director, Best Score (Marvin Hamlisch), Best Original Screenplay (David S. Ward), Costume Design (Edith Head, a record eighth award) and Art Direction–Set Decoration.

The story of a grifter (Redford) who elicits the help of a group of con-men (led by Paul Newman) to hit back at a local gangster (Robert Shaw), everyone is in on the con except the audience. The film recreates the 1930s' world of Prohibition, speakeasies and illegal gambling set to a Scott Joplin score.

There is an old saying that nostalgia is not what it used to be, but Hollywood in the 1970s proved that adage wrong. *The Way We Were* (1973) united box office champs Robert Redford and Barbra Streisand in this post-World War II drama of a mismatched couple – all-round American hero and successful novelist Hubbell Gardner (Redford) and left-wing activist and kooky nice-girl Katie Morosky (Streisand).

The script tries too hard at times, using the backdrop of the Hollywood blacklists during the McCarthy era to point out the political differences of the doomed lovers, but credit must go to the stars for making the characters, the shallow Hubbell and the abrasive Katie, so damn likeable. Then of course, there is also the memorable score and title song which won Oscars® for composer Marvin Hamlisch (1944–2012). Oh go on, watch it again. You know you want to.

A Touch of Class (1973) earned British actress Glenda Jackson (b. 1936) her second Oscar® for Best Actress in three years. Her award for *The Music Lovers* (1970) is one of the great forgotten roles, but Jackson proved this was no fluke by winning her second Oscar® for this 1973 comedy romance with George Segal. Joining an elite list of actresses to win two or more Best Actress Oscars® (also Luise Rainer, Katharine Hepburn, Bette Davis, Olivia de Havilland, Ingrid Bergman, Elizabeth Taylor, Jane Fonda, Sally Field, Jodie Foster, Meryl Streep, Hillary Swank and, more recently, Frances McDormand), Jackson later turned her back on her acting career to enter British politics.

Papillon (1973), based on Henry Charrière's bestselling 1969 novel, was directed by Franklin Schaffner (*Patton*, 1970).

In Charriere's autobiographical tale of life and death and his eventual escape from France's infamous Devil's Island in French Guyana, Steve McQueen gives a layered, underrated performance in what would be the last great film of his career.

McQueen especially excels in the scenes where there is minimal dialogue, when he is alone in his prison cell scurrying for insects to eat, living with natives after one of his earlier escapes, and on the run from authorities in the jungle with another prisoner (Gregory Sierra). With a screenplay by veteran Dalton Trumbo and Lorenzo Semple Jr (*The Parallax View*, 1974), *Papillon* proved a worldwide success for all involved.

Dustin Hoffman (b. 1937) proved an excellent foil for Steve McQueen in *Papillon*, playing the bookish Dega who courts the protection of 'Papy' (McQueen) but does not have the courage to escape. The pair make an unlikely team in this unusual story of friendship set on Devil's Island, but Hoffman more than holds his own against McQueen in the secondary role that was greatly enlarged from the original book to accommodate his star power.

A New York stage actor, Hoffman first came to film prominence playing a lost college kid from an affluent family in *The Graduate* (1967), and then proved his versatility as a street hustler in *Midnight Cowboy* (1969), an adopted Indian brave in *Little Big Man* (1970) and an educated man driven to violence in *Straw Dogs* (1971) before taking on the role of Dega in *Papillon*. He later won two Academy Awards, for *Kramer Vs Kramer* (1979) and *Rain Man* (1988).

Based on William Peter Blatty's bestseller and directed by William Friedkin (*The French Connection*, 1971), *The Exorcist* (1973) scared the daylights out of audiences around the world.

What makes the film scary is not so much the thrilling special effects and the climactic exorcism, but the setting of the story. Suburban Georgetown, Washington D.C. is so ordinary and the performances of the cast are so believable.

Ellen Burstyn as the mother, Lee J. Cobb as the investigating detective, playwright Jason Miller who plays the local priest, and Max von Sydow as the exorcist are all great. However, 14-year-old Linda Blair produces an unbelievably frightening performance as the child possessed by a demon.

Utilizing the voice of Oscar®-winner Mercedes McCambridge as the satanic voice that comes out of the child's body, and a puppet for several confronting scenes including the famous head spinning, *The Exorcist* became the most successful R-rated film to date and the first horror film to be nominated for a Best Film Oscar.

47th Academy Awards®
1974

Best Film: *The Godfather Part II* (Francis Ford Coppola / Paramount)

Best Director: Francis Ford Coppola, *The Godfather Part II*

Best Actor: Art Carney, *Harry and Tonto*

Best Actress: Ellen Burstyn, *Alice Doesn't Live Here Anymore*

Best Supporting Actor: Robert De Niro, *The Godfather Part II*

Best Supporting Actress: Ingrid Bergman, *Murder on the Orient Express*

Containing a film within a film of the early years of the original 'Godfather' (Robert De Niro, left) *The Godfather Part II* won six Oscars® in all, and became the first sequel (of an Oscar®-winning film, no less) to win Best Film. Director Francis Ford Coppola took home three awards, as co-producer, director and screenplay, with original author Mario Puzo (their second).

The Godfather Part II revisits the gangster world of the Corleone crime family under the guidance of the new 'Don', Michael Corleone (Al Pacino, below). The film also won awards for Best Supporting Actor (De Niro), Best Art Direction and Best Original Dramatic Score (Carmine Cappola, the director's father).

Following Academy Award nominations for Best Supporting Actress in the *The Last Picture Show* (1971) and *The Exorcist* (1973), actress Ellen Burstyn (b. 1932) won Best Actress for Martin Scorsese's comedy drama ***Alice Doesn't Live Here Anymore*** (1974).

Alice is single mom who gave up on her singing career to be with her abusive husband (Billy Green Bush) and raise their son (Alfred Lutter). When her husband is killed, Alice and her son move town to escape a potentially disastrous relationship with psychotic cowboy (Harvey Keitel) before she falls for a local rancher (Kris Kristofferson). Funny, sad and confronting in its rawness, *Alice Doesn't Live Here Anymore* (1974) was a success for (above from left) Kristofferson, Burstyn and director Scorsese in what was only his third feature film.

Veteran actor **Art Carney** (1918–2003) caused one of the biggest upsets in Oscar® history when he won Best Actor for ***Harry and Tonto*** (1974). Best known for the 1950s TV show *The Honeymooners* alongside Jackie Gleeson, Carney beat Hollywood heavyweights Al Pacino (*The Godfather Part II*, 1974), Jack Nicholson (*Chinatown*, 1974), Dustin Hoffman (*Lenny*, 1974) and Albert Finney (*Murder on the Orient Express*, 1974) in the Oscar®-winning role of a widowed old man who travels across country with his pet cat, Tonto, and discovers a new outlook on life.

The Godfather Part II
1974

"We're both part of the same hypocrisy, senator, but never think it applies to my family."

Michael Corleone (Al Pacino)

Can a film sequel surpass the original, especially when that film is the modern-day classic, *The Godfather* (1972)? In the hands of original writer Mario Puzo and director Francis Ford Coppola, who also took over the producing duties on this film, it can.

The major concern in undertaking *The Godfather Part II*, however, was that it could affect the legacy of the original film which within two years had become an important part of popular culture. The death of Don Corleone in the first film, and the subsequent reticence by Marlon Brando to reprise the role even in a cameo or flashback, provided the filmmakers with a problem they brilliantly solved.

Coppola always believed that the back story to the rise of *The Godfather* in America, which was laid out in Puzo's original novel, was a film in itself. The career of the new Don, Michael Corleone (Al Pacino), gave Coppola and Puzo the chance to explore the post-war development of Las Vegas, the Senate mafia hearings of the 1950s and even the Cuban revolution of 1959. The two story lines run parallel throughout the film – the origins of the Godfather and the fate of his son, Michael. *The Godfather Part II* is a masterful achievement of narrative and film art, and for me exceeds the original.

Most of the original cast revised their roles (except for Brando and Richard Castellano, who portrayed the rotund Clemenza in *The Godfather*). John Cazale, who had the least to do the first film as the weak Fredo, carries a central part of the plot, as does Diane Keaton as Michael's WASP wife, Kay. Al Pacino as Michael displays an explosive emotional range in this film. *The Godfather Part II* made a star of 31-year-old Robert De Niro, who won an Academy Award for Best Supporting Actor as the young Don Corleone, becoming the first actor to win an Oscar® for portraying an Oscar®-winning character.

There are so many great touches in *The Godfather Part II* which opens, as did the original film, with a wedding. However, this is not a joyful celebration. The Corleone family have resettled from New York to Lake Tahoe, Nevada, but their dream of legitimacy is slipping through their fingers. Trouble back in New York finds its way to Nevada, leading to a showdown – and a betrayal – in Cuba as Michael makes his power play. The final scene, when the Don reflects on what has been lost along the way, especially the loss of family, exposes the dark side of the American dream compared to the malevolent triumph of the first film.

The Godfather Part II won six Oscars®, including Best Film, Best Director (Coppola had lost out to Bob Fosse for *Cabaret* in 1972) and Best Screenplay (Puzo and Coppola, their second). Coppola's father Carmine won an Oscar® for Best Music (Original Dramatic Score, with Nino Rota). The Coppola family are certainly a remarkable family film dynasty. In 2003, daughter Sofia Coppola won an Oscar® for writing *Lost in Translation*; and nephew Nicolas Cage won Best Actor for *Leaving Las Vegas* (1995).

Paramount Pictures / Coppola Company: 200 minutes

Produced and Directed by: Francis Ford Coppola

Screenplay by: Francis Ford Coppola and Mario Puzo, based on the novel *The Godfather* by Mario Puzo

Music by: Nino Rota

Cinematography by: Gordon Willis

Starring: Al Pacino (Michael Corleone), Robert Duvall (Tom Hagen), Diane Keaton (Kay Adams-Corleone), Robert De Niro (young Vito Corleone), John Cazale (Fredo Corleone), Talia Shire (Connie Corleone), Lee Strasberg (Hyman Roth), Michael V. Gazzo (Frank Pentangeli), Morgana King (Carmela Corleone), Richard Bright (Al Neri), Troy Donahue (Merle Johnson), Dominic Chianese (Johnny Ola), Bruno Kirby (young Peter Clemenza), Frank Sivero (young Genco Abbandando), Harry Dean Stanton (FBI agent)

The team behind the 1968 hit *The Producers,* director-writer Mel Brooks (b. 1926) and actor-writer Gene Wilder (1933-2016), produced two comedy gems in the same year in 1974. **Blazing Saddles** (1974) was co-written by Brooks and comedian Richard Pryor, but Warner Bros. refused to cast Pryor in the film because they could not insure him against his being fired (the black comedian was known for controversy and profanity-laden comedy).

Brooks cast TV actor Cleavon Little in the role of Black Bart, and then turned to his old friend Wilder when his original choice as the Waco Kid (veteran actor Dan Dailey) pulled out due to health issues. An absurdist parody of every western cliché relies heavily on puncturing many racist and sexist stereotypes, the film was an enormous success, grossing almost $120 million. Madeline Kahn as the 'Teutonic Titwillow' Lili von Shtupp, was alone worth the price of admission.

Gene Wilder wrote *Young Frankenstein* (1974) as an homage to the great Universal horror films of the 1930s, except with his own bizarre take on proceedings. Wilder plays the grandson of the original Baron Frankenstein ('pronounced Frunk-un-shteen') who returns to Transylvania to claim his rightful heritage and quickly returns to the family business of bringing life to the dead.

After working together on *Blazing Saddles*, Wilder asked Brooks to direct his film project because he thought the studio wouldn't support him as a first-time director. English comic Marty Feldman, as incompetent manservant Igor, and Peter Boyle as the Monster add to the film's absurdity, while comedienne Madeleine Kahn, again, is a knockout as Wilder's prickly fiancé.

Francis Ford Coppola proved that his *Godfather* films were not the only weapon in his film arsenal when he wrote, directed and produced **The Conversation** (1974), a gem of a movie about a lonely, obsessive surveillance professional (Gene Hackman) who overhears what he thinks to be a planned murder among the city's corporate elite.

Hackman's Harry Caul is a character study in minimalist acting as he agonizes over acting upon what he thinks is going to happen, and then when the situation is turned on its head, the paranoia he feels when he realizes 'they' might be watching him. A huge amount of the fun of the film is watching the techno geeks (played by character actors John Cazale, Allen Garfield and Michael Higgins) discuss their gadgets and the reverence they show Harry, but in the same year that *The Godfather Part II* swept the Oscars®, *The Conversation* confirms Coppola's greatness as a filmmaker.

Jack Nicholson

b. 1937

Jack Nicholson burst into mainstream Hollywood films after a decade learning his trade in the counterculture film industry of the 1960s. A series of Oscar®-nominated performances in the early 1970s culminated in his Academy Award-winning role in *One Flew Over the Cuckoo's Nest* (1975). With untapped reserves of angst and anger behind that wicked smile and the one raised eyebrow, Nicholson was often fearless in his film choices (he also starred in a comedy, a musical and a thriller in 1975, the year he won his first Oscar) despite his tendency towards self-parody. Although his directing career did not take off, Nicholson was very much the actor of his generation and was rewarded with Best Supporting Actor for *Terms of Endearment* (1983) and Best Actor for *As Good as It Gets* (1997).

KEY FILMS

Easy Rider (1969)
Five Easy Pieces (1970)
Carnal Knowledge (1971)
The Last Detail (1973)
Chinatown (1974)
The Passenger (1975)
Tommy (1975)
The Fortune (1975)
One Flew Over the Cuckoo's Nest (1975)
The Missouri Breaks (1976)
Goin' South (1978)
The Shining (1980)
Reds (1981)
Terms of Endearment (1983)
Prizzi's Honor (1985)
The Witches of Eastwick (1987)
Batman (1989)
A Few Good Men (1992)
Hoffa (1992)
The Crossing Guard (1995)
As Good as It Gets (1997)
About Schmidt (2002)
Something's Gotta Give (2003)
The Departed (2006)
The Bucket List (2007)

It takes a brave actor to wear a bandage over half his face for most of a film and suffer the indignity of having the chief heavy constantly mispronounce his characters' name. But they were not the only setbacks that private detective J.J. Gittes (Jack Nicholson) suffers in the complex noir-ish film **Chinatown**.

Gittes is lied to, taken for a fool, falls for the femme fatale (Faye Dunaway at her most arresting) and remains offside with the local constabulary for much of the film.

Brilliantly written by Robert Towne and faithfully directed in 1930s style by Roman Polanski, *Chinatown* continued Jack Nicholson's career trajectory towards him winning a Best Actor Oscar.

Famed director John Huston, in an acting role, is the picture of malevolent evil as patriarch Noah Cross, the harborer of a dark family secret and the main cause of much of the skulduggery in drought-stricken California. All the threads come together in *Chinatown* at the end of the film, but there is no happy end for Gittes. Confused? Forget about it, Jake. It's Chinatown.

48th Academy Awards®

1975

Best Film: *One Flew Over the Cuckoo's Nest* (United Artists)

Best Director: Miloš Forman, *One Flew Over the Cuckoo's Nest*

Best Actor: Jack Nicholson, *One Flew Over the Cuckoo's Nest*

Best Actress: Louise Fletcher, *One Flew Over the Cuckoo's Nest*

Best Supporting Actor: George Burns, *The Sunshine Boys*

Best Supporting Actress: Lee Grant, *Shampoo*

One Flew Over the Cuckoo's Nest (1975) was the first film since *It Happened One Night* (1934) to win the top four Academy Awards® – Best Film, Best Director, Best Actress, and an overdue Best Actor Oscar® for Jack Nicholson in his bravura performance as the free-spirited R.P. McMurphy.

The Best Actress Oscar® went to relative unknown Louise Fletcher (pictured left, with Nicholson) who was cast in the pivotal role of Nurse Ratched. *One Flew Over the Cuckoo's Nest* swept the major Oscar Awards for 1975, with Lawrence Hauben and Bo Goldman also winning for Best Adapted Screenplay.

Many felt that Ken Kesey's 1962 novel about a voluntary psychiatric inmate's battle against conformity and institutionalized control would never be filmed. The book had been adapted to the stage in the early 1960s by actor Kirk Douglas, who owned the film rights to *One Flew Over the Cuckoo's Nest* and hoped to bring his version to the screen. Douglas even chose a director, Czech Miloš Forman, but Douglas couldn't get the funding to make the film.

In the mid-1970s, his son Michael Douglas took over the project as producer and cast his friend Jack Nicholson in the lead role. Screenwriter Bo Goldman solved the structural problems with the script by dispensing with the narration by 'Chief' Bromden, the mute Indian that McMurphy befriends when he enters the psychiatric hospital so that he can complete his jail time in more comfortable surrounds.

The younger Douglas hired Forman to direct and obtained the necessary funding from United Artists. Fellow inmates in the film included real patients and staff – Dean Brooks, the superintendent of Oregon State Hospital where the film was made, played the role as the hospital super. Character actors of note include Danny DeVito, Christopher Lloyd, Sydney Lassick, Brad Dourif, Michael Berryman (later to star in *The Hills Have Eyes*, 1977), Scatman Crothers, and of course Will Sampson as The Chief.

Nashville (1975) is director Robert Altman's snapshot of life in the Southern music capital; a patchwork quilt of interconnecting people with disparate lives, some searching for success and fame and others, for love and contentment.

More than 20 characters flit in and out of the film, played by Ned Beatty, Karen Black, Lily Tomlin, Keith Carradine, Shelley Duvall, Scott Glenn, Jeff Goldblum, Barbara Harris, Ronee Blakely, Geraldine Chaplin, Henry Gibson, Elliott Gould and Julie Christie (the latter pair playing themselves).

Was it a drama, was it a musical, was it a comedy? Who knew, but using the country music capital for context, Altman held a mirror up to modern American society (the movie climaxes with an assassination attempt of a public figure while another character seizes the moment to launch her bid for fame).

Nashville won only one Oscar® for Best Original Song, 'I'm Easy' by Keith Carradine. It was unfortunate the film was released in a year of stellar films.

Directed by Hal Ashby, ***Shampoo*** (1975) was a look back at the sexual values in 1960s' Hollywood. Warren Beatty produced, co-wrote (with Robert Towne, *Chinatown*, 1974) and starred in this comedy-drama about a celebrity hairdresser trying to get ahead in Hollywood.

Beatty cast two leading ladies from his personal life, Goldie Hawn and Julie Christie, in main roles as well as veteran actress Lee Grant who won the Oscar® for Supporting Actress, and newcomer Carrie Fisher – the teenage daughter of actress Debbie Reynolds – was also cast as another of the Hollywood hairdresser's sexual conquests.

The film tries to critique the politics and morals of the times with mixed results (the film is set during the 1968 presidential elections) but Beatty deserves praise for tackling a role that reveals his character for who he really is, a shallow stud. At the end of the film, Beatty's character George has cheated on everyone, taken his talent for granted and is left all alone. Perhaps that sums up the 1960s better than most films.

The premise of **Dog Day Afternoon** seemed perhaps far-fetched even for the 1970s – a Vietnam vet wanting to escape an unhappy marriage holds up a bank in his Brooklyn neighbourhood so he can give the money to his transgender lover for a sex change – except that it really happened.

When the robbery goes wrong and the bank staff are held hostage, the man becomes a local hero and a media sensation – and this was decades before the advent of social media and the internet.

Al Pacino (above) is perfect as wild-eyed loser Sonny Wortzik, while his *Godfather* co-star John Cazale elicits much of the sympathy as his hapless, guntoting accomplice 'Sal' Naturale.

As the situation quickly gets out of control after the police arrive, Sonny and Sal emotionally unravel.

Special mention must be made of Charles Durning (as Sgt Moretti), James Broderick (as FBI agent Sheldon) and Chris Sarandon in a scene-stealing turn as Sonny's soon-to-be-female lover. Director Sidney Lumet's handling of the crowd scenes outside the bank are utterly convincing as the mob turn against the cops and cheer the crooks, with tragic consequences.

Steven Spielberg
b. 1946

Steven Spielberg is a born filmmaker with an undeniable ability to please audiences.

He made his first Hollywood film at age 24 and redefined the term 'blockbuster' with *Jaws* (1975) before he turned 30.

Spielberg is responsible for some of the most successful films in history, notably *E.T. the Extra-Terrestrial* (1982), the original *Indiana Jones* trilogy in the 1980s and the *Jurassic Park* trilogy in the 1990s. He intrinsically knows what fans want and how best to deliver it.

His Oscar®-winning *Schindler's List* (1993) displayed a welcome maturity to his filmmaking when so many of his most popular films, including a second Oscar® for directing *Saving Private Ryan* (1998), tended to lapse into sentimentality.

Forty years after *Jaws*, however, Spielberg is still top of his game.

KEY FILMS

Duel (1971)
Jaws (1975)
Close Encounters of the Third Kind (1977)
Raiders of the Lost Ark (1981)
E.T. the Extra-Terrestrial (1982)
Indiana Jones and the Temple of Doom (1984)
The Color Purple (1985)
Empire of the Sun (1987)
Indiana Jones and the Last Crusade (1989)
Hook (1991)
Jurassic Park (1993)
Schindler's List (1993)
Amistad (1998)
Saving Private Ryan (1998)
A.I. Artificial Intelligence (2001)
Minority Report (2002)
Catch Me If You Can (2002)
War of the Worlds (2005)
Munich (2005)
War Horse (2012)
Lincoln (2012)
Bridge of Spies (2015)
The Post (2017)

Jaws (1975) redefined the term 'movie blockbuster' in the 1970s but everyone involved in the project thought it would turn out to be an unmitigated disaster. Director Steven Spielberg was just 28 years old when he embarked on the film adaptation of Peter Benchley's bestselling novel about a rogue shark preying upon the inhabitants of a tourist port.

Spielberg assembled a willing cast – Roy Scheider as Chief Brody, Richard Dreyfuss as marine biologist Matt Hooper, and Robert Shaw as the grizzled seaman Quint – but he was sure he had a flop on his hands when the production team could not get the expensive mechanical shark to work effectively. Spielberg was forced to hide the monster from audience view until the unforgettable climax on the open sea. It proved to be a good result as the tension and expectation builds throughout the film to almost 'Hitchcockian' proportions.

With a memorable score from John Williams and comedic touches added by co-writer Carl Gottlieb, *Jaws* was released in hundreds of North American cinemas simultaneously during the summer of 1975 and became a cinematic sensation.

49th Academy Awards®

1976

Best Film: *Rocky* (United Artists)

Best Director: John G. Avildsen, *Rocky*

Best Actor: Peter Finch, *Network*

Best Actress: Faye Dunaway, *Network*

Best Supporting Actor: Jason Robards, *All the President's Men*

Best Supporting Actress: Beatrice Straight, *Network*

Rocky (1976) was the underdog of the 1976 Academy Awards® that knocked out favorites *All the President's Men* and *Network* to win Best Film. But then, the story of a struggling boxer who gets his one shot at glory was a winner with pretty much the entire world in the late 1970s.

Sylvester Stallone (b. 1946, left) wrote the original screenplay and developed the project at United Artists on the proviso that he played the lead role. With Oscar®-winning direction from John G. Alvildsen and a mighty score from Bill Conti, including the theme 'Flying High Now', Rocky won three Oscars® and spawned numerous sequels over the next 40 years.

Network (1976) won screenwriter Paddy Chayefsky (*The Hospital*, 1971) the Oscar® for Best Original Screenplay in 1976. A satirical take on the morals of American TV, the fictional UBS network leaves its star news anchor Howard Beale (Peter Finch) on air after he has a breakdown and threatens to kill himself on camera.

Only when Beale starts to lose his audience do Network chiefs, played by Faye Dunaway and Robert Duvall, make the decision to take him off air in a way that will maximize ratings. Instead of canceling his show, however, they have Beale assassinated live on TV.

William Holden, as veteran network head Max Shumacher, represents the old guard – principled and cultivated – but even he is seduced by the youth of Diana Christensen (Dunaway).

Schumacher's wife (Beatrice Straight) appears in just one crucial five-minute scene but it was enough to earn her the Oscar® for Best Supporting Actress. Peter Finch became the first actor to win a posthumous Best Actor Oscar® when he died suddenly in January 1977, aged 60. Faye Dunaway also won an Oscar®, giving the film a trio of top acting awards, only to be beaten for Best Film by *Rocky*.

All the President's Men
1976

"We're under a lot of pressure, you know, and you put us there. Nothing's riding on this except the, uh, first amendment to the Constitution, freedom of the press, and maybe the future of the country."

Ben Bradlee (Jason Robards Jr)

How do you make a suspenseful film out of a political thriller when the whole world already knows 'whodunnit?' That was the dilemma facing Robert Redford after he bought the film rights to the Pulitzer Prize-winning *All the President's Men*, the story of how a bungled burglary of Democratic headquarters at Washington's Watergate building and its subsequent cover up brought down President Richard Nixon. Redford secured the services of writer William Goldman (*Butch Cassidy and the Sundance Kid*, 1969) and director Alan J. Pakula (*Klute*, 1971) and the result was a classic of its genre – a tightly scripted, suspenseful political thriller without violence or even the hint of a car chase.

Redford bore little resemblance, physically or emotionally, to the writer Bob Woodward but starring in the film was part of the deal in getting the project financed. For his partner, the brashly confident Carl Bernstein, Woodward chose Dustin Hoffman who was much closer in style and manner to the journalist. Bernstein famously tried to get Redford to film the script written by him and then girlfriend, the writer Norah Ephron (*Sleepless in Seattle*, 1993), in which he was the main hero. Redford's reply was, "But Carl. Errol Flynn is dead." Goldman would go on and win the Oscar® for his screenplay.

The 'film' location of the *Washington Post* is filled with fine character actors who carry the complicated plot – Jack Warden, Martin Balsam, and especially Jason Robards, in his Oscar®-winning role as Ben Bradlee, the editor of the newspaper. Jane Alexander, Ned Beatty and Hal Holbrook, as Washington whistle-blower 'Deep Throat', round out a fine cast. Redford's scenes in a dark car park talking to 'Deep Throat' in the middle of the night add to the tension of the movie. It was not until forty years later that the identity of 'Deep Throat' was revealed to be veteran FBI agent W. Mark Felt (1913–2008).

The forensic trail Woodward and Bernstein (referred to by the amalgam 'Woodstein' by *Washington Post* colleagues) exposes the White House's involvement in a 'dirty tricks' campaign leading up to the 1972 presidential election. The detective work undertaken by the two journalists provides the story but it was the recreation of the entire floor of the *Washington Post* newsroom – including reams of paper, desks, lighting, phone books and typewriters – that became highly influential for other films.

In real life, Woodward and Bernstein were not heroes, or even friends, but colleagues with petty jealousies, shortcomings and blind spots like any other professional journalists. In that regard, the competitive natures of Redford and Hoffman are well-serviced in this film. While Redford shines in the scenes with 'Deep Throat', equally effective are Hoffman's interviews with the female members of the Committee to Re-elect the President (known by the acronym, CREEP). Hoffman's character is sublime with his almost sensitive interrogation of CREEP lawyer Donald Segretti (Robert Walden).

The initial concern that the actors could make well-known Washington people – important people with jobs and careers – appear vain or foolish proved to be unfounded. Everyone in the film, even most of the villains, came out looking good.

All except Nixon.

Warner Bros. / Wildwood Enterprises: 138 minutes

Produced by: Walter Coblenz

Directed by: Alan J. Pakula

Screenplay by: William Goldman,
based on the book by Carl Bernstein and Bob Woodward

Music by: David Shire

Cinematography by: Gordon Willis

Starring: Dustin Hoffman (Carl Bernstein), Robert Redford (Bob Woodward), Jack Warden (Harry M. Rosenfeld), Martin Balsam (Howard Simons), Hal Holbrook ('Deep Throat'), Jason Robards (Ben Bradlee), Jane Alexander (Judy Hoback Miller), Meredith Baxter (Deborah Murray Sloan), Ned Beatty (Martin Dardis), Stephen Collins (Hugh W. Sloan Jr), Lindsay Crouse (Kay Eddy).

Martin Scorsese

b. 1942

Martin Scorsese is another in the long line of New York filmmakers, but one whose intense visual style and innate understanding of his actors have become features of his films.

One of the 'new wave' of Hollywood directors in the early 1970s, he was an assistant director and editor on the Oscar®-winning documentary *Woodstock* (1970), and popular music as narrative often plays an important role in his films, as does his Italian heritage. *Taxi Driver* (1976), a hellish vision of personal isolation, made his reputation. With frequent collaborator Robert De Niro (8 films and counting), they brought *Raging Bull* (1980) to the screen which was voted the best film of the 1980s.

Scorsese has also made a number of great documentaries including *The Last Waltz* (1978), *A Personal Journey Through American Movies with Martin Scorse*se (1995), *No Direction Home: Bob Dylan* (2005), *Shine a Light* (2008), *Public Speaking* (2010) with Fran Lebowitz, and *George Harrison: Living in the Material World* (2011).

In recent years he has worked with Leonardo DiCaprio on 5 films including *The Departed* (2006) – their take on bad cops and Irish gangsters – that won Oscars® for Best Film and Best Director.

Scorsese continues to surprise and shock.

KEY FILMS

Mean Streets (1973)
Alice Doesn't Live Here Anymore (1974)
Taxi Driver (1976)
Raging Bull (1980)
The Color of Money (1986)
The Last Temptation of Christ (1988)
GoodFellas (1990)
Cape Fear (1991)
The Age of Innocence (1993)
Casino (1995)
Gangs of New York (2002)
The Aviator (2004)
The Departed (2006)
Hugo (2011)
The Wolf of Wall Street (2013)

Directed by Martin Scorsese from a script by Paul Schrader, **Taxi Driver** (1976) is a troubling look at alienation in American society and succeeds in blurring the line between hero and villain.

Robert De Niro is Travis Bickle, a Vietnam veteran-turned New York taxi driver, whose decline into hell results in him planning the assassination of a presidential candidate to impress a pretty campaign volunteer (Cybil Shepherd). Although foiled in his attempt, Bickle becomes an unlikely hero when he uses his gun to rescue a child prostitute (Jody Foster) from a seedy pimp (Harvey Keitel).

With dreamlike narration from De Niro and stunning cinematic flashes from Scorsese, the climactic shootout in a brothel is both shocking and mesmerizing – like witnessing a spectacular car accident and then photographing the bodies.

283

50th Academy Awards®

1977

Best Film: *Annie Hall* (United Artists)

Best Director: Woody Allen, *Annie Hall*

Best Actor: Richard Dreyfuss, *The Goodbye Girl*

Best Actress: Diane Keaton, *Annie Hall*

Best Supporting Actor: Jason Robards, *Julia*

Best Supporting Actress: Vanessa Redgrave, *Julia*

Annie Hall (1977) was the surprise hit of 1977, winning Oscars® for Best Film, Best Director, Best Actress and Best Screenplay.

New York comic Woody Allen had been something of an acquired taste for filmgoers, but *Annie Hall* showed Allen at his most mature as a filmmaker winning him a whole legion of new fans. Drawing on his real-life relationships for inspiration, Allen cast former flame Diane Keaton (b. 1946 as Diane Hall) in this perceptive comedy about the pitfalls of falling in love in the big city.

Keaton won the Oscar® for her quirky take on the title character, which Allen wrote as an exaggeration of her personality. Allen still makes his jokes, plays to his neuroses and talks directly to the audience, but he's hard not to like in this totally original romantic comedy.

Fred Zinneman's period drama ***Julia*** (1977) focuses on the relationship between writer Lillian Hellman and her childhood friend Julia who, in the 1930s, is a Jewish intellectual living in Nazi Germany.

When Hellman is invited to Moscow for a writer's conference, she agrees to smuggle money into the country for Julia but the move has fatal consequences. At the time, Hellman (Jane Fonda) was the partner of writer Dashiell Hammett (Jason Robards) and was later blacklisted because of her socialist views.

British actress, Vanessa Redgrave (Julia) and Robards each won Best Supporting Oscars® for the film. Screenwriter Alvin Sargent also won an Oscar®. It was Robards' second successive win in the category (after *All the President's Men*, 1976).

In ***The Goodbye Girl*** (1977), Richard Dreyfus (b. 1947) became the youngest actor in Academy history to win the Oscar® for Best Actor at the age of 30 (since bettered by 29-year-old Adrien Brody in *The Pianist*, 2002). Dreyfus was on a hot streak after the success of *Jaws* (1975) and *Close Encounters of the Third Kind* (1977). His role in *The Goodbye Girl*, as written by playwright Neil Simon (*The Odd Couple*, 1968), was tailor-made for him.

Star Wars (1977) succeeded where *Silent Running* (1972), *Solaris* (1972) and *Dark Star* (1974) failed in the 1970s, finding not only a mass audience for science fiction but also generations of devotees.

With a story from George Lucas (*American Graffiti*, 1973), the key to the film's success was the innovative use of special effects and the casting of the main characters – Luke Skywalker (Mark Hamill), Han Solo (Harrison Ford) and Princess Leia (Carrie Fisher). All actors were relative unknowns when they were cast (that was soon to change), while Oscar®-winner Alec Guinness (*The Bridge on the River Kwai*, 1957) dominates the film as Jedi Master Obi-Wan Kenobi.

With a giant furry Wookie, a Laurel and Hardy pair of robots, sundry aliens and a masked villain Darth Vader (voice of James Earl Jones), *Star Wars* was cinema's new box office champ in the 1970s and spawned numerous sequels and prequels.

Close Encounters of the Third Kind (1977) was Steven Spielberg's more personal vision of aliens, setting the film in suburbia rather than outer space.

Roy Neary (Richard Dreyfuss) plays an American everyman trying to make sense of an 'encounter' with aliens, and instills his character with a believable sense of wonder that audiences can relate to given similar circumstances.

French film director Francois Truffaut is interesting as an international scientist, and Bob Balaban (as the interpreter Laughlin) helps the audience make sense of it all. Melinda Dillon who plays the frantic mother searching for her son after he is taken by the aliens, gives the film the heart it desperately needs.

The special effects (by Douglas Trumbull and Carlo Rambaldi) are the film's towering achievement, and when the aliens finally do show themselves as warm and cuddly rubbery figures, we are not too disappointed. (Is it just me or do the aliens facially resemble the small boy they capture?)

Released in the wake of *Star Wars*' success, *Close Encounters of the Third Kind* did great business in its initial run, and later when re-released as a *Special Edition* in 1981 with some deletions and extra scenes.

51st Academy Awards®

1978

Best Film: *The Deer Hunter* (Columbia / EMI / Universal)

Best Director: Michael Cimino, *The Deer Hunter*

Best Actor: Jon Voight, *Coming Home*

Best Actress: Jane Fonda, *Coming Home*

Best Supporting Actor: Christopher Walken, *The Deer Hunter*

Best Supporting Actress: Maggie Smith, *California Suite*

The Deer Hunter (1978) is a remarkable cinematic experience but it has one flaw. Oscar®-winning director Michael Cinimo uses the deadly game of Russian roulette to symbolize the nature of war, but because it is such a powerful allegory many people thought these events actually happened during the Vietnam War. They didn't.

The film features two key actors from *The Godfather Part II* (1974), Robert De Niro and John Cazale (pictured below), with newcomers Christopher Walken (in his Oscar®-winning role for best Supporting Actor as Nick), John Savage and Meryl Streep (also below). *The Deer Hunter* was the final role for Cazale (1935–1978) who succumbed to lung cancer before the film was completed.

Jane Fonda and Jon Voight (pictured left) won the Best Actor/Actress Oscars® for ***Coming Home*** (1978), Hal Ashby's thoughtful examination of relationships in the wake of the Vietnam War.

Fonda's second Oscar® for the decade, in this film she plays a woman who falls in love with a paralyzed war veteran (Voight) while her troubled husband (the always watchable Bruce Dern) is away fighting in Vietnam.

Coming Home was a welcome counterpoint to the revisionist war film *The Deer Hunter* which was also released in 1978. However, both films provided no easy answers for those men and women physically and emotionally wounded because of the war.

Heaven Can Wait (1978) was Warren Beatty's successful remake of the 1941 film *Here Comes Mr Jordan*.

Beatty as writer (with contributions from co-director Buck Henry, Robert Towne and comedienne Elaine May) reworks the 1940s fantasy of a boxer dispatched to heaven before his time by an incompetent angel. In this remake, the lead is now a quarterback in gridiron football.

Beatty brings his likeable charm to the main role, having a bit of fun perhaps with the criticism that he often dies at the end of his films to evoke maximum audience sympathy.

Ably supported by regular co-stars Julie Christie and Jack Warden, as well as James Mason (as head angel Mr Jordan), Beatty was nominated for Oscars® in direction, writing and as lead actor but unlike Woody Allen the previous year, went home empty handed.

Most people thought the producers of the film ***Superman*** (1978) were crazy, given the kitsch TV series of the 1950s and the prospect of a man in tights being held up by suspension wire.

The finished film, however, turned out to be a huge commercial success largely because of the technical achievement of convincing the audience that a man could actually fly and a highly-paid supporting cast.

With perfectly cast newcomer Christopher Reeve (1952–2004) donning the Superman suit, Marlon Brando (as Superman's father Jor-El) and Gene Hackman (as villain Lex Luthor), the cast brought an often funny and ironic screenplay by Mario Puzo (*The Godfather*, 1972) to life.

Canadian actress Margot Kidder (b. 1948) was a new style Lois Lane – more independent career woman than damsel in distress – while the success of the film spawned several sequels and two reboots.

As imagined by the Monty Python comedy team, ***Monty Python's Life of Brian*** (1979) created so much controversy that the film's backers, EMI, pulled out before the film was even made.

There was a real fear that *Life of Brian* would be a merciless parody of the life of Christ and the film establishment wanted nothing to do with it.

Former Beatle George Harrison, however, stepped in with the necessary funding and the film was eventually made in Tunisia in late 1978.

The Pythons, John Cleese, Terry Gilliam, Eric Idle, Terry Jones (also director), Michael Palin and Graham Chapman as Brian, came out looking pretty good, but the same could not be said for many of the 'followers' who consistently misread the signs and argued whether Brian was, in fact, the Messiah.

Audiences were not so thick, and not only did they get the irony and satire in the film but thoroughly enjoyed the wonderful comedy nonsense from the lads. "Crucifixion anyone?"

Breaking Away (1979) is one of the best coming-of-age films from the 1970s. The story of four friends in the twilight year after high school before the reality of adult responsibilities sets in. The film won writer Steve Tesich the Oscar® for Best Original Screenplay.

Filmed by British director Peter Yates on location in the college-town of Bloomington Indiana, *Breaking Away* follows the adventures of (pictured from left) love-struck Moocher (Jackie Earle Haley), goofy Cyril (Daniel Stern), bike enthusiast Dave (Dennis Christopher) and disillusioned jock Mike (Dennis Quaid).

The climax of the film, which could have so easily been a cliché in lesser hands, sees the local boys take on the college kids in the Little 500 bike race – with obvious results, which are no less exhilarating in this little winner of a film.

Woody Allen

b. 1935

Woody Allen remains the quintessential neurotic New Yorker for a generation of fans who followed his career from stand-up comic and fledgling actor/writer/director to multiple Academy Award winner. Quirky, witty and remotely good-looking (in a nebbish sort of way), Allen proved to be a wonderful observer of relationships, a master of comic timing and an economically clever film-maker. After his breakthrough success with *Annie Hall* (1977), his first 'straight film' (for Allen, that is, which is still incredibly funny), he has made roughly a film a year – often starring himself, but more recently featuring a long line of established stars. Given his complicated private life and the body of work he has still produced, Woody Allen can be seen as a 'Charlie Chaplin' for modern times … a flawed genius.

KEY FILMS

Take the Money and Run (1969)
*Play It Again, Sam** (1972)
Everything You Always Wanted to Know About Sex (But Were Afraid to Ask) (1972)
Sleeper (1973)
Love and Death (1975)
Annie Hall (1977)
Manhattan (1979)
Stardust Memories (1980)
Zelig (1983)
Broadway Danny Rose (1984)
The Purple Rose of Cairo (1985)
Hannah and Her Sisters (1986)
Crimes and Misdemeanors (1989)
Husbands and Wives (1992)
Manhattan Murder Mystery (1993)
*Bullets Over Broadway*** (1994)
Mighty Aphrodite (1995)
*Sweet and Lowdown*** (1999)
Match Point (2005)
*Vicky Cristina Barcelona*** (2008)
*Midnight in Paris*** (2011)
*Blue Jasmine*** (2013)
**not directed by Woody Allen*
***not starring Woody Allen*

Manhattan (1979) may well be Woody Allen's most complete and satisfying film. From the opening scenes of fireworks over New York to the strains of Gershwin's 'Rhapsody in Blue', *Manhattan* finds Allen at the absolute top of his game.

Comparisons to *Annie Hall* were obvious, but although he reunited with co-star Diane Keaton, *Manhattan* was a different love story altogether to their previous collaborations.

Filmed in black and white, Allen plays a divorced father who is having an affair with a high school student when he falls for his best friend's (Michael Murphy) mistress (Diane Keaton).

At the same time, Isaac Davis (Woody Allen) is mortified his ex-wife (Meryl Streep) is writing a tell-all book about the inadequacies of their love life, and trades in his relationship with the young and impressionable student, Tracy (Mariel Hemingway, nominated for Best Supporting Actress) to pursue the icy Mary (Keaton) playing the polar opposite of her lovable *Annie Hall* character.

Only Allen could get away with such a self-absorbed premise and make characters so believable. When his character realizes that he really loved Tracy, Allen delivers a poignant message about love lost as only he could.

52nd Academy Awards®

1979

Best Film: *Kramer vs. Kramer* (Columbia)

Best Director: Robert Benton, *Kramer vs. Kramer*

Best Actor: Dustin Hoffman, *Kramer vs. Kramer*

Best Actress: Sally Field, *Norma Rae*

Best Supporting Actor: Melvyn Douglas, *Being There*

Best Supporting Actress: Meryl Streep, *Kramer vs. Kramer*

Kramer vs. Kramer (1979) was no run of the mill drama about a family break-up (which was still something of a novelty in the 1970s).

As written and directed by Robert Benton (*Bonnie and Clyde*, 1967), *Kramer vs. Kramer* was about real people and the impact divorce has on them all.

The film won five Oscars® including Best Film, Best Director (Benton) and Best Actor (Hoffman), Best Supporting Actress (Streep) and Adapted Screenplay (Benton).

The Oscars® were the first for Benton and Hoffman but each would achieve further success in the 1980s.

Being There (1979), based on the 1970 novella by Jerzy Kolinski, had been Peter Sellers' personal project for much of the decade, but it wasn't until he reprised his role as Inspector Clouseau in the *Pink Panther* movies that he once again had the box office clout to get the movie made.

Director Hal Ashby handsomely creates the world of American power and affluence of Ben Rand (Melvyn Douglas in his Oscar®-winning role) and his younger wife Eve (Shirley MacLaine).

Through a series of accidental opportunities, Chance the gardener, a.k.a. Chauncey Gardiner (Sellers) becomes their house-guest and quickly emerges as a possible candidate for US president.

The final scene is open to a world of interpretation but Sellers' mastery of the role, the penultimate of his career, makes the audience want to believe in him too.

Sally Field (b. 1946) shrugged off sugary TV roles (*Gidget*, *The Flying Nun*) to win the first of two career Oscars® as a unionized factory worker in ***Norma Rae*** (1979). Field had steadily increased her star power in the 1970s and, after playing second lead in several Burt Reynolds comedies, became one of the most sought-after actresses of the 1980s and 1990s.

Alien
1979

"You still don't understand what you're dealing with, do you? The perfect organism. Its structural perfection is matched only by its hostility."

Ash (Ian Holm)

Filmed in England's Shepparton Studios under tight security in the autumn of 1978, 20th Century Fox took great lengths to keep the screenplay of *Alien* a secret. Following quickly on the feel-good success of *Star Wars* and the whimsy of *Close Encounters of the Third Kind* (both 1977), *Alien* was a completely different take on the popular sci-fi medium. In this film, an alien lifeform compromises a spacecraft and viciously picks off the crew one by one. Cleverly marketed with the line, "In space no-one can hear you scream", *Alien* rewrote the book on sci-fi films at the end of the 1970s and proved to be highly influential in the decades ahead as well as spawning several sequels.

Writer Ron Shusett had first imagined the story as a World War II drama with a 'gremlin' attacking the crew of a B52 bomber. Colleague Dan O'Bannon, having written the script for John Carpenter's sci-fi cult classic *Dark Star* (1974), changed the context of the story to the distant future and the word 'alien' leapt off the page at him.

Director Walter Hill was first attached to the project (he would later move to producer) and introduced the subplot of a secret cyborg among the crew. English director Ridley Scott, with only one film under his belt (*The Duellists*, 1977), came on board. A highly sought-after director of commercials, Scott bought a unique visual style to the project.

The most important element in the film's success came in casting a woman in the role of third officer, Ripley. The 'hero' of the piece was filled by relative unknown Sigourney Weaver (b. 1949). When most of the audience looks to Captain Dallas (Tom Skerritt) or Parker (Yaphet Kotto) to save the day, it is Weaver's character Ripley who steps forward to battle the alien.

The cast was made up of stellar character actors including US underground favorites Veronica Cartwright and Harry Dean Stanton and yet-to-be-famous English actors Ian Holm and John Hurt, the latter a late replacement for Jon Finch (*Frenzy*, 1972) who suffered a diabetic attack on his first day of filming.

The crew of the *Nostromo* are not explorers or fighters, they are workers living on an industrial-sized refinery mining resources in space. There is a directive however that they must investigate unknown signals if they encounter them. This adds to the tension of a crew that is already bickering before their vessel is compromised. Interestingly, Scott doesn't show the monster until the final scenes of the film (as with *Jaws*, 1975), when it is revealed in all is terrible glory.

The alien, as imagined by Swiss artist H.R. Giger, is the real star of the film and was based on Giger's highly sexualized images in his 1977 book *Necronomicon*. Giger's 'biomechanics' design – machines as living organisms – won him and his visual effects team the Oscar® for Best Effects–Visual Effects. Interestingly, many in his team (including writer O'Bannon) had been involved in the production of an aborted film of Frank Herbert's novel *Dune* (which would later be made by David Lynch in 1985).

A wonderful musical score from Jerry Goldsmith, especially in the climactic scene, keeps the audience on edge right to the credits.

20th Century-Fox / Brandywine-Ronald Shusett Productions: 117 minutes

Produced by: Gordon Carroll, David Giler and Walter Hill

Directed by: Ridley Scott

Screenplay by: Dan O'Bannon, story by Dan O'Bannon and Ronald Shusett

Music by: Jerry Goldsmith

Cinematography by: Derek Vanlint

Starring: Tom Skerritt (Dallas), Sigourney Weaver (Ripley), Veronica Cartwright (Lambert), Harry Dean Stanton (Brett), John Hurt (Kane), Ian Holm (Ash), Yaphet Kotto (Parker).

Francis Ford Coppola

b. 1939

Francis Ford Coppola started his career as a film journeyman, winning a screenwriting Oscar® for *Patton* (1970) while trying to ignite his directing career.

Against all odds, Coppola transformed *The Godfather* (1972) into a cultural blockbuster. He used his newfound clout to produce *Paper Moon* and *American Graffiti* (both in 1973), found critical success with *The Conversation* (1974) before cleaning up at the Oscars® as writer, director and producer with *The Godfather Part II* (1974).

He then spent the rest of the 1970s bringing *Apocalypse Now* (1979) to the screen and though the project almost destroyed him, the film reflected his singular vision.

After a string of poor films in the 1980s, Coppola had nowhere to go but to *The Godfather Part III* (1990), and though the film inevitably may have disappointed some, it was still nominated for six Oscars®.

KEY FILMS

The Rain People (1969)
The Godfather (1972)
The Conversation (1974)
The Godfather Part II (1974)
Apocalypse Now (1979)
The Outsiders (1983)
Rumble Fish (1983)
The Cotton Club (1984)
Peggy Sue Got Married (1986)
The Godfather Part III (1990)
Bram Stocker's Dracula (1992)
The Rainmaker (1997)

Apocalypse Now (1979) was not just a film to Francis Ford Coppola, making it was a huge part of the director's life. Adapting Robert Conrad's seminal novel *Heart of Darkness* to the context of the Vietnam War was a pet project for Coppola and writer-director John Milius, but the project was fraught with setbacks before its eventual release in 1979.

The story of a navy patrol boat's sojourn into Cambodia to "terminate – with extreme prejudice" a colonel who had gone native seemed simple enough, but the project would have a troubled four-year gestation, as seen in the 1991 documentary *Hearts of Darkness: A Filmmaker's Apocalypse.*

Martin Sheen (right), who replaced actor Harvey Keitel as Willard, suffered a heart attack on the shoot; the set was destroyed by a cyclone; and Coppola had to bribe the Philippine government to supply the necessary helicopters for the key attack scene (above with actor Robert Duvall, centre).

Marlon Brando, who had been hired at great expense for the role of Colonel Kurtz, turned up on set grossly overweight – Coppola had to film his scenes in relative darkness. Coppola was millions of dollars over budget, with no clear ending to his film, but reshoots in 1977 and a year of editing and postproduction saw the film finally released to critical and commercial acclaim. Coppola had pulled off the impossible and made another classic.

Coppola later released *Apocalypse Now Redux* (2001), inserting 49 more minutes of scenes that weren't included on the original release.

299

The 1980s

If the 1970s was the 'directors' decade', the 1980s was very much about the stars. Big budget blockbusters driven by the star power of Michael Douglas, Bruce Willis and Eddie Murphy proved popular, and Hollywood threw millions of dollars at some films in the hope they would be successful.

Epics such as *Gandhi* (1982) and *The Last Emperor* (1987) swept the Oscars® but it was many of the smaller films that found a broader audience … *Back to the Future* (1985), *Platoon* (1986), *Broadcast News* (1987) and *Big* (1988). Sequels to *Stars Wars*, *Alien* and *Raiders of the Lost Ark* dominated the decade, although *E.T. the Extra-Terrestrial* was an original phenomenon.

The Australian film industry gave Hollywood Mel Gibson and Peter Weir; science-fiction made an unlikely star of Arnold Schwarzenegger; and Robin Williams, Steve Martin, John Candy and Bill Murray made their career in comedy. But the decade belonged to Harrison Ford and Meryl Streep. Was there any role they could not do? Horror franchises (*Halloween*, *The Evil Dead* and *Nightmare on Elm Street*) and cop sequels (*Beverley Hills Cop* and the return of Dirty Harry) also proved successful.

That long forgotten member of the audience – the teenager – was rewarded with the release of horror films, teen dramas and romantic comedies becoming part of the teen culture, all to an MTV soundtrack.

Harrison Ford in *Raiders of the Lost Ark* (1981)

53rd Academy Awards®

1980

Best Film: *Ordinary People* (Paramount)

Best Director: Robert Redford, *Ordinary People*

Best Actor: Robert De Niro, *Raging Bull*

Best Actress: Sissy Spacek, *Coal Miner's Daughter*

Best Supporting Actor: Timothy Hutton, *Ordinary People*

Best Supporting Actress: Mary Steenburgen, *Melvin and Howard*

Ordinary People (1980) won four Oscars®, including Best Film and Best Director for first-time director Robert Redford. Young actor, Timothy Hutton won Best Supporting Actor and the film also won Best Writing (Adapted Screenplay).

Mary Tyler Moore (below left) and Timothy Hutton (below right) are part of the upper-class Jarrett family who have problems communicating. The film also stars Donald Sutherland as the stoic father, Judd Hirsch as a psychologist and newcomer Elizabeth McGovern as Conrad's fellow student and passing love interest.

In Robert Redford's directorial debut, the deeply moving *Ordinary People* depicts a family under pressure – an 'ordinary' family, but one no longer able to communicate. Having survived a boating accident that claimed the life of his older brother, teenager Conrad (Hutton, above with Donald Sutherland as his father) meets with a psychologist (Judd Hirsch) and gradually understands why he feels so disengaged (he can't forgive himself for surviving the boating accident). After reconnecting with a friend he had met in the psychiatric hospital (Dinah Manoff), he gradually regains his self-esteem after he asks a member of the school choir (Elizabeth McGovern) out on a date.

There are no easy answers in *Ordinary People*, which makes the film such a rewarding experience. Conrad is still alienated from his friends and his mother, but he is finally making sense of everything when tragedy strikes again. TV star Mary Tyler Moore (right, with Sutherland and Hutton) plays against type as the cold mother, while Donald Sutherland anchors the drama as the father trying to hold everything together. Hutton is central to the story, but was nominated in the Supporting Actor category and duly won the Oscar® in his major film debut.

Robert De Niro

b. 1942

Robert De Niro was tapped for stardom when he won the Oscar® for Best Supporting Actor in *The Godfather Part II* in 1974. Critics had already noted the young New Yorker, who could play a maniac in *Mean Streets* and a dying baseball player in *Bang the Drum Slowly* (both in 1973), but anyone who could follow in Marlon Brando's footsteps and breathe new life into the role of the young Don Corleone had to be going places.

A slew of great performances leading up to his Best Actor award for *Raging Bull* (1980) confirmed his greatness. De Niro mastered violence, comedy, drama and romance in his subsequent roles – and also directed two well-received films – and though he has been accused of making 'too many bad movies', what else is a working actor supposed to do? De Niro loves to work.

KEY FILMS

Bang the Drum Slowly (1973)
Mean Streets (1973)
The Godfather Part II (1974)
Taxi Driver (1976)
The Deer Hunter (1978)
Raging Bull (1980)
The King of Comedy (1983)
Once Upon a Time in America (1984)
The Mission (1986)
Angel Heart (1987)
The Untouchables (1987)
Midnight Run (1988)
GoodFellas (1990)
Awakenings (1990)
Cape Fear (1991)
*A Bronx Tale** (1993)
Casino (1995)
Heat (1995)
Wag the Dog (1997)
Analyze This (1999)
Meet the Parents (2000)
*The Good Shepherd** (2006)
Silver Linings Playbook (2012)

* also director

Martin Scorsese's **Raging Bull** (1980) was a modest success when it was first released, despite being nominated for eight Academy Awards and winning Oscars® for Best Actor (Robert De Niro) and Best Editing (Thelma Shoonmaker). But the film has grown in stature over time and is today regarded as one of the great films from the 1980s, if not the greatest.

De Niro underwent a radical physical transformation to play boxing champion Jake LaMotta (1922-2017) at his prime as a world middleweight champion, and then as a bloated nightclub MC. But it is Scorsese's choreography of the fight scenes (using just a single camera), Michael Chapman's black and white photography (except one key scene in 8mm color) and long-time collaborator Shoonmaker's taught editing, that makes the film so memorable.

Joe Pesci is a standout as LaMotta's put-upon brother Joey, as is unknown teenager Cathy Moriarty who was chose by Scorsese to play LaMotta's abused wife, Vicki. Both were Oscar®-nominated, with Pesci appearing in two more Scorsese-De Niro collaborations, *Goodfellas* (1990) and *Casino* (1995).

The Shining (1980) is every inch a Stanley Kubrick film. After taking a different path with Stephen King's horror novel, and then filling his film with hidden messages, symbols (the color red features predominantly) and visual allegories, Kubrick brought his film-makers obsessiveness to this project (his first horror movie) with principal photography taking more than a year to complete.

As struggling writer Jack Torrance, Jack Nicholson is at the very peak of his game here, battling the hotel's demons as well as his own. The film also stars Shelley Duvall as his beleaguered wife, Danny Lloyd as their son gifted with 'the shining,' and Scatman Crothers as the hotel chef who comes to their rescue. Joe Turkel, one of the doomed soldiers in Kubrick's 1957 film *Paths of Glory*, takes on the sinister role of Lloyd, the bartender who never ages.

The Empire Strikes Back (1980) took *Star Wars* (1977) to a new level, and beautifully sets up the third film in the trilogy, *Return of the Jedi* (1983).

Introducing Jedi Master, Yoda (voice by Frank Oz), the enigmatic Lando Calrissian (Billy Dee Williams) and the repulsive Jabba the Hut, *The Empire Strikes Back* had enough twists and turns to keep *Star Wars* fans on the edge of their seats, and even won over a few more.

In true matinee style, director Irvin Kershner (taking over the reins from George Lucas, who conceived the story) kept fans wanting more. Would Han Solo survive being frozen in a block of carbonite? Would Princess Leia make the right choice between Han and Luke? Would Darth Vader ever be defeated? All would be revealed in *Return of the Jedi* (1983).

In ***Airplane!***, also known as ***Flying High*** (1980), the writer-director team of Jim Abrahams, David Zucker and Jerry Zucker hit the comedic jackpot.

Taking every available corny joke, slotting them into well-known disaster movie scenarios (mainly from the *Airport* film franchise) and casting recognizable character actors – Lloyd Bridges, Peter Graves, Leslie Nielsen – to maximize the parody, the result is a classic of its genre.

With countless pop culture references – professional basketballer Kareem Abdul-Jabar is a bitter pilot, disaster movie songstress Maureen McGovern is a singing nun, TV mom Barbara Billingsley is a jive talking interpreter – *Airplane!* has more laughs per minute than any other movie.

54th Academy Awards®
1981

Best Film: *Chariots of Fire* (Warner Bros / Enigma Films)

Best Director: Warren Beatty, *Reds*

Best Actor: Henry Fonda, *On Golden Pond*

Best Actress: Katharine Hepburn, *On Golden Pond*

Best Supporting Actor: John Gielgud, *Arthur*

Best Supporting Actress: Maureen Stapleton, *Reds*

British film *Chariots of Fire* (1981), the little-known story of 1924 Olympians Eric Liddell (Ian Charleson) and Harold Abrahams (Ben Cross, below) who each have different motivations for running – and succeeding – was the surprise packet of the 1981 Oscars®.

Directed by Hugh Hudson, the film won four Academy Awards®, for Best Film, Best Adapted Screenplay (by the actor, Colin Welland), Best Music (Vangelis, for his iconic score) and Costume Design, unusual perhaps for a film that mainly features 1920s era athletes wearing white shorts and T-shirts. The slow-motion scene of the British athletes training on the beach, however, has become an iconic moment in cinema.

On Golden Pond (1981) won Oscars® for its veteran lead actors – Henry Fonda (his first, aged 76) and Katharine Hepburn (her fourth, aged 74), as well as for writer Ernest Thompson for Best Adapted Screenplay. Hepburn still holds the record for winning the most Oscars by any actor.

Jane Fonda bought the rights to the film with her father in mind for the role of the cantankerous Norman – the father–daughter rift in the film reflective of the sometimes-strained relationship in real life. Henry Fonda was too ill to accept the award and passed away in August 1982.

Reds (1981) was an ambitious project from Warren Beatty even for the 1980s.

The story of American journalist John Reed (Beatty), who covered Russia's October Revolution in 1917 and is buried in the Kremlin, was directed and co-written (with Trevor Griffiths) by Beatty.

Diane Keaton co-starred as Louise Bryant with Jack Nicholson as playwright Eugene O'Neill.

Veteran actress Maureen Stapleton as anarchist Emma Goldman won the Best Supporting Actress, but it was the inclusion of more than 30 filmed testimonies from period 'witnesses' – people who lived and worked with Reed and Bryant – that gave the film its enhanced documentary feel.

Beatty won the Oscar® for directing and the film was a modest success in its original run, but in taking 194 minutes to tell Reed's story, *Reds* just fails to fulfil its epic potential.

Harrison Ford

b. 1942

In the early 1970s, Harrison Ford appeared the actor least likely to achieve superstardom.

After minor roles in *American Graffiti* (1973) and *The Conversation* (1974), Ford worked as a carpenter before the success of *Star Wars* (1977) shot him to stardom.

The popularity of Han Solo was more than matched by his role as Indiana Jones in *Raiders of the Lost Ark* (1981). Suddenly Ford had two film franchises operating – two *Star Wars* sequels and two Indian Jones sequels were released in the 1980s with more to follow in the new millennium.

Virile, handsome and with self-mocking humor, Ford continued his star run with *Blade Runner* (1982), *Witness* (1985) and *Working Girl* (1988). Two films as CIA agent Jack Ryan, *Patriot Games* (1992) and *Clear and Present Danger* (1994) were intersected by a rousing turn in *The Fugitive* (1993). Playing the US President in *Air Force One* (1997) confirmed Ford's status as the world's top box office draw. Lately he has been making sequels to some of his beloved films.

KEY FILMS

American Graffiti (1973)
Star Wars (1977)
Apocalypse Now (1979)
The Empire Strikes Back (1980)
Raiders of the Lost Ark (1981)
Blade Runner (1982)
Return of the Jedi (1983)
Indiana Jones and the Temple of Doom (1984)
Witness (1985)
Working Girl (1988)
Indiana Jones and the Last Crusade (1989)
Patriot Games (1992)
The Fugitive (1993)
Air Force One (1997)
What Lies Beneath (2000)
K-19: The Widowmaker (2002)
Indiana Jones and the Kingdom of the Crystal Skull (2008)
Star Wars: The Force Awakens (2015).
Blade Runner 2049 (2017)

Raiders of the Lost Ark (1981) is a fond homage to the Saturday afternoon adventure serials of the 1950s brilliantly realized for a new generation by George Lucas (producer) and Steven Spielberg (director).

As played by Harrison Ford, archaeologist turned adventurer Indiana Jones is one of cinema's most accessible and well-loved characters. With a boys-own script by future director Lawrence Kasdan (*The Big Chill*, 1985), *Raiders of the Lost Ark* has Jones seek out a missing love interest (Karen Allen), battle Nazi villains, and even evoke the wrath of God.

Spielberg has enormous fun staging numerous visual jokes, fight scenes and action sequences (the hijacking of the convoy carrying the Lost Ark by a horse-riding Jones is worth the price of admission alone).

What more could movie audiences want? The answer was easy – a prequel, *Indiana Jones and the Temple of Doom* (1984) and a sequel, *Indiana Jones and the Last Crusade* (1989).

55th Academy Awards®

1982

Best Film: *Gandhi* (Columbia)

Best Director: Richard Attenborough, *Gandhi*

Best Actor: Ben Kingsley, *Gandhi*

Best Actress: Meryl Streep, *Sophie's Choice*

Best Supporting Actor: Louis Gossett Jr, *An Officer and a Gentleman*

Best Supporting Actress: Jessica Lange, *Tootsie*

Actor-turned-director David Attenborough's intelligent biopic of **Gandhi** (1982) scooped the Oscars® in 1982, winning eight awards including Best Film, Best Actor (for the unheralded Ben Kingsley), Best Screenplay, Best Cinematography, and for Attenborough's faultless direction.

Featuring a star-studded cast including Edward Fox, Trevor Howard, John Mills, Candice Bergen, John Gielgud, Martin Sheen, Ian Charleson (and a young Daniel Day Lewis in key scene early in the film), Attenborough doesn't waste a second of the film's 188 minute running time. But it is Kingsley's success as much as anyone's; he imbues the Mahatma with an earthly stubbornness and determination instead of playing the role as a pious saint.

In *Sophie's Choice* (1982), Alan J. Pakula's adaptation of William Styron's 1979 novel, Meryl Streep (right) confirmed her status as the actress of her generation with a haunting, Oscar®-winning performance as a Polish holocaust survivor hiding a terrible secret.

Also starring Kevin Kline, in his breakthrough role as Sophie's unstable lover, and Peter MacNicol as the young Southern writer who completes the ill-fated love triangle, *Sophie's Choice* is an uncompromising emotional experience largely because of Streep's complex, ultimately heartbreaking performance.

Tootsie (1982) stars Dustin Hoffman as a struggling, albeit difficult actor, Michael Dorsey who dresses as a woman to secure a role on a daytime TV soap.

The complications are obvious. Now dressed as Dorothy Michaels (below left), Hoffman's character falls in love with his co-star in the soap, Julie Nicholls (Jessica Lange), pictured below right, while trying to keep the ruse from his friends (Teri Garr and an uncredited Bill Murray).

What could have been a shallow farce manages to make some pertinent observations about sexism in the 1980s. Hoffman is the real revelation here. Although disappointed he wasn't a 'better looking woman', his makeup, accent and comedic timing make you forget that he is a man deliberately acting as a woman.

For her role in the film, Lange won Best Supporting Actress.

In *The Verdict* (1982), Paul Newman plays against type as alcoholic, ambulance-chasing lawyer Frank Galvin who, given a case to settle as a favor from an old legal friend (Jack Warden), rediscovers his moral conscience and self-respect.

After visiting a bedridden young mother left in a vegetative state because of the negligence of a Church-run hospital, Galvin refuses to take the easy money on offer as a settlement and decides to try the case.

Up against a veteran lawyer (James Mason) and his ambitious team, and dealing with an unsympathetic judge (Milo O'Shea), Galvin then falls for a woman with ambiguous motives (Charlotte Rampling) and sees the case slip out of his hands.

Directed by Sidney Lumet (*12 Angry Men*, 1957 and *Network*, 1976) with a screenplay by David Mamet (*The Untouchables*, 1987), as courtroom dramas go, *The Verdict* is a wonderful character study as Galvin overcomes his many flaws to do what he knows is right.

E.T. the Extra-Terrestrial (1982) was a phenomenon when it was released in June 1982, and quickly captured both the imagination and hearts of the world. A personal project from director Steven Spielberg – a young boy (Henry Thomas), reeling after the departure of his father from the family home, befriends an alien and cares for it after it is left behind – there are elements of his own life reflected in the story, which he also wrote.

The themes in *E.T.* are universal – the children are idealistic, the adults are authoritarian and not to be trusted, and the alien (as realized by special effects wizard Carlo Rambaldi) is wise and lovable. Spielberg mines every ounce of affection from the story and is clearly manipulative in setting up the farewell scene, but perhaps that's why the film works so well. We suspend our disbelief, we want to believe that those kids flew across the face of the moon on their bikes and we rejoice when E.T. 'goes home'. Some of us even cried.

Director Ridley Scott's hotly anticipated follow up to *Alien* (1979), **Blade Runner** (1982), was based on Philip K. Dick's 1968 novel *Do Androids Dream of Electric Sheep?*. The story of an escaped group of 'replicants' (androids) hunted down and terminated by 'blade runner' police, however, had a troubled production.

The studio inserted a sometimes-jarring narration by lead character Rick Deckard (Harrison Ford), and added an incongruous scene at the very end. Several versions of the film have been released over the years, including *The Final Cut* in 2007.

The film was lauded for its pre-digital special effects (by Douglas Trumbull) showing a futuristic vision of a crowded, perennially raining Los Angeles and the evocative score by Vangelis (*Chariots of Fire*, 1981) added to the film's originality. The beautiful Sean Young looks like she walked out of a 1940s noir film; Rutger Hauer and Daryl Hannah evoke real sympathy as two of the replicants, while Ford's performance should not be underestimated for holding the whole thing together.

Like screenwriter Hampton Fancher, many can't agree with those fans and critics who believe Deckard was also a replicant. It makes the ending redundant, and *Blade Runner* is anything but that. A timeless sci-fi classic, Scott later initiated a worthy sequel, *Blade Runner 2049* (2017), directed by Denis Villeneuve, bringing back Hampton Fancher and Harrison Ford.

56th Academy Awards®
1983

Best Film: *Terms of Endearment* (Paramount)

Best Director: James L. Brooks, *Terms of Endearment*

Best Actor: Robert Duvall, *Tender Mercies*

Best Actress: Shirley MacLaine, *Terms of Endearment*

Best Supporting Actor: Jack Nicholson, *Terms of Endearment*

Best Supporting Actress: Linda Hunt, *The Year of Living Dangerously*

Terms of Endearment (1983) won five Oscars® in 1983, including a belated Best Actress award to Shirley MacLaine (b. 1934) pictured below left, beating co-star Debra Winger, (centre) and a Best Supporting Actor nod to Jack Nicholson (right) for his role as a playboy astronaut Garrett Breedlove.

Based on Larry McMurtry's novel of the testy relationship between a southern belle mother and her strong-willed daughter, *Terms of Endearment* also won a trio of Oscars® for James L. Brooks (as producer, director and for his adapted screenplay).

The Right Stuff, Tom Wolfe's 1979 bestselling novel about the elite group of pilots handpicked by NASA after World War II to pioneer America's space program, was thought impossible to transfer to a film medium. Oscar®-winning screenwriter William Goldman tried to lay down a clear pathway that focused on the actual astronauts rather than their achievements.

When writer-director Phillip Kaufman joined the project in 1983, however, he felt Goldman's script had missed the central character of the story – Chuck Yeagar, the pilot who turned his back on NASA but ultimately broke the sound barrier. For Kaufman, Yeagar acts as an important counterpoint to the jingoism of the space race.

The resulting film was a brilliant piece of storytelling starring Sam Shepard, shown above, as Yeagar and Ed Harris, Dennis Quaid, Scott Glenn, Fred Ward, Lance Henrikson, Charles Frank and Scott Paulin as the astronauts.

The Year of Living Dangerously (1982) introduced Australian director Peter Weir and US-Australian actor Mel Gibson to a world audience after their success in *Gallipoli* (1980). Based on David Williamson's screenplay about journalists covering the political turmoil in Indonesia in the 1960s, the film also earned Linda Hunt an Oscar® for Best Supporting Actress for the unusual role of half-Chinese, male cameraman Billy Kwan.

Al Pacino

b. 1940

Al Pacino was almost fired from *The Godfather* (1972) because producer Robert Evans could not see what director Francis Ford Coppola saw in the good looking, but short, New York 'method' actor.

When Pacino's character exploded at the end of the film, revealing all the malevolence and repressed anger Michael Corleone had held inside, the whole world could see what Coppola had seen.

Pacino's run of great roles in the 1970s, a high point being his brilliant portrayal of a rattled bank robber in *Dog Day Afternoon* (1975), set him up for superstardom.

The 1980s were a disappointment, however, although *Scarface*, 1983, later became a cult hit. Pacino came back in the 1990s with a string of fine performances after winning the Best Actor Oscar® for *Scent of a Woman* (1992).

KEY FILMS

The Godfather (1972)
Serpico (1973)
The Godfather Part II (1974)
Dog Day Afternoon (1975)
Bobby Dearfield (1977)
... And Justice for All (1979)
Scarface (1983)
Sea of Love (1989)
Dick Tracy (1990)
The Godfather Part III (1990)
Glengarry Glen Ross (1992)
Scent of a Woman (1992)
Carlito's Way (1993)
Heat (1995)
Donnie Brasco (1997)
The Insider (1999)
Any Given Sunday (1999)

Brian De Palma's *Scarface* (1983), with a script by Oliver Stone based on the original 1932 film starring Paul Muni, failed to find a mass audience when it was released in the early 1980s. Far too violent, much too strong language and a story glorifying the drug trade were just some of the criticisms offered at the time. What was lost in the controversy, however, was how bold the film was.

Featuring a bravura performance from Al Pacino as drug kingpin Tony Montana, the film also gives an early glimpse of the talents of Michelle Pfeiffer and F. Murray Abraham.

Scarface became a cult classic on video, and a much-quoted addition to the canon of Hollywood gangster films.

57th Academy Awards®

1984

Best Film: *Amadeus* (Orion)

Best Director: Miloš Forman, *Amadeus*

Best Actor: F. Murray Abraham, *Amadeus*

Best Actress: Sally Field, *Places in the Heart*

Best Supporting Actor: Haing S. Ngor, *The Killing Fields*

Best Supporting Actress: Peggy Ashcroft, *A Passage to India*

Based on Peter Shaffer's stage play about the life of musical prodigy Mozart (1756–1791), **Amadeus** (1984) reunited director Miloš Foreman and producer Saul Zaentz almost a decade after their success with *One Flew Over the Cuckoo's Nest* (1975). Shot in Prague, a stand in for 1700s Vienna, in natural light, the film was not a huge financial success but critics raved about the look of the film and the performances of F. Murray Abraham as Salieri and Tom Hulce (below left) in the title role.

Amadeus won eight Oscars®, including Best Film, Best Director and Best Actor, for F. Murray Abraham, as well as Writing (Shaffer), Sound, Makeup, Costume Design and Art Direction-Set Decoration.

Places in the Heart (1984) is director Robert Benton's (*Kramer vs. Kramer*, 1979) redolent film of a Depression-era widow and her struggles to feed her young family in small town America.

Places in the Heart won Sally Field her second Best Actress Oscar® in five years, and also awarded Benton for his original screenplay.

The Killing Fields (1984) refers to the horrors forced upon the Cambodian people by the Pol Pot regime in the early 1970s as seen through the eyes of a group of international journalists, headed by real-life American journalist Sidney Schanberg (Sam Waterston).

Cambodian refugee Dr Hang S. Noir (right) became the first non-actor to win an Oscar® for Best Supporting Actor since Harold Russell (*The Best Years of Our Lives*, 1946) for his role as local journalist and interpreter, Dith Pran.

Ghostbusters (1984) was a comedic sensation when it was released in 1984, bringing together the talents of Dan Aykroyd (*The Blues Brothers*, 1980) and the team of Bill Murray and Harold Ramis (*Stripes*, 1981).

Aykroyd originally wrote the film with comedic partner John Belushi in mind, but following Belushi's death in 1982, Ramis came on board as co-writer and Murray took the role of the sarcastic Peter Venkman and completely stole the film.

Under Ivan Reitman's direction, *Ghostbusters* was the hit of 1984 and a merchandise juggernaut (it seemed as though every kid in America was wearing a *Ghostbusters* t-shirt with the film's recognizable logo on it at one time).

Interestingly, the film's Oscar®-nominated theme song by Ray Parker Jr drew a lawsuit from Huey Lewis for its similarities to his band's hit, 'I Want a New Drug'. The success of the film resulted in a 1987 sequel and a 2016 reboot with an all-female cast.

The Natural (1984) heads a raft of baseball movies released in the 1980s (*Eight Men Out*, 1988; *Bull Durham*, 1988; *Field of Dreams*, 1989; *Major League*, 1989) and marks a wonderful return to form for Robert Redford.

Director Barry Levinson gives the film an almost mythical quality, creating a hero from a baseball past that all sports fans would want to believe in.

Although Redford falters in playing a rookie 20 year old, he more than makes up for it as the veteran player searching for his shot at the big time. Glenn Close, Robert Duvall and Kim Basinger play key roles, while Wilford Brimley and Richard Farnsworth excel as veteran coaches.

Once Upon a Time in America (1984) is every bit as good a film as *The Godfather* (1972) – and almost as long as Parts I and II together – but it took decades to achieve classic status.

Italian director Sergio Leone's gangster epic about a group of poor Jewish boys who become New York gangsters was released to great acclaim in Europe in 1984, but the studio hacked the film from 229 to 139 minutes for its US release. The effect was that the non-chronological story made no sense and it flopped.

With brilliant performances from Robert De Niro as Noodles, James Wood as his friend/foe Max and Elizabeth McGovern as the beautiful Deborah (future Oscar® winner Jennifer Connelly plays her as a young girl), *Once Upon a Time in America* boasts a wonderful score from Ennio Morricone and enough characters and subplots for two films.

It wasn't until the film was restored to its original length and released on DVD that it was rightfully regarded as a classic. (There is even a move for an extended director's cut to be released – almost four and a half hours.)

The return of Noodles after three decades in hiding from his gangster past (to a wonderful muzak version of Lennon-McCartney's 'Yesterday') not only evokes a lost era but also the re-emergence of a lost classic.

58th Academy Awards®
1985

Best Film: *Out of Africa* (Universal / Mirage Enterprises)

Best Director: Sydney Pollack, *Out of Africa*

Best Actor: William Hurt, *Kiss of the Spider Woman*

Best Actress: Geraldine Page, *The Trip to Bountiful*

Best Supporting Actor: Don Ameche, *Cocoon*

Best Supporting Actress: Anjelica Huston, *Prizzi's Honor*

Out of Africa (1985) is the type of sweeping drama the Academy loves, rewarding the film with seven Oscars®, including Best Film and Best Director for director-producer Sydney Pollack, as well as Best Cinematography, Best Adapted Screenplay, Best Original Score (John Barry, his third), Best Sound and Best Art Direction.

Based on the memoirs of Karen Blixen (writing as Isak Dinesen), *Out of Africa* benefits greatly from Meryl Streep's central performance, a luscious score from John Barry and David Watkin's stunning cinematography. Robert Redford is miscast as Streep's love interest, English nobleman Denys Finch Hatton, but the movie works on so many levels you can easily ignore this.

Prizzi's Honor (1985) is a black comedy gangster film that sees rival killers, Charley Partanna (Jack Nicholson) and Irene Walker (Kathleen Turner) fall in love, only for the 'family business' to come between them.

The film was directed by film veteran John Huston. Daughter of Huston and partner of Nicholson at the time, Angelica Huston plays Maerose Prizzi, the infatuated daughter of the crime boss. The film earned the third generation of the Huston family, Angelina, the Oscar® for Best Supporting Actress. Pictured above from left to right: Jack Nicholson, Kathleen Turner, John Huston and Angelica Huston.

Peter Weir's ***Witness*** (1985), a uniquely rewarding film of an injured detective John Book (Harrison Ford) hiding out from his corrupt colleagues among an Amish community, won Oscars® for Original Screenplay and Editing.

Veteran TV writers Earl Wallace and William Kelly devised the ingenious premise but it took Hollywood outsider Weir to deliver a totally original film that was another massive hit for film's 'man of the decade' Harrison Ford.

Robert Zemeckis
b. 1952

Robert Zemeckis started out writing scripts with his partner Bob Gale. Unable to get a job directing after several flops in the late 1970s and early 1980s, he finally broke into the A-list with *Romancing the Stone* (1984).

Zemeckis and Gale had been working on a script for quite a while about a teenage boy and a time machine. The result, *Back to the Future* (1985), proved to be a big hit for the duo.

Zemeckis continued to push filmmaking conventions, especially using computer generated digital effects, but his best films have great heart. *Forrest Gump* (1994) won him the Oscar® and as impressive as his 'animated' innovations are, *Contact* (1997), *Castaway* (2000) and *Flight* (2012) display his skill with real actors and complex human stories.

KEY FILMS

Romancing the Stone (1984)
Back to the Future (1985)
Who Framed Roger Rabbit? (1988)
Back to the Future II (1988)
Back to the Future III (1989)
Death Becomes Her (1992)
Forrest Gump (1994)
Contact (1997)
What Lies Beneath (2000)
Cast Away (2000)
The Polar Express (2004)
Beowulf (2007)
A Christmas Carol (2009)
Flight (2012)
The Walk (2015)

Back to the Future (1985) is a pop culture classic that has charmed generations over the past three decades. Steven Spielberg protégés Robert Zemeckis (writer-director) and Bob Gale (writer) deliver a fantastic plot about a time-traveling teenager who journeys back to 1955 to the moment his parents fell in love. The film has wit and an enormous sense of fun.

TV's Michael J. Fox (*Family Ties*) famously took over the role as Marty McFly from Eric Stoltz after Stoltz was deemed unsuitable. Fox (who was aged 23 when the film was made) brought such energy and youthful naiveté to the role, that the producers immediately knew they had made the right casting decision.

Crispin Glover, as Marty's bumbling dad, brings a quirky humor to the film that is missing from the two sequels (1989 and 1990).

As scientist Doc Brown, you almost believe every word Christopher Lloyd (*One Flew Over the Cuckoo's Nest*, 1975) says. What exactly is a flux capacitor, anyway?

59th Academy Awards®

1986

Best Film: *Platoon* (Orion / Hemdale)

Best Director: Oliver Stone, *Platoon*

Best Actor: Paul Newman, *The Color of Money*

Best Actress: Marlee Matlin, *Children of a Lesser God*

Best Supporting Actor: Michael Caine, *Hannah and Her Sisters*

Best Supporting Actress: Dianne Wiest, *Hannah and Her Sisters*

Oliver Stone's Vietnam War film ***Platoon*** (1986) won four Oscars® including Best Film, Best Director, Best Sound and Best Editing. Starring Charlie Sheen (below) as raw recruit Chris Taylor, the film explores the eternal battle between good and evil as personified by competing sergeants, played by Tom Berenger and Willem Dafoe.

Stone's singular vision of the war (the director served in Vietnam in 1967–68) also stars Forest Whitaker, Francesco Quinn, Kevin Dillon, John C. McGinley, Mark Moses and Johnny Depp, in one of his earliest roles, as the interpreter, Lerner. Samuel Barber's 'Adagio with Strings' is a constant presence in the film too.

Platoon (1986) succeeds more than any other movie (even revisionist Vietnam War films such as *The Deer Hunter*, 1978, and *Apocalypse Now*, 1979) in portraying both the horrors of combat and the ambiguity of the Vietnam War.

New recruit Chris Taylor (Charlie Sheen) is assigned to Bravo Company in the US 25th Infantry Division near the Cambodian border. There he encounters a platoon of integrated soldiers, led by the hawkish Sgt Barnes (Tom Berenger, above left) and the compassionate Sgt Elias (Willem Dafoe, above right).

The climax, a brilliantly executed attack on trench positions and the US compound by North Vietnam forces, provides perhaps the clearest indication of the claustrophobic fear that soldiers experience in war.

Platoon succeeds in telling the story from the infantryman's point of view and does not seek to demonize the enemy but explores the enemy within all of us.

A much-anticipated sequel to the *Alien* (1979), the Ridley Scott classic, **Aliens** (1986) was a completely different movie with a different director James Cameron (*The Terminator*, 1984). Ripley (Sigourney Weaver) awakens from a 57-year hyper-sleep and leads a battalion of marines back to the alien planet to rescue 'terra-formers' who have been overrun by the creatures.

A lot tougher and funnier than the original, Cameron overcame the need to show, perhaps, too many aliens by climaxing the film with a tremendous showdown between Ripley (wearing a cargo loader as an exo-suit) and the Queen Alien.

Weaver was Oscar®-nominated for the role, which she would reprise in two more sequels (*Alien 3*, 1992; and *Alien: Resurrection*, 1997).

What the hell is happening in the mind of David Lynch? Many film fans have asked that question over the years especially after the release of **Blue Velvet** (1986).

Best described as a psychological thriller, *Blue Velvet* takes two likeable young stars (Kyle MacLachlan and Laura Dern) and drops them into a suburban hell of Lynch's making.

Former child star Dean Stockwell (b. 1936) has a wonderful scene miming Roy Orbison's 'In Dreams'. Dennis Hooper is unforgettable as the despicable Frank Booth, and Isabella Rossellini (the daughter of actress Ingrid Bergman and director Roberto Rossellini) is a picture of beauty as femme fatale Dorothy Vallens.

Symbolism, dark dreams and sexual themes run rampant in this film, which makes Lynch's achievement even more astonishing.

Stand By Me (1986) was Stephen King's dark take on childhood friendships, as four boys venture off in search of the dead body of a missing boy. Full of pop culture references and music from the early 1960s, the violence, coarse language and the dark mood of the film was very much rooted in the 1980s however.

Directed by Rob Reiner (*This is Spinal Tap*, 1984) the film also featured Kiefer Sutherland (the son of actor Donald Sutherland) and a young John Cusack to good effect.

The film was a huge success, largely from word of mouth, and even drew praise from King who views *Stand By Me* (that was based on his novella, *The Body*) as among the best film adaptations of his material.

Of the four boys (also Wil Wheaton, Corey Feldman and Jerry O'Connell), River Phoenix (1970–1993) showed the most career promise but his life was cut short by a drug overdose when he was just 23.

Ferris Bueller's Day Off
1986

"Life moves pretty fast. If you don't stop and look around once in a while, you could miss it."

Ferris Bueller (Matthew Broderick)

In the mid-1980s, writer-director John Hughes was on a winning streak. Hughes had established a whole subgenre of comedic film – the teenage rom-com, full of the awkwardness of falling in love wrapped up in the hormonal angst of youth. After the success of *Sixteen Candles* (1984), *The Breakfast Club* (1985) and *Pretty in Pink* (1986), this story of a charming slacker playing hooky from school with his friend and girlfriend could have ended up as a cartoon. Under Hughes' direction, however, we have a modern classic full of funny, often perceptive vignettes that have since become part of pop culture.

Ferris Bueller (Matthew Broderick) skips school and heads out into Chicago, with his girlfriend Sloane (Mia Sara) and his best friend Cameron (Alan Ruck) in Cameron's father's prized 1961 Ferrari GT.

Bueller is the quintessential lovable teenager – funny, confident and popular, in short, every teenager's fantasy persona. It's hard not to like Ferris. Director Hughes has the character talk directly to camera, breaking the fourth wall and letting the audience in on the joke (and even admonishing them after the credits).

Ferris Bueller's Day Off made a star of Matthew Broderick, the son of character actor James Broderick (*Dog Day Afternoon*, 1975). Broderick had worked with Alan Ruck on stage and the pair brought great timing and physical comedy to the film. Mia Sara is a picture as Ferris' girlfriend – who wouldn't ditch school if you had a girlfriend like her.

Jeffery Jones as Ferris' nemesis Principal Rooney, Jennifer Grey (the daughter of Oscar®-winner Joel Grey) as Ferris' bitter sister, and Charlie Sheen as philosophical stoner encountered at the police station, each contribute to the fun of the film.

There are so many great moments in *Ferris Bueller's Day Off* – Ferris singing 'Twist and Shout' in a parade down Dearborn Street; the wonderful Ben Stein as an uninspiring teacher ('voodoo economics, anyone?'); a suspicious pair of parking lot attendants ('trust us, we're professionals'); Rooney's humiliating bus ride home in the film's coda; and, of course, the running gag about the 'Save Ferris' movement.

For many, the trio's visit to the Chicago Art Institute (to the tune of The Smiths' 'Please, Please, Please, Let Me Get What I Want' as played by The Dream Factory) is one of the most enlightening moments of this 1980s film.

John Hughes shows the spirit of an adolescent with the insight of an artist. The contrast between the stale classroom environments and the trio's joy of freedom, for example, is portrayed so refreshingly in this film. *Ferris Bueller's Day Off* is full of such rich serendipity, and there is nothing mean-spirited about the comedy.

There is an infectious happiness in this film that brings a smile to the face thirty years later. The film spawned two TV series (*Ferris Bueller*, and *Parker Lewis Can't Lose*) and audiences cried out for a sequel (*Ferris at College, Ferris at Work, Ferris in a Nursing Home*) but why play with perfection?

Paramount: 103 minutes

Produced by: John Hughes and Tom Jacobson

Directed and written by: John Hughes

Music by: Ira Newborn, Arthur Baker and John Robie

Cinematography by: Tak Fujimoto

Starring: Matthew Broderick (Ferris Bueller), Alan Ruck (Cameron Frye), Mia Sara (Sloane Peterson), Jeffrey Jones (Edward R. Rooney), Jennifer Grey (Jeannie Bueller), Lyman Ward (Tom Bueller), Cindy Pickett (Katie Bueller), Edie McClurg (Grace), Ben Stein (Economics Teacher), Charlie Sheen (Boy in Police Station), Richard Edson (Parking Garage Attendant).

60th Academy Awards®

1987

Best Film: *The Last Emperor* (Columbia / Recorded Picture Company / Yanco Films / TAO Film / AAA Soprofilms)

Best Director: Bernardo Bertolucci, *The Last Emperor*

Best Actor: Michael Douglas, *Wall Street*

Best Actress: Cher, *Moonstruck*

Best Supporting Actor: Sean Connery, *The Untouchables*

Best Supporting Actress: Olympia Dukakis, *Moonstruck*

The Last Emperor (1987) won Oscars® for all nine categories in which it was nominated – Best Picture, Best Director, Art Direction, Cinematography (Vittorio Storaro), Costume Design, Editing, Original Score, Sound and Adapted Screenplay (Mark Peploe and Bernardo Bertolucci).

The story of the last emperor of China before the country was invaded by the Japanese in the 1930s, this luscious 163 minute epic stars John Lone and Joan Chen (below), with Peter O'Toole as the boy emperor's English tutor, Reginald Johnston.

The Untouchables (1987) started the Hollywood trend of turning popular TV shows of the 1950s and 1960s into movies.

With a script from David Mamet and directed by Brian De Palma (*Carrie*, 1976), the film was an enormous success when it was released in 1987. *The Untouchables* confirmed Kevin Costner's arrival as a star on the rise while also showcasing the established talent of Robert De Niro (a late replacement for English actor Bob Hoskins in the role of Al Capone) and Sean Connery (who won Best Supporting Actor for his role).

De Palma's vision was certainly more violent and confronting than the sanitized black and white TV show starring Robert Stack.

Charles Martin Smith (*American Graffiti*, 1973) and newcomer Andy Garcia rounded out the team of 'untouchables' who bought down gangster, Al Capone in 1920s Chicago, not of charges of murder, but on tax evasion charges, of all things.

Director Oliver Stone followed his success with *Platoon* (1986) with the equally impressive *Wall Street* (1987).

Starring Charlie Sheen, Daryl Hannah and Michael Douglas, in his Best Actor Oscar®-winning role, *Wall Street* also featured Martin Sheen (Charlie's father) and Hal Holbrook in key roles.

Michael Douglas
b. 1944

Michael Douglas shrugged off the label of Kirk Douglas' son by becoming a star on TV's *The Streets of San Francisco* in the early 1970s and then producing the Oscar®-winning film *One Flew Over the Cuckoo's Nest* (1975).

His film career was patchy until he became an unlikely sex symbol at age 40 after playing the lead role in *Romancing the Stone* (1984). He won the Best Actor Oscar® as corrupt money-man Gordon Gekko in *Wall Street* (1987) and in the same year survived the one-night stand from hell as family man Dan Gallagher in *Fatal Attraction*.

Basic Instinct (1992) took his sex symbol reputation to new heights, but underneath it all Douglas has always been a thoughtful actor, and an underrated light comedian.

The whimsy of *The American President* (1995), the darkness of *The Game* (1997) and the eccentricity of *Wonder Boys* (2000) shows his incredible range and talent.

KEY FILMS

The China Syndrome (1979)
Romancing the Stone (1984)
The Jewel of the Nile (1985)
Fatal Attraction (1987)
Wall Street (1987)
The War of the Roses (1989)
Basic Instinct (1992)
Falling Down (1993)
Disclosure (1994)
The American President (1995)
The Ghost and the Darkness (1996)
The Game (1997)
Wonder Boys (2000)
Traffic (2000)
Behind the Candelabra (2013)

Fatal Attraction was a sensation when it was released in 1987, and as a morality tale about the perils of one-night stands, it packed one hell of a punch.

Michael Douglas (above right) trades in his nice-guy persona and cheats on his wife (Amy Archer) with law colleague Alex (Glenn Close, above left). Everything seems fine, until Douglas is targeted by a series of attacks that threaten the security of his model family – his wife, his daughter and their pet rabbit.

British director Adrian Lynne (*Flashdance*, 1983) tapped the psyche of the American male in this thought-provoking but ultimately violent film. The original ending that had Alex killing herself and framing Gallagher, who is led away in handcuffs by police, tested poorly with audiences. The solution? Give the fans what they want – put Alex inside the family home with a knife and have Mrs Gallagher shoot her to protect the family unit.

Broadcast News
1987

"He personifies everything that you've been fighting against. And I'm in love with you. How do you like that? I buried the lede."

Aaron Altman (Albert Brooks)

As well as being one of the best comedy-dramas of the 1980s, *Broadcast News* is also prophetic in its warning about where news reporting was heading.

At the start of the film, when news producer Jane Craig (Holly Hunter) questions the inclusion of a world record falling dominoes attempt in the nightly news, she could have been talking about the now commonplace dumbing down of news programs and the presentation of news as entertainment. At the centre of the film, however, is an unusual triangular love story.

News journalist Aaron Altman (Albert Brooks) is Jane's closet friend and confident but he wants the relationship to be more. Tom Grunick (William Hurt) is a new generation newsman, where good looks are more important than talent. To Aaron, Tom is 'the devil', and while Jane is wary of Tom, she can't help but fall in love with him. Despite Aaron's best efforts, he cannot bridge the gap between friend and lover, especially with Tom in the way. In conventional Hollywood films, Tom and Jane would live happily ever after but not in *Broadcast News*.

There is an indication early in the film when Tom lies to Jane (after she accidentally berates him in front of his father) that this relationship is not authentic. Aaron puts his heart on the line for Jane, but can only express himself in 'news' terms. Railing against Tom, he tells Jane, "He personifies everything that you've been fighting against. And I'm in love with you. How do you like that? I buried the lede." Explosive, but one who keeps her emotions in check (Jane has a daily ritual in which she forces herself to cry), Jane is ultimately married to her work and her personal integrity ensures she could never fall for someone as narcissistic as Tom or settle for anyone she doesn't truly love.

This was James. L. Brooks' subsequent film after the success of the Oscar®-winning *Terms of Endearment* (1983). A former journalist who created the successful *Mary Tyler Moore Show* (which was set in a news room), Brooks has a great ear for witty, acerbic dialogue and the ability to combine that dialogue with fast-paced direction, just like a real news room. The scene where a video insert has to be prepared at the last minute (in the days before digital technology) is cleverly choreographed. The film is full of great one liners. When news director Peter Hackes (Paul Moore) has to retrench his staff, he earnestly inquires to one: "Now, if there's anything I can do for you ..."

"Well, I certainly hope you'll die soon," is the straight-faced reply.

Jack Nicholson makes an uncredited cameo appearance as a star newsreader, while Joan Cusack makes her mark as Jane's assistant. But it is Hunter's film in a star-making role.

Hurt plays the dim-witted Tom so well, you don't care for him at all; and comedian Albert Brooks is likeable and funny as Aaron, but never sexy.

Broadcast News is that rare film – one that makes you laugh and think and feel but, unlike Jane Craig, doesn't force you to cry.

Gracie Films / 20th Century Fox: 132 minutes

Produced, directed and written by: James L. Brooks

Music by: Bill Conti

Cinematography by: Michael Ballhaus

Starring: William Hurt (Tom Grunick), Albert Brooks (Aaron Altman), Holly Hunter (Jane Craig), Robert Prosky (Ernie Merriman), Lois Chiles (Jennifer Mack), Joan Cusack (Blair Litton), Peter Hackes (Paul Moore), Christian Clemenson (Bobby), Jack Nicholson (Bill Rorish, uncredited).

Full Metal Jacket (1987) was the long-awaited Vietnam War film from master director Stanley Kubrick (seven years after *The Shining*), but there are two distinct films here that don't quite gel together.

The first half of the film reveals the bastardization of basic training on Parris Island, North Carolina as the raw recruits are readied for the rigors of war. R. Lee Ermey, a former US marine instructor, is a standout as a gunnery sergeant who hammers in on three young soldiers – as played by Matthew Modine, Vincent D'Onofrio and Arliss Howard, pictured above with Ermey – with tragic results.

The second half of the film, which explores the unusual Vietnam setting of a city war zone, takes the foot off the throat of the audience, although it is still interesting to see who the enemy is at the end of the story.

Full Metal Jacket (the title refers to the casing of bullets) was filmed entirely in England, and perhaps knowing that is part of the reason you don't really believe what you're seeing.

340

Die Hard (1988) defies common sense, but its success almost singlehandedly resulted in the establishment of a new action genre – the lone hero facing overwhelming odds – and made a star of Bruce Willis (b. 1955).

Willis was known for his light, comedic role on TV's *Moonlighting* (alongside Cybill Shepherd) but the studio backed him all away in this vehicle that was turned down by most Hollywood stars from Frank Sinatra to Arnold Schwarzenegger.

Willis' sardonic irreverence was ready-made for this action tale which also marked the American debut of urbane English actor Alan Rickman (1946–2016), who plays one of the most impressive villains of the 1980s.

Big (1988) was easily the best of the numerous 'role reversal' movies that came out in the 1980s, with Tom Hanks' flawless impression of a boy trapped in a man's body earning him the first of his five Academy Award nominations.

Former TV actress Penny Marshall (*Laverne and Shirley*) shows a deft touch as director – it was the biggest hit of her directing career.

The story moves into a gray area once Hanks enters into a relationship with a colleague played by Elizabeth Perkins, and the family angst of a missing child is never really addressed, but it's important to not overthink the premise. Most children want to grow up before their time, and many of us then spend the rest of their lives trying to relive our youth. *Big* explores these themes in this funny and often poignant film.

One of the key moments in the film is Hanks' inventive dance sequence where his toy store boss (Robert Loggia, pictured left with Hanks) rediscovers his inner child.

61st Academy Awards®
1988

Best Film: *Rain Man* (United Artists)

Best Director: Barry Levinson, *Rain Man*

Best Actor: Dustin Hoffman, *Rain Man*

Best Actress: Jodie Foster, *The Accused*

Best Supporting Actor: Kevin Kline, *A Fish Called Wanda*

Best Supporting Actress: Geena Davis, *The Accidental Tourist*

Rain Man (1988) was the surprise hit of the year, winning Oscars® for Best Film, Best Director, Best Actor and Best Writing. Dustin Hoffman (below left), won his second career Oscar® for Best Actor, as the autistic savant Raymond Babbitt, who is 'liberated' from the institution where he lives by his wheeler-dealer brother Charlie (Tom Cruise, below right) so that Charlie can access money from the estate of their deceased father.

A personal triumph for director Barry Levison (*The Natural*, 1984), the film also confirmed star status upon Tom Cruise (b. 1962) following his success in *Risky Business* (1983), *Top Gun* (1986) and *The Color of Money* (1986) during the decade.

American comics have always held a warm affinity for the British Monty Python team and *A Fish Called Wanda* (1988) takes the best of both worlds to create a comedy classic.

Written by John Cleese, and co-starring fellow Python Michael Palin, the film also stars American actors Jamie Lee Curtis and Kevin Kline (in his Oscar®-winning role as "Don't call me stupid" Otto). *A Fish Called Wanda* is a heist film featuring a group of bumbling bandits and a rare fish.

Directed and co-written by veteran British director Charles Crichton (*The Lavender Hill Mob*, 1951), *A Fish Called Wanda* is Cleese's major mainstream success in the role of lawyer Archie Leech (the real name of actor Cary Grant) who turns thief, with hilarious results. This is a perennial favorite for fans of Cleese and Palin.

Former child actor Jodie Foster (b. 1962) won the first of her two career Oscars® for *The Accused* (1988), the story of a young rape victim who stands up to her attackers. This thought-provoking film, which also stars Kelly McGillis as a crusading lawyer, was based on a real-life incident in Massachusetts in 1983. Foster (*Taxi Driver*, 1976) won her second Oscar for *The Silence of the Lambs* in 1991.

Meryl Streep
b. 1949

Meryl Streep has been nominated for the Academy Award more times than any other actor, which alone is testament to her versatility and talent.

Since her breakout role in *The Deer Hunter* (1978), Streep has been nominated a record 19 times over 35 years – 15 nominations for Best Actress and four as Best Supporting Actress.

Streep has won three Oscars® – Best Supporting Actress for *Kramer vs. Kramer* (1979), and Best Actress for *Sophie's Choice* (1982) and *The Iron Lady* (2012), incredibly thirty years later. No role is too daunting, no accent too difficult nor hairstyle too transforming for her. It is a well-worn cliché that Streep has never given a substandard performance in a film.

Parodied in the media for perhaps being too versatile, watch Streep in *The Hours* (2002), *The Devil Wears Prada* (2006) and *Doubt* (2008) and one can't help but marvel at her star power.

KEY FILMS

The Deer Hunter (1978)
Manhattan (1979)
Kramer vs. Kramer (1979)
The French Lieutenant's Woman (1981)
Sophie's Choice (1982)
Silkwood (1983)
Out of Africa (1985)
Ironweed (1987)
A Cry in the Dark (1988)
Postcards from the Edge (1990)
The River Wild (1994)
The Bridges of Madison County (1995)
One True Thing (1998)
Music of the Heart (2000)
Adaptation (2002)
The Hours (2002)
The Devil Wears Prada (2006)
Doubt (2008)
Julie & Julia (2009)
The Iron Lady (2011)
Into the Woods (2014)
Ricki and the Flash (2015)
The Post (2017)

Prize-winning novel about Depression-era drunks down on their luck, ***Ironweed*** (1987) displays the considerable acting talents of Jack Nicholson, actor-musician Tom Waits (right) and character actor Fred Gwynne. But it is Meryl Streep whose star shines brightly even in this dourest of roles.

Based on William Kennedy's Pulitzer Prizewinning novel, Steep and Nicholson received Oscar® nominations for their performances, largely for resisting the temptation to overact.

This thoughtful film is a master class for Streep's heartfelt underplaying of an angry, broken woman.

Postcards from the Edge (1990) is based on the book by actress Carrie Fisher (*Star Wars*, 1977) about the pitfalls of fame, drugs and having a famous mother (Debbie Reynolds).

Meryl Streep takes the lead role as actress Suzanne Vale who is trying to reclaim her career after yet another stint in rehab, while trying to reconnect with her showy show business mother (Shirley MacLaine).

Directed by Mike Nichols, *Postcards from the Edge* also features Gene Hackman as a patient director, Dennis Quaid as a two-timing producer and Richard Dreyfus as a concerned doctor. Streep impresses as the out-of-control actress.

The film appeals to audiences for showing the pitfalls of a Hollywood upbringing, not least because it's all so true.

62nd Academy Awards®

1989

Best Film: *Driving Miss Daisy* (Warner Bros.)

Best Director: Oliver Stone, *Born on the Fourth of July*

Best Actor: Daniel Day-Lewis, *My Left Foot*

Best Actress: Jessica Tandy, *Driving Miss Daisy*

Best Supporting Actor: Denzel Washington, *Glory*

Best Supporting Actress: Brenda Fricker, *My Left Foot*

Driving Miss Daisy (1989) is one of the most maligned Oscar®-winning films in recent history, with its name synonymous with safe choices taken by the voting Academy. The characterization is unfair, however, with the film being a product of its historic context – the Jim Crow days of the Deep South in the early 1960s.

After a long career on stage, Jessica Tandy (1909–1994) became the oldest Best Actress winner in history when she won the Oscar® aged 79. The film also stars Morgan Freeman (b.1937) in an early, breakout role as Miss Daisy's driver, and Dan Aykroyd as her son. The film was directed by Australian Bruce Beresford who was not nominated for his work.

In ***My Left Foot*** (1989), British-born Irish actor Daniel Day-Lewis (b. 1957) won the first of his three career Best Actor Oscars® for his portrayal of handicapped Irish writer-artist Christy Brown, who suffered from cerebral palsy and could only control the movement of his left foot. Brenda Fricker won Best Supporting Actress as Brown's mother.

Dr Eileen Cole (Fiona Shaw) plays Brown's physical therapist, pictured above with Day-Lewis. The classically-trained Day-Lewis made only ten films over the next 25 years, but won further Oscars® for *There Will Be Blood* (2007) and *Lincoln* (2012).

Denzel Washington (b. 1954) made the leap from TV drama (*St Elsewhere*) in the 1980s into mainstream film and won the first of his two career Oscars® as Best Supporting Actor in the Civil War drama ***Glory*** (1989). The story of one of the first black military units to serve with distinction on the Union side during the Civil War, *Glory* also starred Morgan Freeman, Andre Braugher, Matthew Broderick and Cary Elwes.

Dead Poets Society (1989) was a hugely influential film on release at the end of the decade, with an unsentimental performance from comedian Robin Williams as a sympathetic and inspiring teacher at an all-boys school in the 1950s.

Directed by Peter Weir (*Witness*, 1985), a raft of young acting talents (with Williams above, from left, Gale Hansen, Allelon Ruggerio, Ethan Hawke, Dean Kussman, James Waterston, Robert Sean Leonard and Josh Charles) could have played out a potential 'us and them' plot (the 'them' being those nasty adults), but Tom Shulman's Oscar®-winning screenplay struck a chord with the public and the film did enormous business worldwide (a staggering $240 million in returns).

Dead Poets Society garnered Williams (1951–2014) the second of three Best Actor nominations for his role (coming after *Good Morning, Vietnam* in 1987 and *The Fisher King*, 1991).

Crimes and Misdemeanors (1989) features a multifaceted story from actor-writer-director Woody Allen that cleverly comes together in the final, ironic scene of the film.

Two stories run parallel for much of the movie – Allen's character is filming a documentary about his more successful brother-in-law (Alan Alda), meanwhile a successful ophthalmologist (Martin Landau) is having problems with his obsessive mistress (Angelica Houston).

The divergent storylines come together at the end of the film after their relationships, motives and crimes have been revealed to the audience.

TV hero Alan Alda (*M*A*S*H*) found a late-career niche in this film as a self-obsessed comedian. Landau, Houston, Claire Bloom and Jerry Orbach are all excellent in the 'criminal' story, which could possibly have stood alone but here acts as the perfect counterbalance to Allen's bittersweet observations about success and the fairness of life.

When Harry Met Sally (1989) was brought to the screen by the combined talents of director Rob Reiner (*Stand By Me*, 1986) and writer Nora Ephron (*Sleepless in Seattle,* 1993). A clever comedy about the relationship between two college buddies played by Meg Ryan and Billy Crystal (pictured) whose deep friendship, over time and against their better instincts, develops into love.

The film broke Crystal into the movie mainstream after a decade of good performance on TV's *Soap* and in character roles on film while Ryan's role helped establish her film persona as a quirky, strong-willed love interest.

Much of Crystal's banter was improvised by the comedian on set, while the film's most famous scene – Ryan's fake orgasm in a restaurant – features Reiner's mother as the woman who delivers the now-famous line, "I'll have what she's having."

The 1990s

There was a new player in Hollywood in the 1990s – computer animation. State of the art technologies slipped over from the science fiction genre into mainstream films, enhancing movie experiences such as *Terminator 2: Judgment Day* (1991), *Jurassic Park* (1993) and 1994 Best Film winner *Forrest Gump*.

Digital sound, computerized effects and breakthrough animation changed the movie-going experience and helped usher in a new genre – the computer-animated film aimed at children but with enough pop culture references and in jokes to satisfy adults. *Toy Story* (1995) is a standout example produced by Pixar Animation Studios and Walt Disney Pictures.

Leading the way were filmmakers James Cameron (*Titanic*, 1997) and Robert Zemeckis (*Contact*, 1997), who actually invented the technologies they wanted to use.

Oliver Stone, David Fincher, Spike Lee, Quentin Tarantino and the Coen Brothers brought their own visions to the screen as an increasing number of independent filmmakers found their audience.

There were stars of course – Julia Roberts, Tom Cruise, Tom Hanks and Kevin Costner but also actor-comedians Mike Myers, Jim Carrey and to a lesser extent Hugh Grant.

But the real stars were the technicians working behind the scenes to make futuristic and complex movies so believable. By the end of the decade, the computer age was well and truly here, and brave new worlds were being explored in *The Matrix* trilogy and the *Star Wars* prequels.

Ralph Fiennes and Liam Neeson in *Schindler's List* (1993).

63rd Academy Awards®

1990

Best Film: *Dances with Wolves* (Orion / TIG Productions)

Best Director: Kevin Costner, *Dances with Wolves*

Best Actor: Jeremy Irons, *Reversal of Fortune*

Best Actress: Kathy Bates, *Misery*

Best Supporting Actor: Joe Pesci, *GoodFellas*

Best Supporting Actress: Whoopi Goldberg, *Ghost*

Dances with Wolves (1990) was the first western to win the Oscar® for Best Film since *Cimarron* (1931) and led a revitalization of the genre with film audiences. The epic story of a Civil War Union Army lieutenant (Costner) who travels west to command an abandoned army post and gradually earns the trust the native Americans who also live there won seven Oscars®.

Kevin Costner won two Academy Awards as producer (with Jim Wilson) and as first-time director. Other for awards were Best Cinematography (Dean Semler), Best Adapted Screenplay (Michael Blake), Best Original Score (John Barry) and Best Editing (Neil Travis).

Ghost (1990) is a romantic fantasy directed by Jerry Zucker (*Airplane!*, 1980) that won Whoopi Goldberg an Oscar® for Best Supporting Actress as a fake medium who becomes the unwanted vehicle for ghost Sam Wheat (Patrick Swayze, 1952–2009) to solve his own murder.

With an interesting blend of humor and drama, *Ghost* boasts a career best performance from Demi Moore as the grieving widow. *Ghost* became a worldwide hit and later, a stage play.

Misery (1990) was another successful adaptation of a Stephen King novel, with a screenplay by William Goldman and directed by Rob Reiner (the team behind *The Princess Bride*, 1987).

Kathy Bates (b. 1948) won the Oscar® for Best Actress for her portrayal of psychotic Annie Wilks, a devoted fan of writer Paul Sheldon (James Caan).

GoodFellas
1990

"You mean, let me understand this cause, ya know maybe it's me … but I'm funny how, I mean funny like I'm a clown, I amuse you? I make you laugh?"

Tommy DeVito (Joe Pesci)

Not since *The Godfather* (1972) has a director been so successful in creating the world of the gangster, but director Martin Scorsese brings his own take to the genre with *GoodFellas* (1990).

Brutally violent, vulgar, and sometimes funny with an almost documentary feel to it, *GoodFellas* features seminal performances from *Raging Bull* co-stars Robert De Niro and Joe Pesci (in his Oscar®-winning role for Best Supporting Actor) and a career-defining turn from Ray Liotta as central character and narrator Henry Hill.

The 1986 book *Wiseguys* by Nicholas Pileggi – the husband of Nora Ephron, writer of *Silkwood* (1983) and *When Harry Met Sally* (1989) – about life in a Mafia family immediately attracted the interest of director Martin Scorsese.

A gang of New York's Italian-Irish gangsters indoctrinate a young boy named Henry Hill into their mob world in the 1950s and stories of armed robbery, airport heists, insurance scams and mob hits abound. The introduction of drugs into Hill's inner circle, however, ultimately proves Hill's undoing and when he is arrested for dealing cocaine, he turns informer. To save his family from mob retribution, he unveils the inner workings of 'wiseguys' and 'goodfellas'.

Joe Pesci portrays flashy psychopath Tommy DeVito brilliantly ("I'm funny how, I mean funny like I'm a clown, I amuse you?" he asks a worried Henry Hill). But it is the chilling duplicity of De Niro's character 'Jimmy the Gent' that drives the film. Liotta's Henry Hill is a willing participant in the mayhem that follows, but Scorsese fills the screen with wonderful characters including the always reliable Paul Sorvino as a mob leader, Lorraine Bracco as Hill's outspoken wife, mob pal Frank Sivero from *The Godfather Part II* (1974) and Samuel L. Jackson in an early (thankless) role. Scorsese's mother Catherine plays Tommy's over-protective mom.

GoodFellas was not a huge hit when it was released (it was competing with the hit film, *Dances with Wolves*, 1990) and failed to double its $25 million production costs (Scorsese's most expensive film to date). However, it has grown in stature over the years.

Key scenes in the film are illuminated by classic rock music such as Cream's 'Sunshine of Your Love', George Harrison's 'What is Life', The Stones' 'Gimme Shelter', The Who's 'Magic Bus' and Harry Nilsson's 'Jump into the Fire'. The movie should have won an Oscar® for best use of Derek and the Dominos' 'Layla', with Scorsese using the song as a soundtrack to the vicious murders of the gang members after they turn on each other.

GoodFellas can be viewed as the start of Scorseses' 'modern' gangster trilogy, followed by *Casino* (1995) and the Academy Award-winning *The Departed* (2006), but it stands alone as one of the best films of the genre – perhaps even the best (as Roger Ebert believed).

Scorsese uses every device in his arsenal – freeze frames, a non-linear timeline, first-person narration and even has Hill talk directly to camera in the final scene as he contemplates the rest of his life in witness protection as an ordinary Joe.

Interestingly, the real Hill later divorced his wife and came out of hiding. He died of heart failure in 2012, aged 69.

Warner Bros.: 145 minutes

Produced by: Irwin Winkler

Directed by: Martin Scorsese

Screenplay by: Nicholas Pileggi and Martin Scorsese, based on Pileggi's 1986 book *Wiseguys*

Cinematography by: Michael Ballhaus

Starring: Robert De Niro ('Jimmy the Gent' Conway), Ray Liotta (Henry Hill), Joe Pesci (Tommy DeVito), Lorraine Bracco (Karen Hill), Paul Sorvino ('Paulie' Cicero), Frank Sivero (Frankie Carbone), Frank Vincent (Billy Batts), Tony Darrow (Sonny Bunz), Mike Starr (Frenchy), Chuck Low (Morrie Kessler), Samuel L. Jackson ('Stacks' Edwards), Catherine Scorsese (Tommy's mother), Gina Mastrogiacomo (Janice Rossi), Debi Mazar (Sandy).

James Cameron
b. 1954

Canadian filmmaker James Cameron established a career in Hollywood by writing *The Terminator* (1984) and then held out for an offer to direct. The film's success resulted in his screenplay for *Aliens* (1986) getting the green light, and Cameron's script and his direction gave the sequel to Ridley Scott's 1979 classic a tough military look.

In *The Abyss* (1989), he stretched filmmaking boundaries by using cutting edge technology, while *Terminator 2: Judgment Day* (1991) showed he had both the vision and ability to handle ambitious projects.

True Lies (1984) was a fun spy spoof but it was *Titanic* (1997), the most expensive movie made at that time, that won Cameron three Oscars® (Best Film, Best Director and Best Editing).

The success of *Avatar* (2009) again broke records, with Cameron focused in recent years on inventing new technologies to explore new film worlds.

KEY FILMS

The Terminator (1984)
Aliens (1986)
The Abyss (1989)
Terminator 2: Judgment Day (1991)
True Lies (1994)
Titanic (1997)
Avatar (2009)

In *Terminator 2: Judgment Day* (1991), writer-director James Cameron achieved the rare feat of producing the sequel to a classic film that actually improved on the original. This was in no small part due to the trail-blazing technical effects, a winning performance from first-time actor, teenager Edward Furlong, and Arnold Schwarzenegger as the hero of the story.

Character actor Robert Patrick plays a memorable liquid metal Terminator that 'Arnie' has to contend with, but Cameron makes the most of his then record $100 million budget and puts it all up there on the screen for audiences to enjoy.

64th Academy Awards®

1991

Best Film: *The Silence of the Lambs* (Orion)

Best Director: Jonathan Demme, *The Silence of the Lambs*

Best Actor: Anthony Hopkins, *The Silence of the Lambs*

Best Actress: Jodie Foster, *The Silence of the Lambs*

Best Supporting Actor: Jack Palance, *City Slickers*

Best Supporting Actress: Mercedes Ruehl, *The Fisher King*

The Silence of the Lambs (1991) was the first film since *It Happened One Night* (1934) to win the top four Oscar® awards – Best Film, Best Director (Jonathan Demme, pictured left), Best Actor (Anthony Hopkins, below right) and Best Actress (Jodie Foster, below left).

With an Oscar®-winning screenplay adapted by Ted Tally, *The Silence of the Lambs* also holds the distinction of being the only horror film to win the Best Film award. Having succeed where *The Exorcist* (1973) and *Jaws* (1975) failed, the movie started a whole franchise of Lecter-inspired films.

Adapted from the 1988 Thomas Harris novel, *The Silence of the Lambs* – itself a sequel to *Red Dragon* which was filmed as *Manhunter* in 1986 – Jonathan Demme's stylistic psychological thriller pits CIA heroine Clarice Starling (Jodie Foster) against captured serial killer Hannibal Lecter (Anthony Hopkins) in an effort to gain an insight into the mind of Lecter protégé, killer 'Buffalo Bill' (Ted Levine).

Interestingly, Scott Glenn received 'above the title' billing alongside Foster and Hopkins. His character, CIA head Jack Crawford, plays a more central role in the original book, but it's the uneasy relationship between Starling and Lecter that makes the film succeed so well. Hopkins and Foster did not speak to each other off set until the final day of shooting in order to keep their film characters on edge.

The Silence of the Lambs made a star of Hopkins after almost 25 years in film. The source material produced a sequel (*Hannibal*, 2001) and two prequels (*Red Dragon*, 2002) and *Hannibal Rising* (2007), although none of them reunited Hopkins with Foster, who declined to repeat her Oscar®-winning role.

Oliver Stone

b. 1946

Oliver Stone served as a volunteer infantryman in the Vietnam War before writing the scripts for *Midnight Express* (1978), for which he won an Oscar® and *Scarface* (1983). Turning to directing, Stone released *Salvador* (1986) and *Platoon* (1986) in the same year – two completely different films about different wars but each brilliant in their own right.

Platoon won four Academy Awards®, including Best Film and Best Director, and Stone followed this with *Wall Street* (1987).

After winning another Oscar® for *Born on the Fourth of July* (1989), Stone continued to question the establishment and stretch filmmaking boundaries. *JFK* (1991) blurred the lines between fact and fiction and *Natural Born Killers* (1994) blurred the lines between art and violence. Despite some failures along the way, with *Any Given Sunday* (1999) Stone firmly establishes his talent for telling stories in original ways.

KEY FILMS

Salvador (1986)
Platoon (1986)
Wall Street (1987)
Born on the Fourth of July (1989)
The Doors (1991)
JFK (1991)
Heaven & Earth (1993)
Natural Born Killers (1994)
Nixon (1995)
Any Given Sunday (1999)
W. (2008)
Savages (2012)
Snowden (2016)

JFK (1991) offers a compelling case that the assassination of the US President in 1963 was the result of a government conspiracy, but despite an almost forensic examination of the evidence by District Attorney Jim Garrison (Kevin Costner), Oliver Stone's powerful film suffers from over-analysis, bold-faced bias and some good old fashioned movie trickery.

As good a film as *JFK* is, (it also won Oscars® for cinematography and editing), read *Oswald's Ghost* by Norman Mailer or *Parkland* by Vincent Bugliosi and it's hard not to draw the alternative view that Lee Harvey Oswald was a lone assassin.

If that is indeed the case, then a great film such as *JFK* is more of a fiction than even the filmmakers would have us believe.

65th Academy Awards®
1992

Best Film: *Unforgiven* (Warner Bros. / Malpaso)

Best Director: Clint Eastwood, *Unforgiven*

Best Actor: Al Pacino, *Scent of a Woman*

Best Actress: Emma Thompson, *Howards End*

Best Supporting Actor: Gene Hackman, *Unforgiven*

Best Supporting Actress: Marisa Tomei, *My Cousin Vinny*

As revisionist westerns go, **Unforgiven** (1992) is now regarded as one of the very best. Veteran actor-director Clint Eastwood won the Oscar® for Best Film (as co-producer) and Best Director (and also wrote the main music theme!) and also takes the lead role as retired killer Will Munny, who comes out of retirement to kill a man for the reward money.

Eastwood generously allows veterans Morgan Freeman, Richard Harris and Gene Hackman (in his Oscar®-winning role for Best Supporting Actor) to share in the reflected glory of this fine film. *Unforgiven* won four Oscars, including Best Editing (Joel Cox), and was dedicated to Eastwood's film mentors Don Seigel (1912–1991) and Sergio Leone (1929–1989).

Based on E.M. Forster's novel about three families that represent the English class system during the Edwardian era, **Howards End** (1992) was the first film made by the British production team of Ismail Merchant (producer), James Ivory (director) and writer Ruth Prawer Jhabvala (writer).

This beautifully made film won Oscars® for Best Actress (Emma Thompson), Adapted Screenplay (Prawer Jhabvala) and Art Direction-Set Decoration, and features wonderful performances from Anthony Hopkins (above with Thompson), Vanessa Redgrave and Helena Bonham Carter (right, with actor Sam West).

Quentin Tarantino
b. 1963

Quentin Tarantino is a walking encyclopedia of camera styles, projection formats and film genres, and has successfully tapped into this knowledge to create a body of work that quickly achieved cult status.

His first feature film, *Reservoir Dogs* (1992), a heist film told in flashback, sets the tone for what is to come.

Tarantino is the *enfant terrible* of modern film and his screenplays, full of politically incorrect dialogue and plot twists, have earned him two Oscars®: Best Original Screenplay (with Roger Avary) for *Pulp Fiction* (1994); and Best Original Screenplay for *Django Unchained* (2012).

He has weathered controversies over the violence, racism, sexism and even historic revisionism in his films but his fans don't care. Full of pop culture references and cinematic flourishes, even his failures have their devotees. Despite a tendency to put everything (including himself) into his films, Tarantino is a modern-day auteur – a movie geek turned master filmmaker.

KEY FILMS

Reservoir Dogs (1992)
Pulp Fiction (1994)
Jackie Brown (1997)
Kill Bill: Volume 1 (2003)
Kill Bill: Volume 2 (2004)
Death Proof (2007)
Inglourious Basterds (2009)
Django Unchained (2012)
The Hateful Eight (2015)

Reservoir Dogs (1992) is a totally original crime film from first-time writer-director Quentin Tarantino.

The story of a group of crooks brought together for a jewel heist that goes terribly wrong was championed by Harvey Keitel, who took on the key role as the mysterious Mr White.

The film's explosive ensemble cast – Tim Roth as the insider, Michael Madsen as the psychopath Vic Vega, Steve Buscemi as the rationalist ('Why do I have to be Mr Pink?') and Chris Penn as 'Nice Guy' Eddie – brought the non-chronological story to life with pop culture references, nods to crime films such as *The Taking of Pelham, One, Two, Three* (1974) and many morally-vacant sequences along the way.

The film was a huge hit in Europe (it was actually banned in the UK until 1995) and announced the arrival of new style of filmmaker – Tarantino.

The cast of crooks, pictured above from left, are Michael Madsen, Quentin Tarantino, Harvey Keitel, Chris Penn, Lawrence Tierney (partially obscured at back), Tim Roth, Steve Buscemi and Edward Bunker.

66th Academy Awards®
1993

Best Film: *Schindler's List* (Universal / Amblin Entertainment)

Best Director: Steven Spielberg, *Schindler's List*

Best Actor: Tom Hanks, *Philadelphia*

Best Actress: Holly Hunter, *The Piano*

Best Supporting Actor: Tommy Lee Jones, *The Fugitive*

Best Supporting Actress: Anna Paquin, *The Piano*

Schindler's List (1993) is Steven Spielberg's crowning career achievement, which won seven Oscars® including Best Film and Best Director which were both firsts for Spielberg.

The story of the German industrialist (Liam Neeson) who rescued more than a thousand mostly-Polish Jews from the Holocaust was based on Thomas Keneally's Booker-prize winning book *Schindler's Ark* (1982).

At more than three hours, Spielberg's black and white epic fulfills its promise to future generations not to forget the horrors of the Nazi regime, in part personified by a chilling performance from Ralph Fiennes as SS Captain Amon Göth.

The Piano (1993) is a difficult story to categorize, as is to be expected for a film from New Zealand. Written, directed and produced by Australian Jane Campion, *The Piano* won Oscars® for Holly Hunter as a mute Scotswoman sold into marriage, and 11-year old Anna Paquin for Best Supporting Actress playing Hunter's daughter.

Campion was also thrice nominated (for Best Film, Best Director and Writing) and took home the Oscar® for Best Original Screenplay.

The title refers to the lead character's prized possession which is abandoned on a New Zealand beach and becomes the symbol of her emotional stand-off with her new husband (Sam Neill) and a kind neighbor (Harvey Keitel).

Remains of the Day (1993), adapted by Ruth Prawer Jhabvala from the novel by Kazuo Ishiguro and directed by James Ivory, stars Anthony Hopkins and Emma Thompson as servants who repress their affection for each other in the line of duty in prewar England.

For all his histrionics in his Oscar®-winning role as 'Hannibal the Cannibal' Lecter two years before, Hopkins shows his immense skill in making the Darlington Hall butler such a sympathetic and lonely character.

Remains of the Day (1993) has much to say about love lost and what remains in the memory decades later.

Groundhog Day
1993

"You want a prediction about the weather, you're asking the wrong Phil. I'll give you a winter prediction: It's gonna be cold, it's gonna be grey, and it's gonna last you for the rest of your life."

Phil (Bill Murray)

In 1993, Oscar®-winning writer William Goldman (*Butch Cassidy and the Sundance Kid*, 1968; and *All the President's Men*, 1976) reflected on the state of movies in his memoir *Adventures in Screenwriting*. Of all the films released that year, Goldman believed the comedy *Groundhog Day* (1993) would be the one remembered in ten years' time. Goldman also lamented the lack of recognition of comedic films to the point of even suggesting that there should be Oscar® awards for best comedy film, comedy performance and even screenplay. If that were the case, *Groundhog Day* would have surely scooped the pool.

With an ingenious premise from writer Danny Rubin, *Groundhog Day* is the comedy that keeps on giving – day after day after day. More than 20 years after its release, the film stands up as one of the best films of the 1990s and remains a masterly example of comedic writing, pacing and direction. The film has also had such a big impact on pop culture that the term 'groundhog day' has entered the vernacular to describe the sameness of everyday life.

Former *Saturday Night Live* comedian Bill Murray (b. 1950) brings the perfect mix of sardonic wit and cosmic bewilderment to vain TV weatherman Phil Connors who finds himself trapped in Punxsutawney, Pennsylvania, on Groundhog Day (February 3) and fated to repeat the same day over and over again.

Under the direction of close friend Harold Ramis (*Stripes*, 1981), Murray's immense skill as a comedic actor is shown by his measured reactions to increasingly familiar situations as he relives the same day.

Murray's performance is alternatively sarcastic, hilarious and even poignant as he finally realizes that he must start thinking about others before the cosmos will allow him to move on.

Actress Andie McDowell, the focus of Phil's unwanted attentions, is refreshingly original in the role of TV producer Rita Hanson. McDowell would score another major hit the following year alongside Hugh Grant in *Four Weddings and a Funeral* (1994). Comedian Chris Elliott has little to do as the pair's third wheel cameraman but Stephen Tobolowsky has a hilarious recurring role as insurance salesman Ned Ryerson, as do most of the supporting characters in this film. Marita Geraghty plays the naïve local beauty who falls for Phil's perfected charm, while Ken Hudson Campbell (as the genial man Phil meets in the hallway each morning) and Murray's older brother Brian Doyle-Murray as a town councilor are just a few of the cast of characters Phil encounters.

Perhaps the secret to *Groundhog Day*'s mass-market appeal is ultimately how cleverly the film delivers the universal Buddhist message of rebirth. The film's reputation continues to grow and, at the time of writing, there are plans to turn the story into a stage musical. Bill Murray and Harold Ramis apparently fell out during the production of the film, although they reconciled shortly before Ramis' death in 2014, which shows just how serious making a classic comedy can be. And another thing – you can never again listen to Sonny and Cher's 'I Got You Babe' without thinking of this film.

Columbia Pictures: 101 minutes.

Directed by: Harold Ramis

Produced by: Trevor Albert and Harold Ramis

Screenplay by: Danny Rubin and Harold Ramis

Story by: Danny Rubin

Music by: George Fenton

Cinematography by: John Bailey

Starring: Bill Murray (Phil Connors), Andie MacDowell (Rita Hanson), Chris Elliott (Larry the camera man), Stephen Tobolowsky (Ned Ryerson), Brian Doyle-Murray (Buster Green), Angela Paton (Mrs. Lancaster), Robin Duke (Doris the waitress), Marita Geraghty (Nancy Taylor)

67th Academy Awards®

1994

Best Film: *Forrest Gump* (Paramount)

Best Director: Robert Zemeckis, *Forrest Gump*

Best Actor: Tom Hanks, *Forrest Gump*

Best Actress: Jessica Lange, *Blue Sky*

Best Supporting Actor: Martin Landau, *Ed Wood*

Best Supporting Actress: Dianne Wiest, *Bullets over Broadway*

Forrest Gump (1994) was a pop culture hit in 1994, largely due to breakthrough computerized scenes from director Robert Zemeckis that allowed his guileless lead character (played by Tom Hanks) to interact with historical figures such as JFK, LBJ and John Lennon. The film grossed more than $600 million worldwide.

With a great 1960s soundtrack, *Forrest Gump* won six Oscars® including Best Film, Best Director, Best Actor, Best Adapted Screenplay, Best Editing and, not surprisingly, Best Visual Effects. Tom Hanks won successive Best Actor Oscars® for this role after winning for *Philadelphia* (1993), emulating the great Spencer Tracy (1937–38).

Pulp Fiction (1994), Quentin Tarantino's keenly anticipated follow-up to cult hit *Reservoir Dogs* (1992), is a three-course banquet of violence, black humor and pop culture. The intoxicating mix of stories unfold in three-part, non-chronological structure as a pair of hitmen, some hapless thieves and an embittered boxer cross paths.

Pulp Fiction singlehandedly resurrected the career of John Travolta (above left) after a decade in the wilderness and made a star out of Samuel L. Jackson (above right).

Also starring Bruce Willis as the boxer, Uma Thurman (pictured right), as the gangster's moll with a love of adventure, Ving Rhames as the gangster and Eric Stoltz as a panicked drug dealer, *Pulp Fiction* also features appearances from Christopher Walken, Harvey Keitel and Tim Roth. To top it off, it has a killer soundtrack.

A controversial film on release that quickly found favor in the mainstream, Tarantino and writing partner Roger Avery later won Oscars® for Best Original Screenplay.

The Shawshank Redemption (1994) was a modest success on its release in 1994, and then again during the awards season in 1995, but achieved classic status on home video and TV. Based on Stephen King's 1982 novella *Rita Hayworth and Shawshank Redemption*, the film was nominated for seven Academy Awards® including Best Film and Best Actor (Morgan Freeman) but came out empty handed in a year when *Forrest Gump, Pulp Fiction* and *The Lion King* dominated the Oscars®.

Tim Robbins and Morgan Freeman (above), give brilliant performances in the central roles and are ably supported by a raft of character actors, including veteran James Whitmore as a worn-out con, Bob Gunton as the corrupt prison warden and Clancy Brown as a brutal guard. Robbins' portrayal of the falsely imprisoned Andy Dufresne's pursuit of freedom and the resignation of Morgan Freeman's career criminal 'Red' Redding struck a chord with audiences, but credit must also go to writer-director Frank Darabont for his skilful handling of a complex story told over a 20-year period.

Based on a true story, **Heat** (1995) brought together the talents of Robert De Niro and Al Pacino as protagonists 20 years after they both appeared in *The Godfather Part II* (1974). Arch-criminal Neil McCauley (De Niro) and Lt. Vincent Hanna (Pacino) play cat and mouse for much of the film before facing off in a scene in a coffee shop where they both put their cards on the table.

Written and directed by Michael Mann (*The Last of the Mohicans*, 1992), *Heat* was a superior heist thriller with a stellar cast including Val Kilmer, Tom Sizemore, Natalie Portman, Ashley Judd and Amy Brenneman – and some exhilarating action sequences.

The final showdown between De Niro and Pacino doesn't disappoint and the film, though perhaps running half an hour longer than it should have, proved every bit as successful as the hype surrounding its two stars.

68th Academy Awards®
1995

Best Film: *Braveheart* (Paramount / 20th Century Fox / Icon)

Best Director: Mel Gibson, *Braveheart*

Best Actor: Nicolas Cage, *Leaving Las Vegas*

Best Actress: Susan Sarandon, *Dead Man Walking*

Best Supporting Actor: Kevin Spacey, *The Usual Suspects*

Best Supporting Actress: Mira Sorvino, *Mighty Aphrodite*

Braveheart (1995) was an imaginative reworking of the William Wallace legend from 13th century Scotland by actor-director Mel Gibson and writer Randall Wallace (no relation to the original).

Wallace was Oscar® nominated for Original Screenplay, only to lose out to Chris McQuarrie's *The Usual Suspects* (1995).

Gibson was the eighth professional actor to win the Best Director Oscar® in the previous two decades (following Woody Allen, Robert Redford, Warren Beatty, Richard Attenborough, Sydney Pollack, Kevin Costner and Clint Eastwood).

Writer Christopher McQuarrie creates an inescapable labyrinth of a plot in ***The Usual Suspects*** (1996) as five desperate thieves are brought together at the behest of master criminal Keyser Söze.

Pictured above from left, Kevin Pollack, Stephen Baldwin, Benicio del Toro, Gabriel Byrne and Kevin Spacey play the five criminals, but who is Keyser Söze and what does he want? The mere mention of his name creates fear and panic. Director Bryan Singer utilizes his fine cast (also Pete Postlethwaite, Chazz Palmintieri and Suzy Amis) and keeps the audience guessing right up until the startling climax.

Kevin Spacey won his first Oscar® as Best Supporting Actor for the role 'Verbal' Kint.

Se7en
1995

"Realize detective, the only reason that I'm here right now is that I wanted to be."

John Doe (Kevin Spacey)

Se7en contains a thoroughly original thriller premise – a serial killer murders random people who, according to his warped mind, have committed each of the seven deadly sins: gluttony, greed, sloth, lust, pride, envy and wrath. The genius of Andrew Kevin Walker's script, however, is that it grabs the audience's attention early, lays out the clues and then encourages us to race ahead of the two detectives investigating the crimes. This reaches a dramatic crescendo at the end of the film but, by the time you realize what is happening, all you can do is sit back and watch like some fish caught in a net.

The style of the film is a continuation of director David Flincher's dark world of *Alien 3* (1992), with a perennially raining urban setting (of an unnamed city) where lurid murders are being committed – an obese man is force-fed until his stomach ruptures; a lawyer has a pound of flesh cut from his abdomen; a pedophile is tied to his bed and photographed as he starves to death; a prostitute is raped by a client wearing a bladed sex toy; a model chooses suicide after her nose is cut off.

However, *Se7en* is more than a series of gruesome murders. It's a topflight psychological thriller that puts your imagination into overdrive because, although the victims have suffered terrible deaths, Fincher only shows the crime scenes.

In the casting of Morgan Freeman and Brad Pitt as the mismatched detectives – one, old and cynical; the other, young and quick to judge – Fincher takes the time to establish their characters early in the film.

The intervention of Det. Mills' pretty wife Tracy (played by Pitt's then girlfriend Gwyneth Paltrow) unites the pair in pursuit of the killer 'John Doe' and plants the seed for later in the film when Paltrow (or our memory of her) becomes an important part of the story.

In a clever sleight of hand, the audience literally doesn't see Kevin Spacey coming (Spacey is unbilled) and when his character suddenly gives himself up, his hands bloodied but his attitude superior, we are once again thrown off kilter. What is happening?

In a revised screenplay, John Doe was killed in a standard shootout with the detectives but it is to Fincher's credit that he filmed the 'what's in the box' ending that Walker wrote in his original draft. The film leaves you thinking long after you left the movie theatre.

Se7en is a highly influential film with its innovative cinematography, dank art decoration, the use of industrial music and even its distinctive opening title sequences. The film was a gamechanger of the genre, spawning numerous imitators but none with the intelligence and bravado of Fincher's film.

New Line Cinema: 127 minutes

Produced by: Arnold Kopelson and Phyllis Carlyle

Directed by: David Fincher

Written by: Andrew Kevin Walker

Music by: Howard Shore

Cinematography by: Darius Khondji

Starring: Morgan Freeman (Detective Lieutenant William Somerset), Brad Pitt (Detective David Mills), Gwyneth Paltrow (Tracy Mills), Kevin Spacey ('John Doe', uncredited), R. Lee Ermey (Police Captain), John C. McGinley (SWAT team leader), Richard Roundtree (District Attorney Martin Talbot).

Tom Hanks

b. 1956

Tom Hanks is Hollywood's comedic and dramatic 'everyman' – no small achievement when he can appeal to such a huge film audience. Emerging in the 1980s as a light comedian after the success of *Splash* (1984), it was not until almost a decade later that *Sleepless in Seattle* (1993) marked him as a romantic lead. *Philadelphia* (1993), for which Hanks won his first Oscar®, revealed untapped depths of dramatic talent in the likeable and quirky actor. The following year, he made it back-to-back Oscars® with *Forrest Gump* (1994), in which he walked that fine line between idiot and savant. Since then, he has starred in some of Hollywood's biggest films (*Saving Private Ryan*, 1998), voiced animated films (*Toy Story*, 1995) and directed (*That Thing You Do!*, 1995) and produced (TV mini series *From Earth to the Stars*, 1998; *Band of Brothers*, 2002; and *The Pacific*, 2010).

KEY FILMS

Splash (1984)
Big (1988)
A League of Their Own (1992)
Sleepless in Seattle (1993)
Philadelphia (1993)
Forrest Gump (1994)
Apollo 13 (1995)
Toy Story (1995)
*That Thing You Do!** (1996)
Saving Private Ryan (1998)
You've Got Mail (1998)
The Green Mile (1999)
Toy Story (1999)
Cast Away (2000)
Road to Perdition (2002)
Catch Me If You Can (2002)
The Terminal (2004)
The Da Vinci Code (2006)
Charlie Wilson's War (2007)
Cloud Atlas (2012)
Captain Phillips (2013)
Saving Mr. Banks (2013)
Bridge of Spies (2015)
* also director

Apollo 13 (1995) is Hollywood filmmaking at is very best – a failed moon-landing, very much part of a forgotten past of scientific endeavor – is brought to the screen in every thrilling detail by director Ron Howard (*Cocoon*, 1985).

Tom Hanks confirms his star status as astronaut Jim Lovell and is ably supported by Kevin Bacon, Bill Paxton, Gary Sinese and Ed Harris playing fellow NASA colleagues who collectively make this space drama very real.

It was the second successive teaming of Hanks and Sinese (*Forrest Gump* wasn't released when *Apollo 13* was being shot) and the irony that the mission is saved by the man who was left behind on earth worked wonderfully in this film about the unsung heroes of the space race.

Toy Story (1995), and its subsequent sequels, defied the limitations of its computer-animated medium to become a much-loved favorite of children and adults alike. The debut film from the Pixar Animation Studio (which was later acquired by Disney for $7. 4 billion), the success of *Toy Story* was followed by more masterpieces: *A Bug's Life* (1998), *Toy Story 2* (1999), *Monsters, Inc.* (2001), *Finding Nemo* (2003), *The Incredibles* (2004), *WALL-E* (2008), *Up* (2009), *Inside Out* (2015) and *Coco* (2017). The nostalgic toy characters, the wonderful animation, the funny script, Randy Newman's music and the voice actors headed by Tom Hanks (as Woody) and Tim Allen (Buzz Lightyear) combine in a unique animated film that has real heart.

69th Academy Awards®

1996

Best Film: *The English Patient* (Miramax / Tiger Moth Productions)

Best Director: Anthony Minghella, *The English Patient*

Best Actor: Geoffrey Rush, *Shine*

Best Actress: Frances McDormand, *Fargo*

Best Supporting Actor: Cuba Gooding, Jr., *Jerry Maguire*

Best Supporting Actress: Juliette Binoche, *The English Patient*

The English Patient (1996) won nine Oscars® including Best Film, Best Director, Best Supporting Actress (Juliette Binoche, left), Cinematography and Score, although actors Ralph Fiennes and Kristen Scott Thomas as the doomed lovers at the centre of the story missed out on Best Actor, Best Actress awards.

Anthony Minghella's mesmerizing film of Michael Ondaatje's Booker Prize-winning novel also proved third time lucky for producer Saul Zaentz following the success of *One Flew over the Cuckoo's Nest* (1975) and *Amadeus* (1984).

Jerry Maguire (1996) finds writer-director Cameron Crowe, star Tom Cruise, girl-next door Renee Zellweger, and the exuberant Cuba Gooding Jr at the top of their acting game.

A sports manager (Cruise) wakes up one day and realizes the company he works for doesn't really care about its clients and so he branches out on his own with a naïve single mom as his secretary (Zellweger) and one gridiron-playing client (Cuba Gooding Jr who won Best Supporting Actor). Child actor Jonathan Lipnicki all but steals a film that is often more cynical than sentimental.

Billy Bob Thornton was a struggling songwriter and actor when he wrote the role of his career in ***Slingblade*** (1996). The character, Karl Childers, started life in the short film, *They Call it a Slingblade* before Thornton expanded the story, starred in and directed the feature film, which was made for just a million dollars.

A recently released mental prison inmate (Thornton, right) befriends the family of a young boy (Lucas Black, left) and becomes their protector when an abusive boyfriend (Dwight Yoakam, in a chilling performance) threatens their stability. Thornton's Oscar®-winning adapted screenplay set him on a career of quirky character roles and underground musical success.

Fargo
1996

> "Ma'am, I answered your question! I answered the darned... I'm co-operatin' here!"
>
> Jerry Lundegaard (William H. Macey)

Filmmaker brothers Joel and Ethan Coen have an interesting worldview, as represented by their films *Raising Arizona* (1987), a film about baby kidnappers; *Miller's Crossing* (1990), their take on gangsters, and *Barton Fink* (1991), the story of a delusional screenwriter. *Fargo* (1996) however, was easily their most coherent and best realized film to date, with enough quirky humor and character studies for it to stand out above the pack of 'who dunnits?'

Fargo is set in the town of the same name, Fargo, Minnesota. Car salesman Jerry Lundegaard (William H. Macy) arranges for two out-of-town hoods (Steve Buscemi and Peter Stormare) to kidnap his wife so he can scam his rich father-in-law (Harve Presnell). The situation quickly escalates out of control but local trooper Marge Gunderson (Frances McDormand) diligently and somewhat eccentrically pursues the case.

The dialogue captures the local accents and social culture brilliantly (the Coens grew up in Minneapolis, Minnesota) which is an integral part of the charm of the film and the cult following it has developed.

Marge is the ultimate anti-hero – she's pregnant, she's working on a serious crime case that she is totally out of step with, and she's questioning everything. Jerry Lundegaard, on the other hand, is incompetent and spineless – he sacrifices his own family to get him out of the financial trouble he is in.

McDormand, who is married to Ethan Coen, won the Oscar® for Best Actress for this film while former TV actor William H. Macy (*ER*) was nominated for Best Actor. Macy excels in the role of the soulless car salesman whose grand plan slowly unravels with tragic consequences. His scenes with McDormand, the pregnant trooper who sees through his lies. ("Ma'am, I answered your question!" he tells Marge snippily. "I answered the darned ... I'm co-operatin' here!") are among the best in the film.

Steve Buscemi adds to his 'weird little guy' repertoire while Peter Stormare achieves a lot in saying very little.

Harve Presnell, so memorable in 1960s musicals *The Unsinkable Molly Brown* (1964) and *Paint Your Wagon* (1969), is totally believable as the hard-nosed businessman who marginalizes his son-in-law. "We're not a bank, Jerry," he tells Lundegaard when he comes to see him for a loan.

Buscemi's contract killer with the 'small man' syndrome has some of the best lines. "I'm not going to debate you Jerry," he says to Macy when they organize the handover of the money. Even when Buscemi's character comes out on top, burying the excess ransom money in the snow to collect later, his small mindedness results in him meeting a very unpleasant ending. Like Lundegaard, he is the ultimate loser.

The Coens have a lot of fun with reality in this film – in the opening credits state "This is a true story" but they then provide the disclaimer that 'characters and events are fictitious' at the end of the film. Which is true? At best *Fargo* is loosely based on real events, but with the Coen's unique visual style.

The pair won their first Oscar® for original screenplay, and a decade later won a trio of awards for *No Country for Old Men* (2007) as writers, directors and producers.

PolyGram Filmed Entertainment/Working Title Films: 98 minutes

Produced, Directed and Written by: Joel Coen and Ethan Coen

Music by: Carter Burwell

Cinematography by: Roger Deakins

Starring: Frances McDormand (Trooper Marge Gunderson), William H. Macy (Jerry Lundegaard), Steve Buscemi (Carl Showalter), Peter Stormare (Gaear Grimsrud), Harve Presnell (Wade Gustafson), Kristin Rudrüd (Jean Lundegaard), Steve Reevis (Shep Proudfoot), John Carroll Lynch (Norm Gunderson).

70th Academy Awards®

1997

Best Film: *Titanic* (Paramount / 20th Century Fox / Lightstorm Entertainment)

Best Director: James Cameron, *Titanic*

Best Actor: Jack Nicholson, *As Good as It Gets*

Best Actress: Helen Hunt, *As Good as It Gets*

Best Supporting Actor: Robin Williams, *Good Will Hunting*

Best Supporting Actress: Kim Basinger, *L.A. Confidential*

Titanic (1997) matched the record set by *Ben-Hur* (1959) by winning 11 Academy Awards® in 1997, including Best Film and Best Director for James Cameron.

As a technical achievement, few films can match the scope and brilliance of Cameron's film which went on to become the first to earn $2 billion in returns.

Although Kate Winslett (below left) was nominated for, but missed winning, Best Actress and Leonardo DiCaprio (below right) was not nominated for Best Actor, they were electric on screen appealing to audiences around the world.

James L. Brooks' *As Good as it Gets* (1997) took the acting honors that year, earning Jack Nicholson a third award (his second Best Actor Oscar®) for his role of Melvin Udall, alongside former child star Helen Hunt (b. 1963) who won Best Actress.

Good Will Hunting (1997) was written by young actors Ben Affleck and Matt Damon, who went on to win the Academy Award for Best Original Screenplay for their story of a young maths genius (Damon) struggling to leave his modest Boston background behind him and achieve his full potential.

Gus Van Sant's film is certainly original, and works much better as a drama after producers dispensed with the 'thriller' aspect of the original plot where Will is 'hunted' by the CIA. The film benefits most from Robin Williams' Oscar®-winning performance (Best Supporting Actor) as a sympathetic psychologist.

The humor and the psychology may have dated somewhat and the film follows a predictable narrative but it's great to watch Damon and his buddy Affleck strut their stuff with such belief and youthful bravado.

L.A. Confidential (1997) stars three young Australian actors – Russell Crowe, Guy Pearce and Simon Baker – in key roles of this confronting James Ellroy story about corruption in the LA Police Department in the 1950s.

Kevin Spacey, James Cromwell and Kim Basinger, in her Oscar®-winning role for Best Supporting Actress, also feature in this handsomely-mounted film by Curtis Hanson.

Told in noir style but with a '90s sensibility, Crowe and Spacey fared best from the dense story, with both going on to win Oscars® in ensuing years.

L.A. Confidential also takes a wide swipe at the morals of the magazine industry at the time, with Danny De Vito as a sleazy publisher and David Strathairn as a brothel operator adding to the authenticity of the era.

Writer-director Paul Thomas Anderson's ***Boogie Nights*** (1997), charts the lives and careers of minor players in the 1970s porn film industry; their personal destruction due to an excess of sex and drugs, and the impact on home video on a once thriving industry.

Anderson fills his multi-layered film with wonderful eccentrics and vignettes – Burt Reynolds (pictured left) as filmmaker Jack Horner, Mark Wahlberg (centre) as aspiring porn star 'Dirk Diggler', and Julianne Moore (right) as the tragic 'Amber Waves'. It's a big cast that also includes Heather Graham, John C. Reilly (second from right), Phillip Seymour Hoffman (right), Don Cheadle (as a country and western loving 'brother'), Thomas Jane, Alfred Molina and William H. Macy as a comic-tragic cameraman.

Burt Reynolds and Julianne Moore were both Oscar® nominated for their roles, with Reynolds giving a brilliant, late-career performance as a flawed man with artistic pretensions. *Boogie Nights* also marks the arrival of former rapper Mark Wahlberg as a movie star, although Dirk Diggler reveals the who the real star is at the end of the film.

Al Pacino must have thought long and hard about appearing in another gangster film after being synonymous with *The Godfather* trilogy, *Scarface* (1983) and the underrated *Carlito's Way* (1993). That would have been until he read the script for ***Donnie Brasco*** (1997), based on the true story of undercover FBI agent Joseph D. Pistone (played by Johnny Depp) who infiltrates the New York Mafia.

Pacino's portrayal as 'second banana' gangster 'Lefty' Ruggiero is matched only by Depp, who gives a career-best performance as 'Donnie', the FBI agent 'Lefty' unwittingly sponsors into the Mob. Michael Madsen, James Russo and the always watchable Bruno Kirby play the gangster crew 'Lefty' hopes to be named boss of, only to be bypassed by Madsen's 'Sony Black'. Anne Heche makes the most of the thankless role of Pistone's neglected wife.

Violent, poignant and funny in parts (especially the scene where Depp explains to the FBI the different uses of the phrase 'forget about it' amongst the gangsters), English director Mike Newell builds the tension as Donnie Brasco is drawn deeper into the criminal world. The ending is bitter-sweet; there are few winners in this story, which makes *Donnie Brasco* such a remarkable film.

71st Academy Awards®

1998

Best Film: *Shakespeare in Love* (Miramax / Universal / Bedford Falls Company)

Best Director: Steven Spielberg, *Saving Private Ryan*

Best Actor: Roberto Benigni, *Life Is Beautiful*

Best Actress: Gwyneth Paltrow, *Shakespeare in Love*

Best Supporting Actor: James Coburn, *Affliction*

Best Supporting Actress: Judi Dench, *Shakespeare in Love*

Shakespeare in Love (1998) was a surprise winner of the 1998 Academy Award for Best Film, beating warm favorite *Saving Private Ryan*, perhaps winning because it is a totally original historical romantic comedy.

The ingenious script won a Best Original Screenplay Oscar® for Marc Norman and Tom Stoppard (*Rosencrantz and Guildenstern Are Dead*, 1968). Gwyneth Paltrow as a cross-dressing actor won Best Actress and Judi Dench as Queen Elizabeth I picked up Best Supporting Actress.

Joseph Fiennes (the younger brother of Ralph Fiennes) plays the love-struck William Shakespeare. He lost out in the Oscar® race to Roberto Benigni for *Life is Beautiful* (1998), a once in a lifetime performance.

Saving Private Ryan (1998) is one of the most gripping war films made by Hollywood and it took someone with the skill of Steven Spielberg to make it.

The problem with *Saving Private Ryan*, however, is that it is so believable, especially the opening scenes about the invasion of Normandy, that it's not a film that you actually enjoy watching or want to watch time and time again. Some of the scenes are hard to stomach (remember, this is not a documentary) – the death of the medic played by Giovanni Rubisi; the stabbing of rifleman Mellish (Adam Goldberg) by a released German soldier as the medic's colleague cowers outside; and the final attack at Ramelle in France.

Some scenes strike the wrong note – the negativity of Edward Burns' character, the breaking down of Private Ryan (Matt Damon, right) under enemy gunfire, and the speech by a dying Tom Hanks at the end of the film – but Spielberg succeeds more than he fails and deservedly won his second Oscar® for Best Director.

Tom Hanks as Captain Miller, who is charged with the responsibility of finding Ryan after the young paratrooper loses three brothers on D-Day, gives a wonderfully restrained performance as the peacetime English teacher trying to hold his band of men together.

The Truman Show
1998

It's interesting to note that there were very few 'reality shows' on TV in the 1990s when *The Truman Show* was released in 1998. The internet was in its infancy, YouTube had not been invented and the 30-plus seasons of *Survivor* had not yet commenced. Possibly the success of Jerry Seinfeld (1991–98), a show about nothing, was a catalyst for this film. What is clear is that *The Truman Show* was ahead of its time. It features an uniquely original screenplay from New Zealand-born writer-director Andrew Niccol (*Gattaca*, 1997) which is perceptively brought to the screen by Australian director Peter Weir.

Peter Weir (b. 1944) became internationally known for his directing of Australian films *Picnic at Hanging Rock* (1975) and *Gallipoli* (1981) before coming to Hollywood and earning six Academy Award nominations in the ensuing years (*Witness*, 1985; *Dead Poets Society*, 1989; *Green Card*, 1990 as writer, *The Truman Show*, 1998; and *Master and Commander: The Far Side of the World*, 2003, also as producer). Equally adept at historical dramas, romantic comedies and intelligent satires such as *The Truman Show*, Weir brought an outsider's sensibility and a wonderful sense paranoia to this film.

In the story Truman Burbank (Jim Carrey) is raised from infancy without knowing he is the star of his own reality TV show. He is surrounded by actors, who play his family and friends, and lives in TV-land's biggest, dome-encased sound stage. It is a stroke of genius that Weir cast comedian Carrey to play someone so guileless, yet believable and sympathetic. This is no wacky Carrey comedy – his portrayal of Truman's slow realization that something is wrong in the fictional township of Seahaven is understated and poignant.

Ed Harris is totally believable as Christof, the creator and director of the show ("Cue the sun!"). Truman's escape from Seahaven (in a small boat named the *Santa Maria*) while being bombarded by a storm generated in the control room not only reveals Christof's pathology but also satirizes the lengths TV networks will go to maintain ratings. Laura Linney (*Primal Fear*, 1996) features in an early breakout role as Truman's 'wife', while Noah Emmerich (*Little Children*, 2006) is a standout as Truman's conniving 'best friend' Marlon.

Truman's fake world opens up in the middle of the film when a TV reporter (Harry Shearer) interviews the show's producers. This allows the audience to appreciate the lengths to which they have gone to keep Truman captive for so long. Weir uses every available camera angle to portray Truman's TV reality, his growing doubts about his life and his eventual escape. Interestingly, Ron Howard directed a film with similar themes the following year, *EDtv* (1999) starring Matthew McConaughey, but 'Ed' knew that he was on a reality TV show and played up to the cameras. Weir's film, and Carey's portrayal, are much more subtle and ironic.

Not only is *The Truman Show* about Truman's life, but it says just as much about the audience watching him. Truman's farewell to Christof, and the audience – "Good morning, and in case I don't see ya, good afternoon, good evening, and good night!" – crowns an intelligent film with a telling postscript. What's on next?

Scott Rudin Productions/Paramount: 103 minutes

Produced by: Scott Rudin, Andrew Niccol, Edward S. Feldman and Adam Schroeder

Directed by: Peter Weir

Written by: Andrew Niccol

Music by: Burkhard Dallwitz

Cinematography by: Peter Biziou

Starring: Jim Carrey (Truman Burbank), Ed Harris (Christof), Laura Linney (Hannah Gill, playing Truman's wife), Noah Emmerich (Louis Coltrane, playing Marlon), Natascha McElhone (Sylvia, playing Lauren Garland), Brian Delate (Walter Moore, playing Kirk Burbank), Holland Taylor (Alanis Montclair, playing Angela Burbank), Harry Shearer (Mike Michaelson), Paul Giamatti (control room director).

The Big Lebowski (1998) was a typically quirky offering from Ethan and Joel Coen (*Fargo*, 1996) about three bowling buddies who get in over their heads in a complicated case of mistaken identity, kidnapping and fraud.

As 'The Dude', Jeff Bridges creates one of the great stoner throwbacks to the 1970s, while Coen favorites John Goodman (as Walter) and Steve Buscemi (as Donny) are wonderful as his bumbling friends.

Their adventures as they come up against punk nihilists, stylish pornographers and a feminist artist (Julianne Moore) originally missed capturing a mainstream audience on release but quickly became a cult classic.

Philip Seymour Hoffman (as corporate flunky Brandt), Tara Reid (as a gold-digging trophy wife), John Turturro (as a pederast bowling opponent, Jesus) and Sam Elliott (as the old-style cowboy who blows into town) add to the fun.

Great music, stunning visual dream sequences and wonderful stoner humor makes *The Big Lebowski* a bewilderingly funny experience. As Bridges (far left) says to the stranger at the bar (Sam Elliott, right), "The Dude abides."

The Thin Red Line (1998) was Terrence Malick's long-awaited follow up to the Oscar®-winning *Days of Heaven* (1978).

Based on James Jones' 1962 novel (following his *From Here to Eternity*), *The Thin Red Line* was filmed in North Queensland, Australia and released in the wake of Spielberg's *Saving Private Ryan*. Like Malick's previous films, *The Thin Red Line* is a beautiful film that attracted an all-star cast (Sean Penn, Jim Caviezel, Elias Koteas, Ben Chaplin, Nick Nolte, John Cusack, Adrien Brody, Jared Leto) although many scenes were cut from the 170-minute final release and some actors (George Clooney, John Travolta and Woody Harrelson) appear only briefly.

Different in style and context to Spielberg's war film, Malick's film also won critical acclaim and earned over $100 million.

Fight Club (1999) polarized critics and audiences when it was released in 1999, but is now universally regarded as one of the best films of the decade because of its highly influential visual style (from director David Fincher), quirky visual effects and its violent plot with a clever twist. Brad Pitt and Edward Norton (pictured above) make a great team (or do they?), with Helena Bonham Carter, Jared Leto and rock singer Meat Loaf effective in supporting roles.

With its commentary on advertising, violence, conformity and insanity, *Fight Club* struggled to recoup its production costs on its first release but became a cult classic on home video.

The films of director **David Fincher** (b. 1962), pictured right, have a dark visual style that still manages to dazzle. Obsessively professional and uncompromising in his vision, Fincher's penchant for long tracking shots was taken to a new level in the digital age.

Sci-fi fans may not have appreciated his work on *Alien 3* (1992), but *Se7en* (1995) single-handedly established a new genre of edgy, even lurid, psychological thrillers, while the anarchy of *Fight Club* (1999) earned him a cult following.

72nd Academy Awards®

1999

Best Film: *American Beauty* (DreamWorks / JinksCohen Co.)

Best Director: Sam Mendes, *American Beauty*

Best Actor: Kevin Spacey, *American Beauty*

Best Actress: Hilary Swank, *Boys Don't Cry*

Best Supporting Actor: Michael Caine, *The Cider House Rules*

Best Supporting Actress: Angelina Jolie, *Girl, Interrupted*

American Beauty (1999), the story of a suburban dad (Kevin Spacey) who suffers a mid-life crisis as he grapples with the thought of sleeping with his daughter's friend, isn't nearly as sordid as it sounds in the hands of first-time director Sam Mendes. The film won five Oscars®, for Best Film, Best Actor, Best Director, Best Original Writing (Alan Ball) and Best Cinematography (Conrad L. Hall, this second).

Spacey is ably supported by Annette Benning, as his unhappy wife; Thora Birch, as their emo daughter and Mena Suvari, the object of Spacey's attention. Chris Cooper gives a memorable performance as the neighbor from hell, while Wes Bentley plays Cooper's disengaged son to perfection.

In 1993, 21-year-old transgender man Brandon Teena (born Teena Brandon) was raped and murdered in Nebraska by two male acquaintances when they discovered he was really a woman.

Filmmaker Kimberley Pierce chose this story – at a time when transgender issues were not widely known – as her feature film debut. Actress Hilary Swank (right) won the first of her two career Oscars® (also *Million Dollar Baby*, 2004) in a startling transformative and sympathetic performance, while the director and film were Oscar®-nominated.

Boys Don't Cry (1999) also stars Peter Sarsgaard (above left) and Brendan Sexton (right) as the killers, Chloë Sevigny as Brandon's girlfriend and Alicia Goranson as Brandon's similarly ill-fated friend Becky.

The Matrix (1999) raised computer-generated special effects and stylized action sequences to a new level at the end of the century, but writer-directors The Wachowski Brothers relied on a story of a messiah entering a futuristic world to capture the attention of audiences.

Keanu Reeves (b. 1964) is believable as Neo (for a guy who doesn't know where he is or who he is) while Laurence Fishburne and Carrie-Anne Moss are suitably stone faced as Neo's computer hacker colleagues.

As Agent Smith, Hugo Weaving is a memorable, multi-faceted villain while Joe Pantoliano is well cast as a duplicitous programmer.

What does *The Matrix* really mean? The popcorn audience may not have cared, but after taking more than $600 million dollars worldwide, the film generated two sequels, *The Matrix Reloaded* and *The Matrix Revolutions* (both 2003) that did not provide obvious answers. Curiously in the DVD box set, the Wachowski's chose not to do a directors' commentary but instead provide two alternative commentaries: three (highly critical) film critics (Todd McCarthy, John Powers and David Thomson) contrasting against the commentary of two highly savvy philosophers, Dr Cornel West (who has a cameo in the sequels) and Ken Wilber, who provide great insight to the many meanings of *The Matrix*.

The Sixth Sense (1999) is a film with one of the best twists in cinema history, with writer-director M. Night Shyamalan redirecting audience attention away from the real role of Bruce Willis' child psychologist when dealing with a young boy's emotional issues.

The audience knows that the boy "sees dead people" because Shyamalan shows us what the boy sees, but he still manages to hide the truth about Willis' psychologist (even from the character) right until the very end.

Australian actress Toni Collette, as the boy's mother, helps the story immensely by grounding the emotional drama in the here and now, while Willis gives a career-best performance as the psychologist who can't understand why his marriage is falling apart. Haley Joel Osment as the terrorized child is totally believable.

There are genuine thrills and chills in this horror story that not even Shyamalan has been able to reproduce in his subsequent films.